CHILDREN IN PHOTOGRAPHY
150 YEARS

CHILDREN IN PHOTOGRAPHY
150 YEARS

Photographs selected by
Jane Corkin

Text by
Gary Michael Dault

A FIREFLY BOOK

Copyright © 1990 Firefly Books Ltd.
All works: © the artist
ISBN-0-920668-68-2 paperback
ISBN-0-920668-75-5 hardcover

This book is published in connection with the national touring exhibition
"The Hongkong Bank of Canada Photographs Of Children: 150 Years",
curated by Jane Corkin
and organized by the Winnipeg Art Gallery, presented at:

Dalhousie Art Gallery, June 27 – September 4

Saidye Bronfman Centre, October 9 – November 8

Memorial University Art Gallery, December 6 – January 20, 1991

Winnipeg Art Gallery, February 14 – March 31

Koffler Art Gallery, May 2 – June 16

Art Gallery of Hamilton, July 18 – September 22

Vancouver Museum, October 18 – December 1

Glenbow Museum, January 18 – March 15, 1992

Edmonton Art Gallery, April 11 – May 24.

Text: Gary Michael Dault with the exception of pages 144, 242, 246 and 262.

Design: DUO Strategy and Design Inc.

Typesetting and Pagination: On-line Graphics

Cover photograph: HENRI CARTIER-BRESSON *Rue Mouffetard,* Paris, 1954

Canadian Cataloguing in Publication Data

Dault, Gary Michael
 Children in photography

Published in conjunction with an exhibition held at
the Dalhousie Art Gallery, June 27–September 4,
1990, and travelling to other galleries.
ISBN 0-920668-75-5 (bound) ISBN 0-920668-68-2 (pbk.)

1. Photography of children – History.
2. Photography of children – History – Exhibitions.
I. Corkin, Jane. II. Canadian Museum of
Civilization. III. Title.

TR681.C5D3 1990 779'.25074'71 C90-094070-0

A Firefly Book
Published by
Firefly Books Ltd.
250 Sparks Avenue
Willowdale, Ontario, Canada
M2H 2S4

Printed and bound in Canada

CONTENTS

ACKNOWLEDGEMENTS

The national touring exhibition, The Hongkong Bank of Canada Photographs of Children: 150 Years and the companion book, entitled *Children In Photography: 150 Years*, have been accomplished in a very short period of time, thanks to the exceptional efforts of a truly fine team.

Special acknowledgement is due to those who have assisted in sponsoring this project: to Hongkong Bank of Canada for their generous underwriting of the exhibition and the tour, and whose gift of Canadian works from this show to the Winnipeg Art Gallery showed their commitment to Canadian photography; to James H. Cleave, President and Chief Executive Officer of Hongkong Bank of Canada, for his support of this project; to Paul Bailey, who expressed his support of the project through his love of photographs and creativity in marketing; to Nina Wright, of Arts and Communications Counselors, who found the corporate backing and got the project rolling; to Janet Conover, also with Arts and Communications Counselors, who coordinated all aspects of this project on behalf of Hongkong Bank of Canada, including organizing their gift and the press materials, and who arranged the touring exhibition with ten fine institutions. With a project of this magnitude there is always one individual who provides the glue that holds it all together. Janet took this role with unselfish determination and a fine wit.

I am indebted to Carol Philips, the Director of the Winnipeg Art Gallery, who was excited about the project from its inception. Carol took a leading role; her support and advice have been much appreciated. Thanks also to Shirley Madill and Susan Swan from the curatorial office; designer Tiana Korchak; the photography department, Ernest P. Mayer and Sheila Spence and Donna Bolster, Education Department, all from Winnipeg Art Gallery. Carol Beggs, the Registrar and her assistant Karen Kisiow, deserve special thanks. Carol's great organization skills kept it all together under adverse circumstances. Carol coordinated all aspects of locating the works. I appreciate her dedication and tenacity to the end.

Judith Tatar from my own gallery, diligently prepared the lists of photographers and researched the biographical information with unflinching dedication. She also coordinated all aspects of the book from the writing, through editing and design, to press. I would like to thank Karen Reddy, who joined us just in time to take over some loan letters and to research some crucial information about the photographers; Robert Roch our Registrar; Brian Scully who always kindly makes himself available for advice on even obscure details; and Patti Cooke, the Director of the gallery, who always allows the brilliant momentum of a project to forge ahead.

Thanks also go to Katherine Govier and Hilton Tudhope for their generous gift of expression; to Kim Sprenger for her fine coordinating efforts; Jeff Nolte, who provided excellent transparencies and prints; MaryAnn Camps, Cheryl Taylor and Nora Camps who, respectively, produced and designed the catalogue; Lionel Koffler, who published the book with barely enough time to let the ink dry, and remained calm and persistent through it all; Gary Michael Dault, whose endless ability to put out words never ceases to amaze me; Robert Enright and Meeka Walsh who, as the Winnipeg Art Gallery's freelance editing team, displayed wit and intelligence at all times.

We are very pleased to be associated with the participating museums and their staff: Mern O'Brien, Director of the Dalhousie Art Gallery; Peter Krausz, Curator of Saidye Bronfman Centre; Pat Grattan, Curator of Memorial University Art Gallery, Jane Mahut, Director of the Koffler Gallery; Ihor Holubizsky, Assistant to the Director of the Art Gallery of Hamilton; David Hemphill, Director of the Vancouver Museum, Kate Davis, Assistant Director (Programming) at Glenbow Museum; and Elizabeth Kidd, Curator of the Edmonton Art Gallery.

My colleagues were generous with information, time, the loan of works, and copyright releases. They frequently loaned works that added significantly to the whole, and responded quickly to help our project.

My thanks go to: Joan Schwartz and Brian Carey at the National Archives of Canada in Ottawa; Susan Kismaric, at the Museum of Modern Art in New York; Dr. Shirley Thompson, Director, James Borcoman and Ann W. Thomas, Curators, at the National Gallery of Canada in Ottawa; Barbara Boutin also of the National Gallery of Canada, who circumvented a usually lengthy process to get us materials; Anne Tucker, of the Museum of Fine Arts, Houston; Musée d'arts contemporain, Montreal; Weston Naef, of the Getty Museum in Los Angeles; Jeffrey Fraenkel, Fraenkel Gallery; Katherine Chapin of the Facchetti Gallery; Barbara Schaeffer of the Reference Library, George Eastman House; Katherine Ware of the Oakland Museum; Terence Pitts of the Centre of Creative

Photography in Arizona; and Thomas Walther, Edwynn Houk, Helen Wright, Pamela Harris, Kathleen Lamb and Ken Jacobson.

Special thanks are due to the private lenders who agreed, even if reluctantly at times, to take works off their walls and allow others to enjoy them: Diane Alan; Edward Ballard; Rebecca Ballard; David and Betsy Barlow; Bev and Jack Creed; Donald Corkin; Edward R. Downe Jr.; Rebecca Dubinsky; Patricia C. Kennedy; Robert Koch; Ezra Mack; Kathleen Maclellan; Alexandra Marshall; Susan Muir; Dr. Arthur Rubinoff; Richard Sandor; Brian Scully; Hugh and Vanessa Scully; Walid El-Alaili; and Nina and Norman Wright.

Most of all, our thanks go to the photographers who gave us their work and made the entire project possible. Many of their studio assistants and personal curators have helped with loans, copyrights, information and immediate responses to shipping problems. We appreciate their dedication: Nell Gutman; Richard Tardiff; Susan Friedewald; Pat McCabe; Shelly Dowell; Nan Richardson; Teri Barbero; Kathleen Grossett; Linda Fiske.

To the photographers who are lenders, my most sincere thanks. This catalogue is dedicated to you, and to the children:

Louise Abbott, Laurence Acland, Simeon Alev, Richard Avedon, John Baldessari, Edouard Boubat, Robert Bourdeau, Mary Bourdeau, Debbie Fleming Caffery, Harry Callahan, Henri Cartier-Bresson, Barbara Cole, Arlene Collins, Burt Covit, Judith Crawley, Martha Davis, Robert Doisneau, Mary Ellen Mark, Robert Frank, Debra Freidman, John Gutmann, Pamela Harris, Gail Harvey, Helen Heighington, David Hlynsky, Horst, Joanne Jackson Johnson, Tony King, Michael Klein, William Klein, David Laurence, Carol Marino, Linda McCartney, Sheila Metzner, Robert Minden, Joan Moss, Roger P. Mulligan, Nic Nicosia, Nicholas Nixon, Jeff Nolte, Irving Penn, Gilles Peress, Birgitta Ralston, John Reeves, Deborah Samuel, Francesco Scavullo, Nigel Scott, Tom Skudra, Michael Spano, Greg Staats, Lubo Stacho, Andreas Trauttmansdorff, Ray Van Dusen, Grey Villet, George Zimbel, Rick Zolkower, Wolfgang Zurborn.

PHOTOGRAPHS OF CHILDREN: 150 YEARS

This exhibition is about children and photographers. It is also about inner worlds made visible through play, about the artistic vision delighting in its own reflection, about innocence and imagination captured—and set free for all to see.

As the concept of the exhibition took shape in my mind, I began to truly appreciate the kinship that exists between a photographer and a child. The best photographers retain the qualities of childhood far beyond their childhood years. Some of their best subjects are children who are unencumbered by experience or prejudice. Both photographer and child share innocent solemnity and insights that cut to the heart of a matter, revealing in the moment something about each other, and about each of us.

The photographs in this collection cross many genres, and traditions within genres. Portraiture is one example. Victorian photographer Julia Margaret Cameron worked in natural settings, but preferred images of an idealized world that gave the children she photographed an other worldly aura of innocence preserved. There are studio portraits such as those made by the 19th-century Canadian photographer William Notman. Carol Marino, a modern Canadian photographer best known as a master of still life and landscape, also is represented here by a studio portrait of a mother with twins. Czech Lubo Stacho's photos, technically portraits but embracing documentary, are tight, pure images that evoke a sense of time passing.

Portrait photographers who often work in the studio and are also highly acclaimed in the tradition of still life or fashion—Horst, Scavullo, Avedon, Penn, Scott, Samuel and Zolkower, for example—all have a body of personal work that includes wonderful, noble portraits of children. These photographers cross barriers by setting a ''stage'' for their artistic directions, then allowing their sitters' fantasies to take over in creating the image.

The documentary genre is well represented here, and by this I mean photographs that are intended as a tool for social comment or change. This ''photograph-as-political-statement'' genre often expresses deeply felt emotions about the violence done to children who cannot speak or act for themselves. They turn us inward to our own response to hunger, to cold, to an uncaring world that forces children to grow beyond their years. An early example is *The Temperance Sweep* (1877) by Scottish photographer John Thompson. His book *Street Life in London* (1878) was one of the first to depict the stark reality of the urban poor. The dignity and directness of Thompson's work anticipated that of Lewis Hine, an American who tirelessly photographed women and children at their jobs. Hine presented thousands of photographs to Congress in an effort to change that nation's labor laws. One of his most famous known images is included in this collection: *Sam,* the Newsie, standing on the street at three in the morning, a bundle of papers under his arm.

Many photographers in the documentary tradition have made images of children for the purposes of improving our world. "It gives me an immense amount of satisfaction to work with these things which are vital and at the very heart of life today," wrote Margaret Bourke-White. Her sentiments would be echoed by other dedicated documentarians such as Mary Ellen Mark, Diane Arbus, Russell Lee and Arthur Rothstein. Similarly, war photographers such as Robert Capa and Gilles Peress reveal the often devastating emotional reverberations of conflict on the lives of the children who are its innocent victims.

Documentary photographers have also given us a glimpse of exotic worlds undergoing immense change. Canadian David Hlynsky, for example, travelled to Poland before changes to the Eastern Bloc countries. He brought back images, such as the one represented here of a child and his grandmother, that portray a life less harsh than popular misconceptions would have us believe. Robert Minden's images of the Doukhobours of British Columbia's southern interior help us to understand people of whom we know little. Debbie Fleming Caffery's photographs of American plantation workers, and those by Greg Staats of his people on the Six Nations Reserve, also show us how photography can become an instrument of empathy—children frequently have that instantaneous effect—and thus an instrument of freedom.

An associated type of documentary photograph is probably best called "anthropological." Edward Curtis, for example, travelled extensively in the northwest United States and Canada under the generous patronage of banker J.P. Morgan to painstakingly record the everyday lives of Native peoples.

The third category represented in this collection is pictorialism. Early genre images, related to the "aesthetic" movement of photography, are typified here by Sutcliffe and Kuehn. Alice Boughton's photograph of her own children playing chess uses a soft, dream-like—"pictorial"—depiction of the scene to achieve the desired emotion. The Victorian period also saw the bizarre post-mortem photograph. These sentimental keepsakes, often of a child lying on a little bed, were charming. With infant mortality as high as fifty per cent during the mid-19th century, grieving parents carried these images on small *cartes-de-visite* in memory of their departed child.

Photographers' own children account for the major body of some photographers' work. Aenne Biermann, for example, worked in Germany during the experimental days of the Bauhaus. She broke up space in a very abstract way, softening her planes with emotional relationships. Tony King used his children to make strong statements about all children. Sheila Metzner, a highly motivated career mother, photographed her five children at various stages of growth, often on a set where the elements could be controlled. Other photographers represented in this collection prefer to cast subjects as in their own play; Frances Flaherty, Barbara Cole, Nic Nicosia and Andreas Trauttmansdorff all use this technique. On occasion the fairytale quality becomes surreal, as can be seen in the work of Helen Heighington.

Finally, there is the unadorned street aesthetic exemplified by the great André Kertész. The work of Kertész sparked my interest in children as a subject of photography to begin with, and keeps it fresh to this day. His photographs demonstrate his ability to cut through the extraneous to the essence of

2

what he found before him. As the images here clearly show, his wonder-*full*, gentle, almost innocent eye was perfectly suited to portraying the life of the child on its own terms.

Also working in Kertész's French tradition were Henri Cartier-Bresson, Edouard Boubat, Robert Doisneau and American William Klein; the Mexican, Manuel Alvarez Bravo, and European Americans John Gutmann and Robert Frank. There is a fine tradition of North American work as well, including Americans Walker Evans and Helen Levitt, and Canadians Thaddeus Holownia and Gail Harvey. Their work shows a sense of humor, and of joy; they are gentler than the documentarians. Even the less happy aspects of life are shown with a sense of surprise that lets the street present its own point of view. These artists take what is in front of them, wherever they find it, and put it into a formal framework in which the only device is their own vision.

In looking through this collection, it is clear to me that photographs of children bear a remarkable power. They capture for us in the moment a quality unique to the photographic art, where the observer and the observed spontaneously collaborate—no matter how contrived the setting—to reveal something new about our relationship to the qualities of the child within each of us—to newness, to innocence, to vulnerability, to wonder. These photographs provoke, they demand response and, like children, require it more of the heart than of the mind.

Jane Corkin
April, 1990

JULIA MARGARET CAMERON
British, born India, 1815 – 1879

The Kiss of Peace, 1869
13⅞″ × 11″ albumen print
Private Collection

Consonant with Victorian yearnings towards beauty and truth of an unassailably stellar sort, as exemplified by the paintings of George Frederick Watts and the sonorous mythologizings of Lord Tennyson, the photographs of Julia Margaret Cameron capture the high seriousness of any art that is central to the moral fabric of its time. "My aspirations," wrote Cameron, sounding as Victorian as it is possible to sound, "are to ennoble photography and to secure for it the character and the uses of High Art by combining the real and the ideal and sacrificing nothing of Truth by all possible devotion to Poetry and *beauty*. . . ." Buried among those stentorian, Carlyle-like capitalized abstractions, however, lay an approach to photography that at its best (when, for example, she concentrated on portraiture and steered clear of the sentimental tableaux of the O.G. Rejlander type) resulted in character studies of great authority. Glowing with the natural light she insisted upon, survivors of the mercilessly long exposure times they were heir to, her sitters turned into radiant personifications of emotional states everybody had experienced and could understand: here was roseate love, tender devotion, fidelity, faith, innocence. In this perhaps most famous of Mrs. Cameron's photographs, a mother (portrayed here by the beautiful Mary Hillier, Cameron's parlormaid) bestows upon her daughter the archetypally maternal kiss of blessing. It is part of Cameron's achievement, however, that her photographs were both ennobling and, at the same time, pioneering essays in a new kind of realism. As Lord David Cecil wrote about Cameron, "Neither children nor young women are idealized, in the bad sense of the word. Mrs. Cameron made it a principle never to touch up a print. These pictures, while expressing her ideal vision of femininity and of childhood, are also accurate likenesses of their subjects."

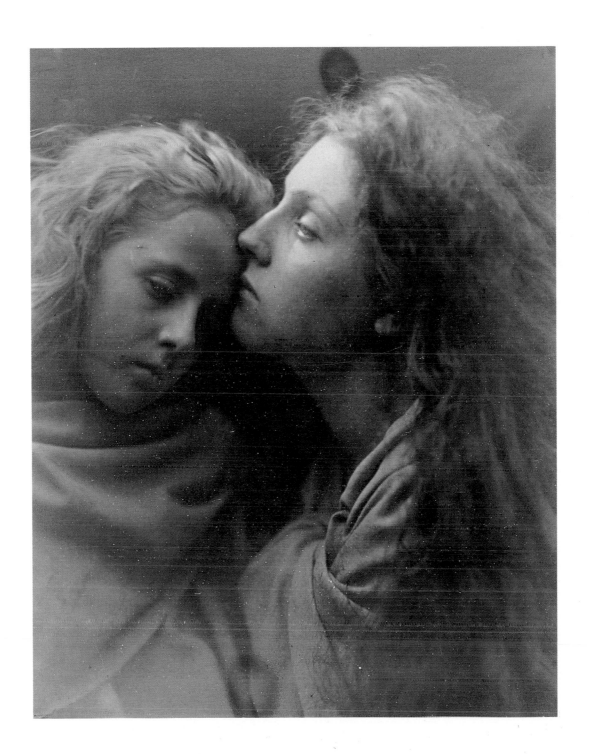

F[RANÇOIS] X[AVIER] FILTEAU
Canadian, active 1874 – 1898 in Hull, Quebec

*Post-mortem photograph of unidentified infant
in laying-out dress, c. 1888*
5″ × 3⅜″ collodian print
Collection of National Archives of Canada/PA173023

The post-mortem photograph was a sub-genre of the
daguerreotype and, for modern tastes, a lugubrious addition to the
popular Victorian world of the carte-de-visite. Morbid though it
appears today, it was common enough for a grieving family to ask
a photographer to make a memorial photo of a family member
who had died. It was far too common, unfortunately, that this
photograph should have to be of a child. It is a touching and
distressing characteristic of the post-mortem picture that the
subject was never to be seen as potentially asleep or in some other
attitude that would have disguised the true nature of the situation.
It was important—perhaps in some way it was even cathartic—that
the deceased, look coldly and stiffly departed, the hieratic
photograph being all that remained, except memory.

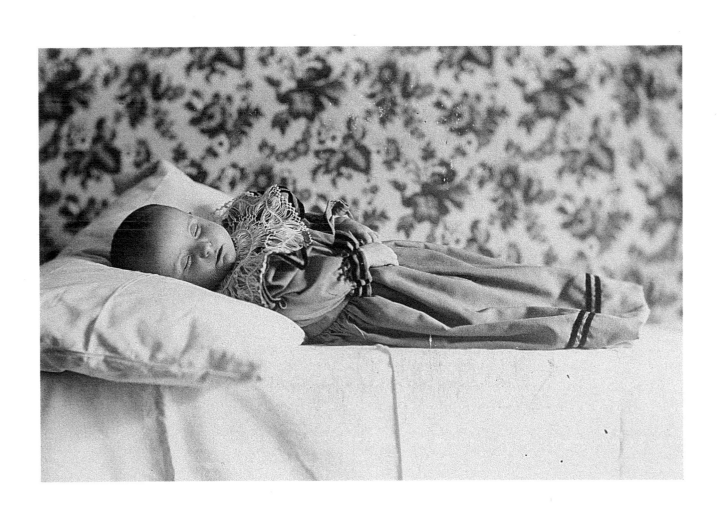

LEWIS CARROLL
British, (born Charles Dodgson), 1832 – 1898

Two Young Girls, c. 1870
3⅝″ × 3″ composite albumen print
Private Collection

For Lewis Carroll, photography was a hobby. It was a hobby, however, upon which he expended a great deal of time (he made photographs from May 1856 until July 1880) and devotion.

Perhaps too much has been made—and in the wrong way—of Carroll's fondness for photographing little girls. He did make photographs of other subjects: there is a superb portrait of Tennyson, of Dante Gabriel Rossetti, of Christina Rossetti and her mother, of novelist George Macdonald, of the actress Ellen Terry, and of the Misses Lutwidge, two of Carroll's aged aunts, engaged in what appears to be a fearsome game of chess. But it is undeniably true that little girls held a genuine fascination for him. *Not* little boys. "I am fond of children," Carroll wrote once in a letter, "except boys. To me they are not an attractive race of beings." With little girls he evidently felt more at ease. "He himself said that children [girl children] were three-fourths of his life," wrote Helmut Gernsheim in his study of the photographer (1949), "and that in their company his brain enjoyed a rest which was startlingly recuperative. To play with children was a tonic to his whole system. . . ." If prurience played a part in the energizing effect of Carroll's relationship with his young friends, its only outlet was photography, which was controlled both by Carroll's own insistence upon the presence of parents-as-chaperones and by the innate fineness of his own sensibility.

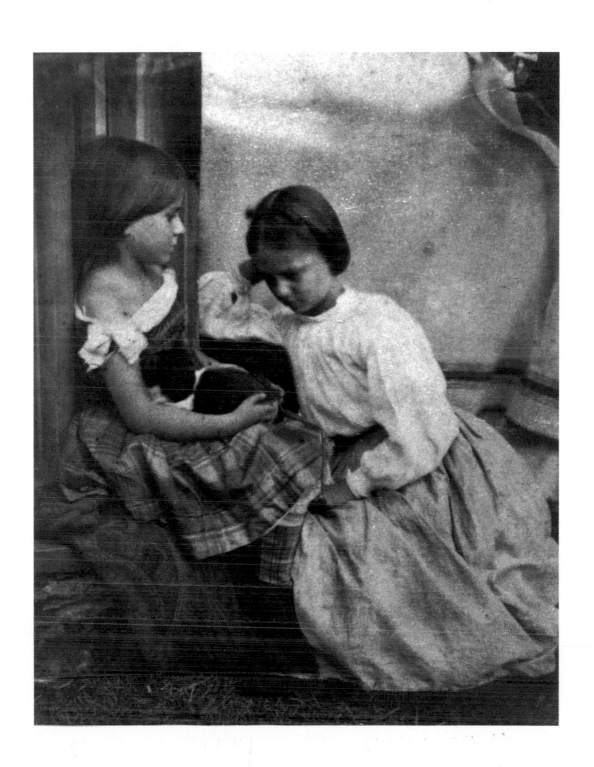

ANDREJ KARELIN
Russian, 1837 – 1906

Photoalbum, c. 1870
9 ¼″ × 6 ¾″ albumen print
Collection of Mayer and Mayer

These three Russian girls are busy with the late 19th-century's equivalent to an evening in front of the VCR. They are browsing through the family's collection of photographs—mostly, judging from the size of the images, a collection of carte-de-visite photographs. The carte-de-visite was the innovation of Adolphe-Eugène Disdéri, court photographer to Napoleon III. Building on the popularity of the daguerreotype, Disdéri discovered a method by which a number of images could be photographed onto the same glass-plate negative and be processed all at the same time—a primitive sort of photographic printing press. The result was, of course, cheaper photographs. So inexpensive were they, in fact, that people exchanged them the way they do business cards today. The rage for the carte-de-visite grew to maniacal proportions: cardomania. Just when the fervor for trading and collecting them was waning, around 1865, another development came along to replace them—the cabinet card, a still inexpensive photograph, but available in a size four times larger than the carte-de-visite. Large enough to prop on your mantelpiece and look at from the other side of the room, like television.

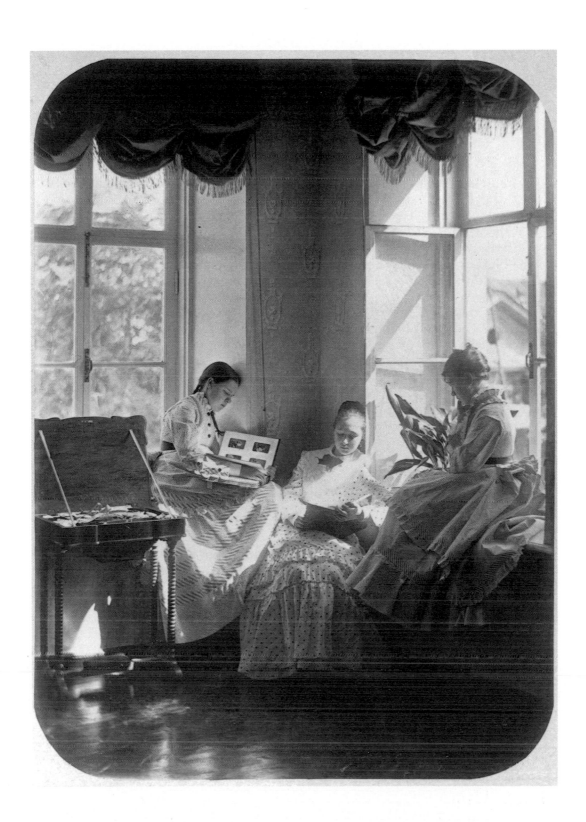

JOHN THOMPSON
British, 1837 – 1872

The Temperance Sweep, 1877
3¾″ × 2¼″ woodburytype
Collection of Gary Michael Dault

John Thompson spent much of his life as a photographer travelling through the Orient, visiting and taking pioneer photographs in Siam, Vietnam, Cambodia, Formosa, the Malay peninsula and, especially, China. He left England in 1862, when he was twenty-five years old, travelling almost constantly (with a one-year visit to Edinburgh, his birthplace, in 1866) until 1872 when he returned to London to publish his four-volume *Illustrations of China and Its People* (1873-4).

During the four years Thompson spent back in England, before returning to the Orient, he labored diligently (with journalist Adolphe Smith Headingly) on the work of photojournalism by which he is probably best remembered today, his *Street Life in London*, 1878. Conceived as a sort of sequel to and updating of sociologist Henry Mayhew's *London Labour and London Poor* (1862), *Street Life in London* consisted of 36 woodburytypes (with commentary) of the urban poor, photographed with a sensitivity and tact that made them into something beyond clinical studies. Indeed the best of them possess a dignity and a directness that can be said to anticipate works like Paul Strand's New York photographs of forty years later.

The Temperance Sweep is so labelled, of course, because this particular dustman seems to have (untrue to type) sworn off drink; there is even a sort of halo-like scratch in the wall behind him that fits over his head like an acknowledgement (perhaps no more than a photographic coincidence, but amusing nonetheless). But while Thompson's photograph is ostensibly about this dour and strangely awkward chimneysweep, it seems actually to be more about the sweep's winning little assistant, leaning, with engaging insouciance, in the doorway. You begin to feel that this remarkable boy takes his stern-visaged employer less than seriously. This is one cool kid, Victorian or not.

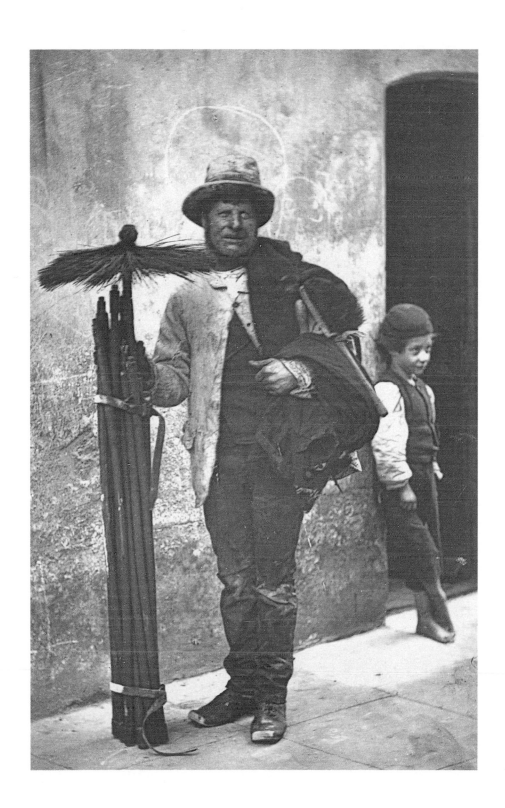

WILLIAM NOTMAN
Canadian, 1857 – 1913

Studio Portrait, c. 1880
3¼″ × 2¼″ albumen print
Private Collection

William Notman, without question the best-known Canadian photographer of the 19th century, emigrated from Scotland in 1856. A decade later, he had photographic studios in Ottawa, Toronto and Halifax, in addition to his base of operations in Montreal. Later, he would expand even further, setting up branches in such centers as Albany, N.Y., Saratoga Springs, N.Y. and Boston.

Part of the popular appeal of his studio photographs lay in Notman's attempt to recreate an outdoor realism indoors. Of his famous Cariboo Hunting series, Edward L. Wilson, editor of the then influential *Philadelphia Photographer*, wrote, "Nature has been caught—not napping—but alive! Out of doors has been brought indoors with the elements. . . " In this touchingly stiff little portrait, nature is most assuredly alive if a bit bundled up. This stalwart child, the triumph of winter clothing over expressiveness, has been set down amidst a tundra of soapflakes and told, no doubt, to look as if he were having fun in the snow. He is grimly doing his best, but he looks very small and alone at the center of all this artifice.

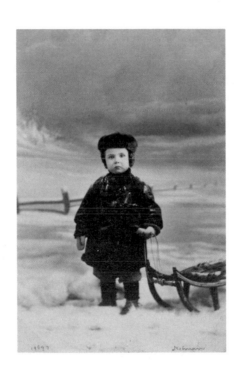

FRANK MEADOW SUTCLIFFE
British, 1853 – 1941

Water Rats, 1886
5½" × 7½" albumen print
Private Collection

According to Michael Hiley, author of the *Sutcliffe* volume in the *Aperture History of Photography Series* (1979), Frank Meadow Sutcliffe frequently referred to himself as a "limpet," a small clingy sort of shellfish that "sticks fast to seashore rocks." The seashore rock that Sutcliffe stuck fast to was the English port town of Whitby on the Yorkshire coast, a picturesque fishing village 250 miles from London. Sutcliffe had been born in Leeds, but moved with his family to Whitby when he was seventeen years old. So perfectly did the life and activities of the town suit his temperament that Sutcliffe spent virtually all the rest of his long life there, working as a photographer and, late in his career, as curator of the museum of the Whitby Literary and Philosophical Society.

The delightful naturalness and even offhandedness of his photographs are traceable both to his innate and formidable skill as a photographer and, at the same time, to his being so familiar a figure on the local scene, so fully accepted by the town's fishermen and their families. About the generation of his famous photograph *Water Rats*, Sutcliffe has written:

> One hot morning I saw three naked boys shoving an old box about in the harbour. I went to them; asked them how long they were likely to be there. They said all day, if I liked; for, though they ought to be at school, the kid-catcher could not come into the water after them. I offered them one penny each to wait till I fetched the camera. My offer of wages had spread, for, when I returned, I found thirteen boys naked. When they saw me, they all stood in a row in the same position, which was a cross between a soldier at attention and the Greek slave. I have regretted that I did not take them so. I was at a loss to know what to do with so many sitters, as the box would only hold two, till I saw an empty boat at the other side of the harbour.

The finished photograph won the artist a medal at the 1886 exhibition of the London Photographic Society.

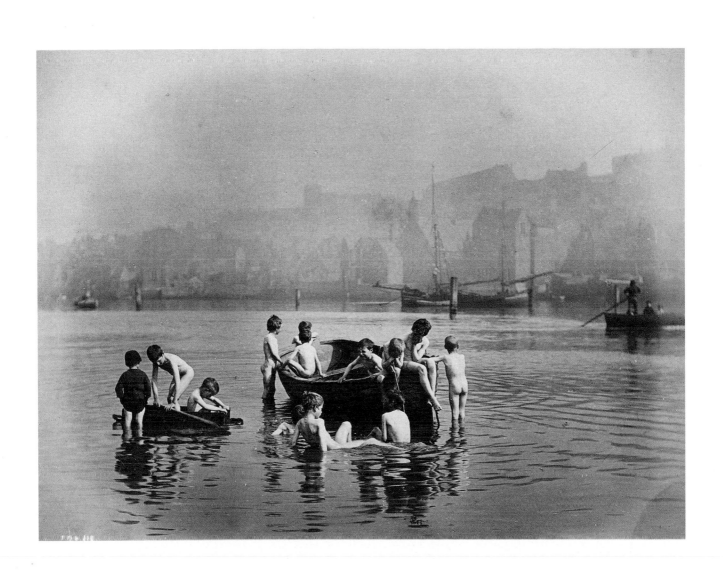

FRANK MEADOW SUTCLIFFE
British, 1853 – 1941

Excitement, c. 1885
10″ × 17¼″ vintage toned silver print
Collection of Jane Corkin Gallery

What is most remarkable about this photograph is surely its composition: the extreme, even radical lateralness of it, its daring horizontality. This horizontality is all the more forceful because it is the product of the accumulation of a lot of individual verticalities: all those becapped boys in a crowded lineup facing back into a picture plane which consists of, as far as the viewer can tell, nothing whatsoever. The tripartite division of the photograph—into stone sea-wall, the row of boys and the emptiness of the air above their heads — is subtly broken by the section of wall at the left and by the running out towards the viewer of the graphically crisp lines of perspective provided by the seams in the massive cut stones of the breakwater.

Sutcliffe's brilliantly effective photographic emptinesses, such as the endless bright space running behind the heads of the boys, are a kind of trademark of the photographers. P.H. Emerson called this erasing to nothing of certain planes beyond the sharply realized subject "the differential focus principle"—a means of causing the background to retreat while leaving the principal subject in high definition. Part of this effect, as Michael Hiley points out, came about as a controlled technical effect. Part of it, as well, was the product "of the haze that naturally hangs over Whitby harbour."

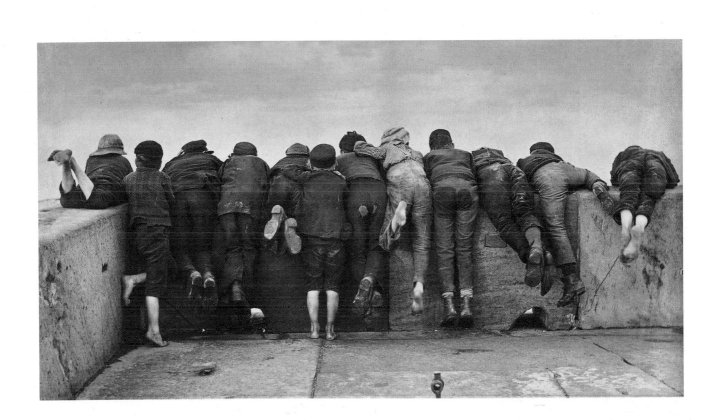

HEINRICH KUEHN
Austrian, born Germany, 1866 – 1944

Hans and Lotte in a Meadow, c. 1908
9⅛″ × 11⅝″ platinum print on tissue
Collection of Rebecca Dubinsky

One of the leaders of the aesthetic movement in photography, the Austrian photographer Heinrich Kuehn was, along with Stieglitz, Frank Sutcliffe, Robert Demachy, Frederick Evans, J. Craig Annan and a number of other pictorialist photographers, a member of the international Linked Ring Brotherhood, formed in 1892 to advance the cause of art photography. Much of the work of the Linked Ring looked to painting—Impressionist painting—for inspiration, a tendency which led Alfred Stieglitz, for one, to abandon the Ring in pursuit of cleaner, less worked-up photography. In order to bring about a painterly feeling to their prints, the Linked Ring artists, Kuehn and Demachy in particular, paid a good deal of attention to complex, highly controllable chemical processes by which they could achieve texture, facture softness of surface— processes like multiple gum printing, introduced by Kuehn in 1897.

This delicate pastorale, image is unabashed Impressionism. The little picture nonetheless possesses a genuine, if derivative, beauty. It is superbly composed, for example. And the warm sunlight with which it is saturated seems not so much to have fallen over it as to have come welling up from somewhere within the picture, a liquid radiance.

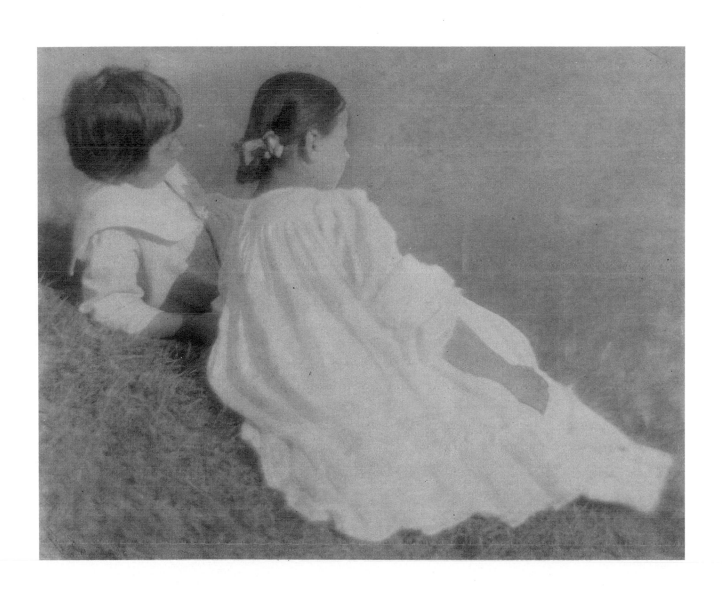

HEINRICH KUEHN
Austrian, born Germany, 1866 – 1944

Two Children Reading, c. 1900
17¾″×15″ gum-bichromate
Private Collection

Among the pictorialists of photography's earlier days, Heinrich Kuehn was especially valued by his peers (by Alfred Stieglitz in particular) for the psychological power of his portraits. Part of this power was traceable to Kuehn's conviction that however soft and painterly an image might be made, it also needed a clear, strong presence, available for inspection; the image was not to get lost in the idealist mists of an art-for-art's-sake aesthetic. While this nascent purism is not always discernable in a lot of Kuehn's obviously picturesque photography, it speaks forcefully from his portraits. "It seems to me," Kuehn wrote to Stieglitz in January of 1905, "that the highest achievement of photography must be based on obtaining pictorial effect without messing around. We know there are painters but the photographer is not permitted to paint." Kuehn's *Two Children Reading* is "aesthetic" only in its satisfyingly solid composition. Otherwise, it is just what it purports to be: a study of two children reading. What has been so deftly caught—and this is what the painter could perhaps not manage easily—is the intensity children bring to any activity, like this one, which gives them pleasure. The child holding the book is tremulously but proudly in charge of the story-reading. The little girl leaning in to share the book is delighted to be included. The wide-open volume holds them both—holds them pictorially like calipers or a set of compasses.

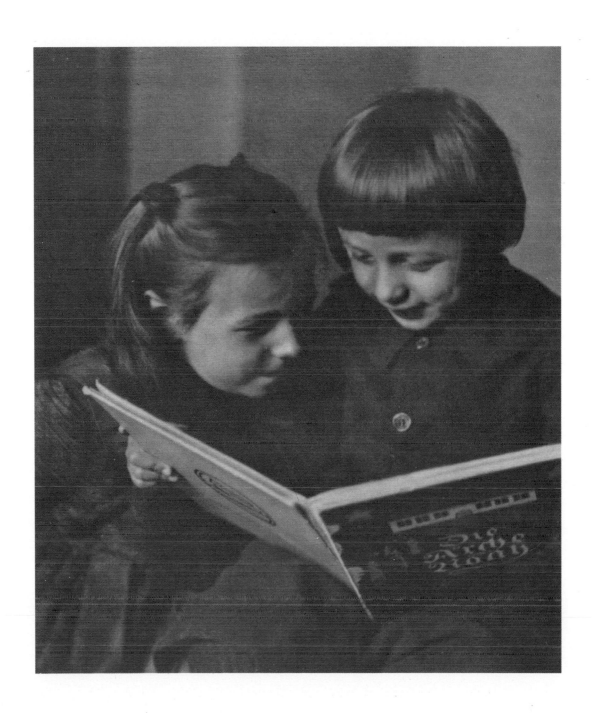

F. HOLLAND DAY
American, 1864 – 1933

Portrait of Clarence White Jr., c. 1900
4⅜″ × 3¾″ platinum print
Collection of Ezra Mack

In his time, at the turn of the century, American photographer F. Holland Day was regarded as the peer of the powerful Alfred Stieglitz and a twin pole in the taste-making firmament. As a publisher, he was the first to make the then scandalous works of Oscar Wilde and Aubrey Beardsley available in North America (as well as the so-called bible of the decadents, the notorious *Yellow Book*). Day was friend to and an influence upon such photographers as Clarence White, Gertrude Käsebier, Edward Steichen and Frederick Evans and was especially encouraging, it seems, to his younger cousin, Alvin Langdon Coburn. Kahlil Gibran was his protégé—and often one of his models.

French photographer Robert Demachy wrote about Day's own photographs:

Mr. Day is what we call in French 'un raffiné', a man of delicate and subtle taste, who finds particular delight in special color tones and combinations of lines and curves, which either pass unnoticed by the general public or only appeal to their minds after repeated or prolonged study.

Such a description might apply to Day's charming portrait of one of the sons of photographer Clarence White, a pictorialist tour de force of diaphanous light effects of the sort referred to contemptuously by the press of Day's time as "Fuzzyography." Ultimately, Day had a fatal falling-out with Stieglitz which resulted in his being excluded from Stieglitz's prestigious periodical *Camera Work*. This in itself was enough to put his reputation into eclipse. Day's story has been excellently recounted in Estelle Jussim's biography *Slave to Beauty: The Eccentric Life and Controversial Career of F. Holland Day—Photographer, Publisher, Aesthete*, 1981.

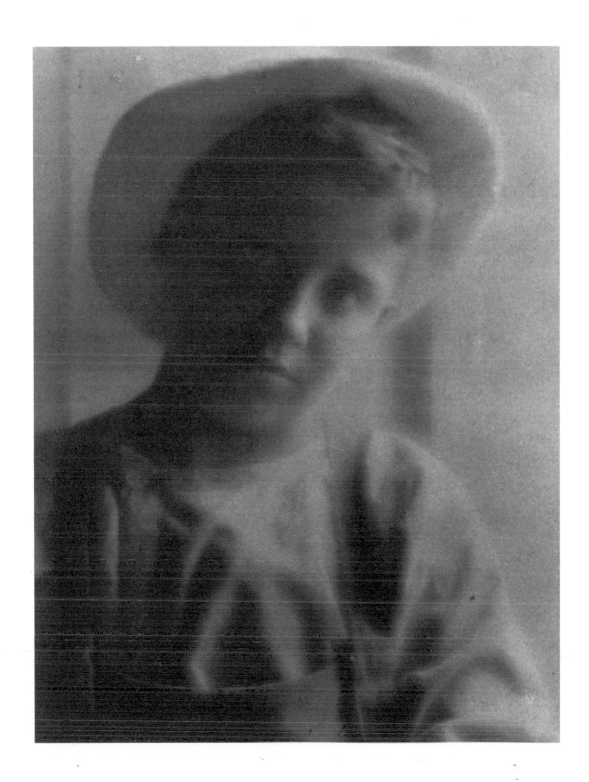

EDWARD STEICHEN
American, born Luxembourg, 1879 – 1979

Mary Learns to Walk, c. 1905
7" × 5" photogravure
Private Collection

During his Photo-Secessionist days, as a confidante of Alfred Steiglitz and a contributor to *Camera Work,* Edward Steichen revelled in photography's employment of painterly, impressionistic effects. Some of the photographs he produced during this period are among the most brilliantly realized works ever made within this particular genre—works such as *The Pool—Evening, Milwaukee, 1899*; *The Flatiron Building—Evening, New York, 1905*; *The Big White Cloud, Lake George, New York, 1903*; and the two superb *Steeplechase Day* photographs of 1905. This charming photograph of Steichen's wife and his daughter Mary (born July 1, 1904) partakes fully of the photographer's penchant for veilings of golden light held in a pointilliste haze. At the same time, it introduces not only a firm sense of structure but also a structure that is symbolic. Here, the trees that arch up on either side of the mother and child function as a portal, a structural manifestation of the sense of accomplishment the child will feel when the first steps are successfully taken. The trees here are like stilts, crutches, legs themselves, symbols of stance.

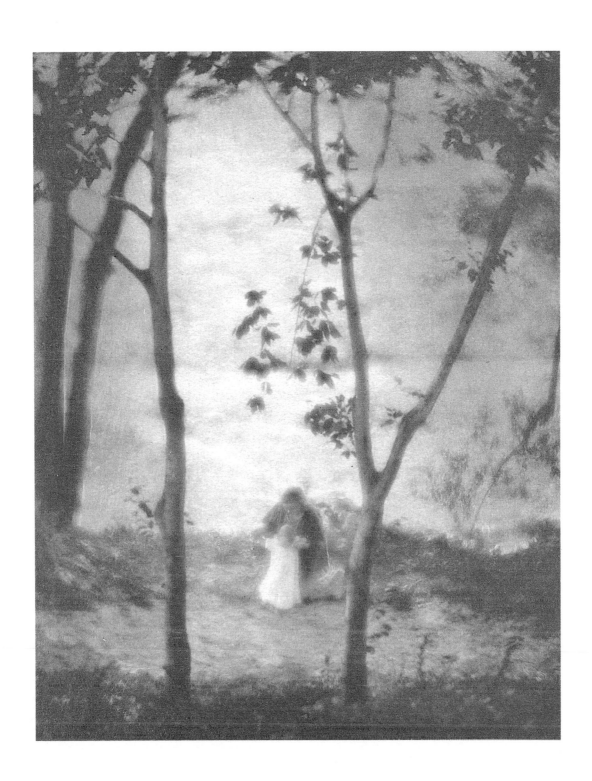

HARRY C. RUBINCAM
American, 1871 – 1940

Untitled, c. 1905
6½″ × 8½″ vintage silver print
Private Collection

Harry C. Rubincam was a member of the Photo-Secessionist group. He is probably best known for his superlative *The Circus Rider* (1905) which appeared in photogravure format in Stieglitz's *Camera Work*. An early masterwork of photographic naturalism, *The Circus Rider* (sometimes also known as *Under the Big Top*) is a seductive presentation of sunlight filtering through the canvas of the circus tent and sifting down onto a bareback rider in a white dress standing up on her white horse.

Rubincam's charming vignette of his son with his train is not the modernist landmark *The Circus Rider* is. And yet it is a highly winning photograph—splendidly composed, tenderly felt and luminous with the soft veiling light so admired by the Photo-Secessionists and compelling still. The burnished metallic sheen of the locomotive is irresistible.

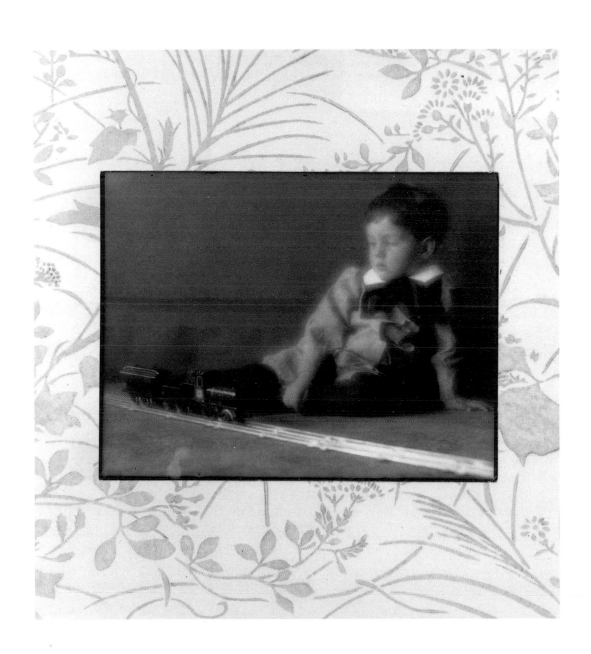

CLARENCE WHITE
American, 1871 – 1925

Boys Going to School, 1908
8″ × 6¼″ photogravure
Private Collection

Of all the members of the Photo-Secessionist group who joined the magnetic, larger-than-life figure of Alfred Stieglitz in their collective insistence that photography was as fine a fine art as any other, Clarence H. White probably possessed the best eye. John Szarkowski rather grumpily maintains, in his *Looking At Photographs* (1973), that White had more talent than he had ideas, his "ideas" being nothing more, in essence, than a taste of "Whistler-by-reproduction," a dash of "turn-of-the-century" *japonaiserie*", and rather too much of the baleful influence of the "largely narcissistic attitudes" of the Photo-Secessionists themselves. No matter. He had an exquisite eye. Which is probably better for a photographer than "ideas."

White's remarkable *Boys Going to School*, 1908, is a compositional tour de force. Structurally, it bears comparison to Stieglitz's famous *Going To The Start*, 1904, which is also vertically bisected. With the almost symmetrically balanced heads of the boys moving across the very bottom of the photograph—one is tempted to risk the oxymoron and claim that they are moving statically across the photograph—there is nothing to support the rest of the picture, nothing to keep the bottom from dropping out but the upward reach of the tree and its branching out sideways in both directions across the top. The rest of the picture is light. No doubt there is the fragrance of Japanese influence here. There is also a compositional fervor which is entirely White's.

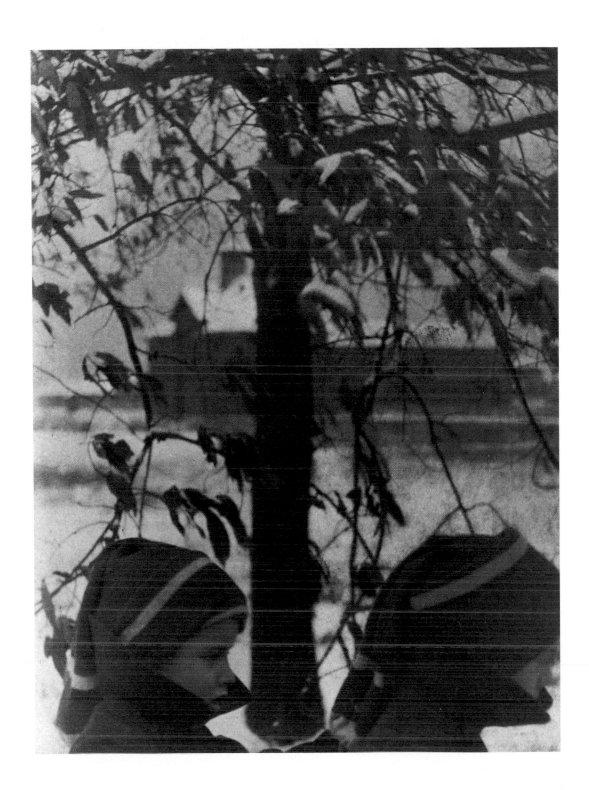

CLARENCE WHITE
American, 1871 – 1925

Drops of Rain, 1908
7¾″×6″ photogravure
Collection of Brian M. Scully

Like White's *Boys Going to School*, most of the ostensible content of his *Drops of Rain* is to be found at the bottom of the photograph. As splendid (and as photographically engaging) as the glassy sphere is, however, it should be remembered that White's title refers us to the vast plane of light provided by the glass of the window, which is animated and modified by the shower of raindrops against it. It is this fall of rain which is the photograph's true subject. There is a relationship, however, between the rain and the glassy sphere the boy is holding: the sphere looks like one individual drop of the rain, epically magnified. A moment of reverie is all it takes to turn each of the raindrops beating against the window into glass spheres too. Thinking about the volume of rain falling in the year, in the street, in the town, as far as the rainstorm extends, is to imagine a veritable sublimnity of glass spheres, falling everywhere to earth.

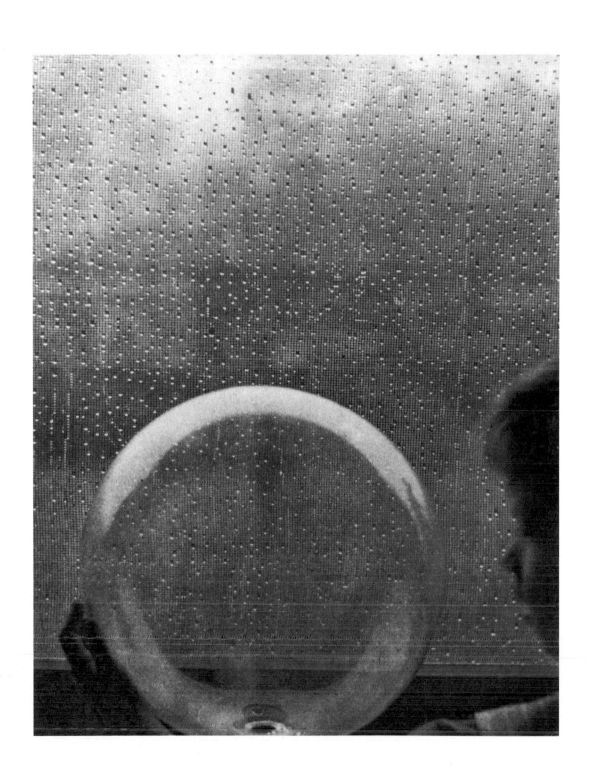

CLARENCE WHITE
American, 1871 – 1925

Boy with Wagon, 1908
8⅛″ × 6½″ photogravure
Collection of Gary Michael Dault

Not the least remarkable feature of Clarence White's *Boy With Wagon* is the discreteness of its pictorial elements, the way every moment of the picture remains free of adherence to every other moment. The little boy, as winsome as any in photography, seems only tangentially related to the floor and not at all related to the dark, heavy door that provides a sweep of backdrop for the composition—or rather, the anti-composition—of the photograph. Nor does he seem very connected to his wagon. The diagonal of its handle, reaching up and across the picture to the boy's little white hand, is insufficiently forceful, graphically, to serve as a pictorial support. Rather than look out at the photographer or at the wagon, the boy looks across the photograph, up and out of it, to some point beyond the picture-plane—a point which completes the very delicately managed, subtly positioned, triangulation begun by the boy's eyes and the wagon. This lightly sketched triangulation is still not enough to order the photograph's structure—which remains nebulous. This is modernity. The way it moves within the photograph is to isolate the boy entirely from his setting and from his attributes, throwing him back upon himself. The photograph thus pushes towards some status as a fable of modernity itself, an early manifestation of fracture and psychic isolation.

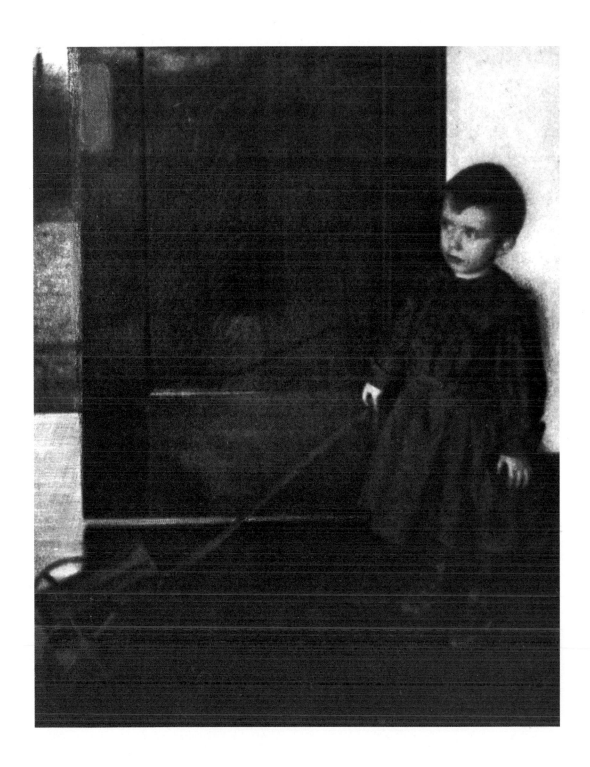

ALICE BOUGHTON
American, 1865 – 1943

Boughton's Children Playing Chess, c. 1910
7⅜″×9¼″ platinum print
Collection of Rebecca Dubinsky

Like many pictorialist photographers at the turn of the century, Alice Boughton studied painting in both Paris and Rome. Shortly afterward, upon returning home, she gained employment from Gertrude Käsebier, working as her studio assistant. In 1904, she was listed in Stieglitz's *Camera Work* as an Associate of the Photo-Secession and, two years later, she was elected a Fellow of that distinguished body. All the while, she continued to work equally at photography and at painting.

The lessons of painting (especially considerations of composition) were important to Boughton, as they seem to have been to most of the Photo-Secessionists. This photograph of her children playing chess maintains a genuine pictorial energy because of the subtle inclusion of the hazy wooden chair in the background, the compositional function of which is to add pictorial weight to the child at the left who is shorter than her sister and would, without the chair, loosen and dissipate the delicate balance of the two figures pivoted about the centrally located chessboard, itself a convenient image of confrontation and equilibrium.

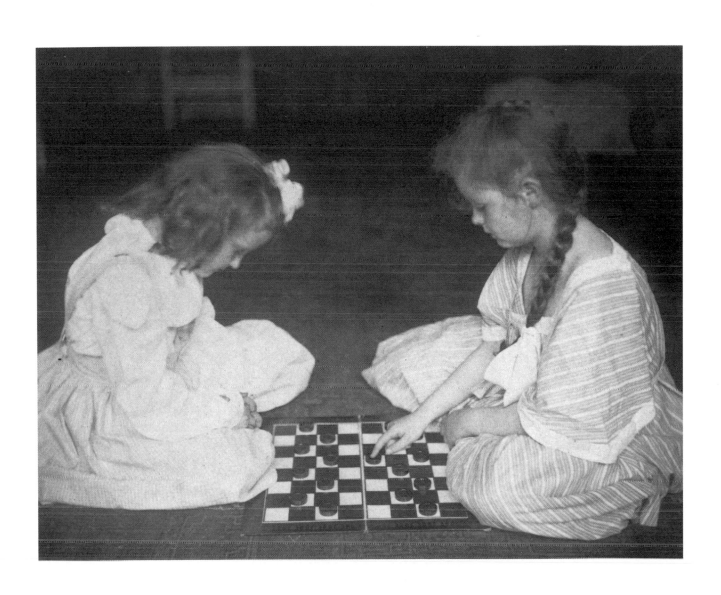

LEWIS HINE
American, 1874 – 1940

Peace in the Heart of the Storm
(Ellis Island during a hectic day), c. 1910
14″ × 8½″ vintage silver print
Private Collection

Like his predecessors John Thompson and Jacob A. Riis (whose powerful study of the poor of New York, *How the Other Half Lives,* was published in 1890), Lewis Hine employed his camera to give a shape and a voice and eventually a complete moral topography to the exploited, the disadvantaged, the economically and socially invisible. Trained as a sociologist at Columbia University, Hine began his career as a photographer in 1904, photographing immigrants coming into the United States through Ellis Island. Photographs like this one (which invariably bore majestic, literary titles like *Peace in the Heart of the Storm* and *The Ellis Island Madonna*) possess a stirring monumentality and a compositional orthodoxy that mimic certain archetypal moments in art history. This Madonna and child study, while particularized by the detailing of jewellery and the patterning of the clothing and the wire-mesh fence (which, pictorially speaking, reads not so much like the bureaucratic divisiveness of a fence as it does an allover background design, something vaguely Moorish out of Delacroix), has all the iconic nobility of traditional mother-child groupings. The mother and child here are allowed to remain aesthetic rather than being pressed into service as sociological. This is art, not research—an ordering of concerns that would soon exchange places within Hine's work.

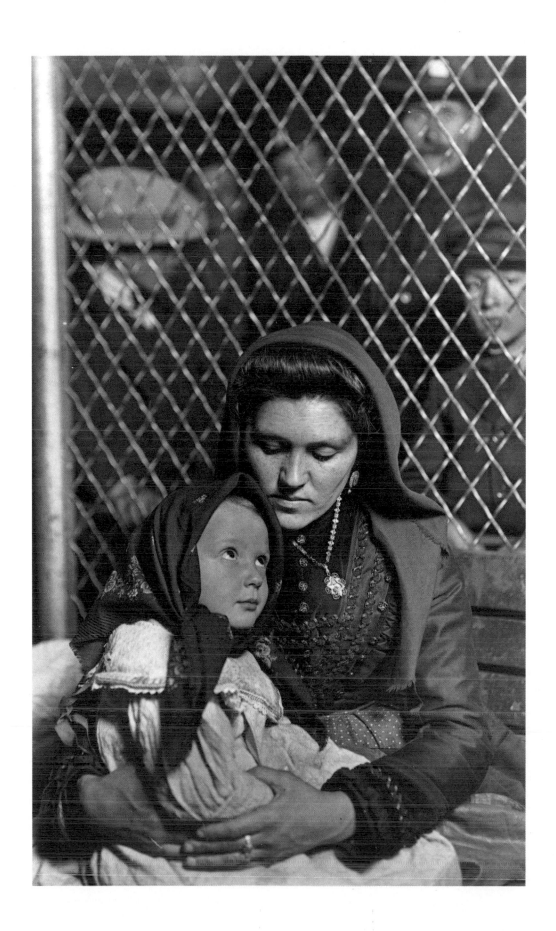

LEWIS HINE
American, 1874 – 1940

Mother & Son Carrying Homework, New York, 1908
5″ × 7″ vintage silver print
Collection of Brian M. Scully

After 1907, Hine's work changed. The photographs he made for the Pittsburgh Survey in 1907 and for the National Child Labor Committee from 1908 until 1918—while no less handsome than the large-scale genre photographs from Ellis Island—are now explicitly documentary. Their purpose, whatever the beauty of their compositional clarity, is to examine the lives of the working children of America and their families. Suddenly the photographs are about individuals, not emblematic types. In this photograph, a specific mother and her specific son carry "homework," clothes to be sewn or laundered. The photograph is brilliantly organized. The dark-clad mother and son, having rounded the corner from the bright sun-flooded street behind them, have now entered the darker half of the photograph (a darkness conveniently provided by the façade of the building on the corner which holds them like a painted backdrop), a darkened passage which provides an economical symbol for the oppressiveness of the hard labor that lies before them.

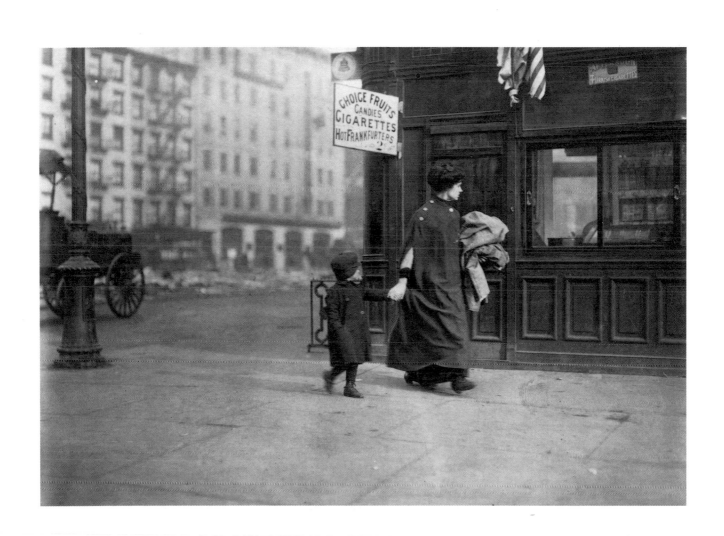

LEWIS HINE
American, 1874 – 1940

Corn Vendor, New York City, 1907
10½″ × 13½″ vintage silver print
Private Collection

Lewis Hine's amiable vignette of children buying corn-on-the-cob from a New York street vendor (a "corn cobbler") possesses a sweetness and an innocence that are rare in Hine, given that most of his work was made as a contribution to a revelation of the appalling working conditions under which both adults and children labored at the turn of the century. It is as if this photograph were made during one of those hallowed in-between moments, a transitional photographic weightlessness floating amid the stern demands of Hine's larger sociological purpose. The photograph provides a useful comparison to Wallace MacAskill's *The Organ Grinder* of 1924 (see p. 55).

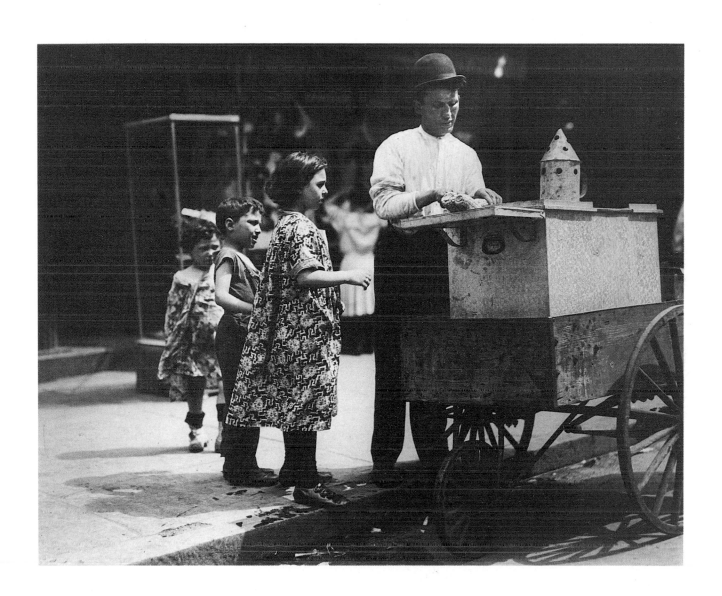

LEWIS HINE
American, 1874 – 1940

Sam, Beaumont, Texas, 1913
4¾" × 6¼" vintage silver print
Private Collection

Lewis Hine's photograph of plucky Sam the newsboy is a small masterwork—a virtual encyclopaedia of the photographer's documentary and aesthetic ideas. Everything in the photograph contributes to Hine's presenting the boy as a tiny hero. He is made larger-than-life or is, at least, given a scalelessness that makes it hard to see him as anything but monumental. He stretches, for example, all the way from his shiny, firmly planted boots almost to the top of the picture-plane. The lamppost beside him functions as a doubling of the boy's strength, an echo of his stance and stamina. The central spine-like positioning of both Sam and his lamppost allows the entire space of the photograph to revolve around them, making him the axis of this strangely evacuated world in which he waits. The only intrusion into the space Sam inhabits is the shadow—presumably of Hine himself, engaged in the taking of the photograph. Aesthetically, the presence of the shadow anticipates by forty years the appearance of the photographer's shadow as a necessary part of a photograph's modernist narrative—as in the work of artists such as Robert Frank and Lee Friedlander.

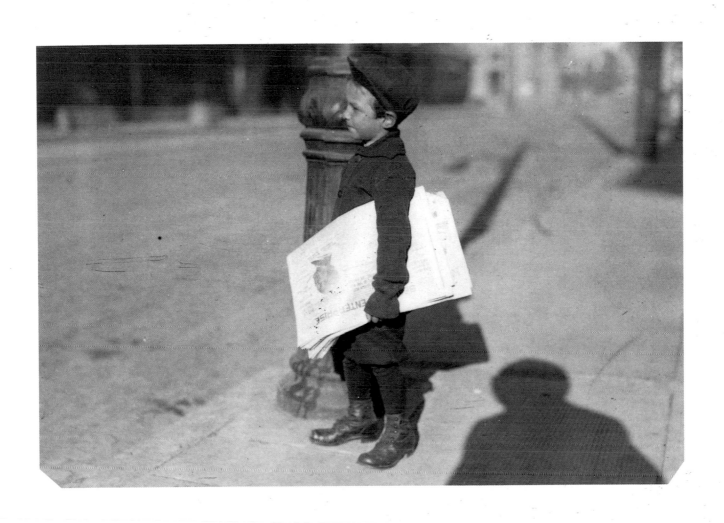

DORIS ULMANN
American, 1884 – 1934

Two Children with Bouquet, c. 1920
6 9/16″ × 4 9/16″ platinum print
Collection of Patricia C. Kennedy

This haunting photograph, fragrant with a gentle, vanished past, is almost enterable in its peacefulness, in its presentation of the conditions over which might be heard murmuring voices carrying on the summer air. "Looking at a photograph," writes Roland Barthes in *Camera Lucida* (1981), "I inevitably include in my scrutiny the thought of that instant, however brief, in which a real thing happened to be motionless in front of the eye." This quiet talk, with flowers, is so knowable it almost becomes a part of everyone's personal history—through possibility, not through memory. A photograph, as Barthes points out, is never, in essence, a memory. On the contrary, a photograph "actually blocks memory, quickly becomes a counter-memory."

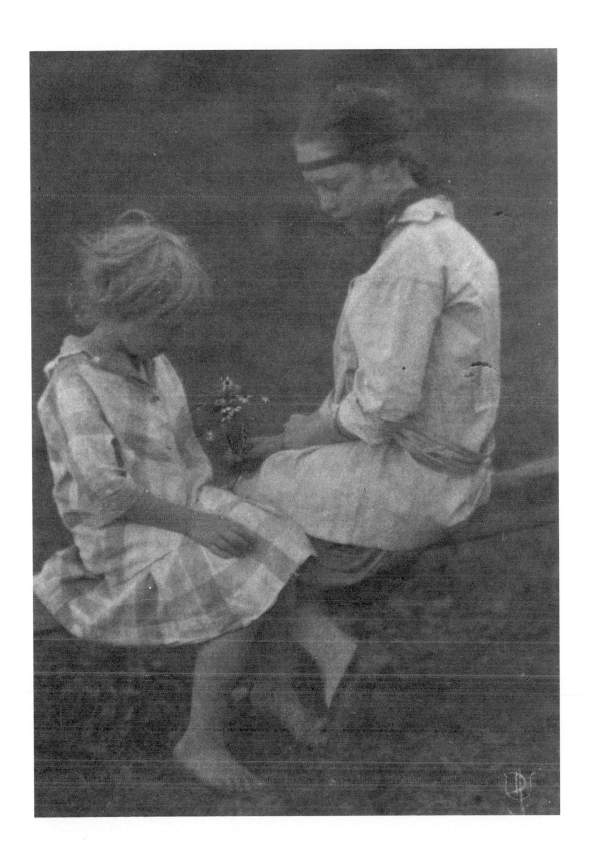

WILLIAM GORDON SHIELDS
Canadian, 1883 – 1947 lived in the United States

Untitled, N.Y.C., c. 1920
10″ × 8″ vintage silver print
Collection of Diane Alan

Very little is known about the Canadian photographer William Gordon Shields. What we do know is the result of the research of Michael Bell of the Agnes Etherington Art Centre, Queen's University, Kingston, whose scholarly tenacity resulted in 1989 in an exhibition of Shields' work and an invaluable catalogue: *Pictorial Incidents: The Photography of William Gordon Shields.* According to Bell, Shields was a "well-to-do amateur" who had photographed in Hamilton, Ontario, and had then moved to New York where he forged a connection with Clarence White and the pictorialist movement. Certainly Shields' photographs demonstrate all of the devotion to light effects and all of the painterly interest in composition espoused by that most aesthetically rarified of photo-methodologies and philosophies.

This, however, is a strange photograph for Shields, as it would have been for any of the pictorialists, because of its drama, because of the apparent urgency of its action. The setting appears to be a railway station. The woman is hurrying from one point to another, carrying one of her children in her arms. The other child seems old enough to manage alone. The photograph is filled with the tension all such transitions generate, especially the anxiety of becoming separated. There is something odd about the older child standing touching his mother's skirts. For while the mother appears to be under way, heading out of the picture plane towards the photographer, the child seems rooted to the spot, unable or unwilling to move, unmindful of the necessity of moving. The mother, furthermore, seems not to have noticed.

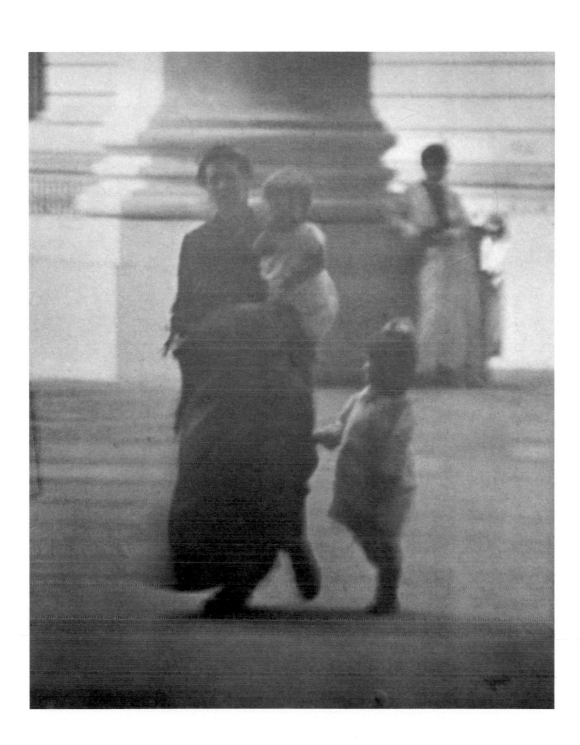

EDWARD SHERIFF CURTIS
American, 1868 – 1952

Chaiwa-Tewa, Profile, 1921
15½″ × 11½″ plate 415, photogravure
Private Collection

Edward S. Curtis was both anthropologist and utopian. In 1896 he began a mammoth photographic project: a general survey of Indian life in North America so ambitious that when it was finally completed, in 1930, it comprised twenty volumes culled from nearly 40,000 negatives. "While primarily a photographer," Curtis wrote about his intentions, "I do not see or think photographically; hence the story of Indian life will not be told in microscopic detail, but rather will be presented as a broad and luminous picture. . . ." Whether or not this is a failure to "think photographically" might be debated. It was assuredly, however, a preview of the soft, Arcadian world of a vanishing noble people that Curtis ultimately preserved in the pages of *The North American Indian*. His portraits, as photo-historian Ian Jeffrey points out, "accentuate soulfulness; his Piutes and Pawnees are as spiritual and grave-eyed as any of Mrs. Cameron's Victorian notables. They are also portrayed in much the same way, as possessors of an inner light which shines forth from the darkness."

If Curtis was rather hard on himself about his ability to think photographically, he was equally pessimistic about the final sociological effect the photographs might have, their "broad and luminous strokes" notwithstanding. But although his work may have lacked a true anthropological rigor, it was nevertheless a treasure trove of detail about Native ways of life and, especially, about Native arts. Perhaps, in the end, what was unsatisfactory anthropology was merely art for art's sake—for Curtis had a superlative eye. You can still feel the delight he has taken in the beautifully architectural structuring provided by the twin coils of this young woman's hair.

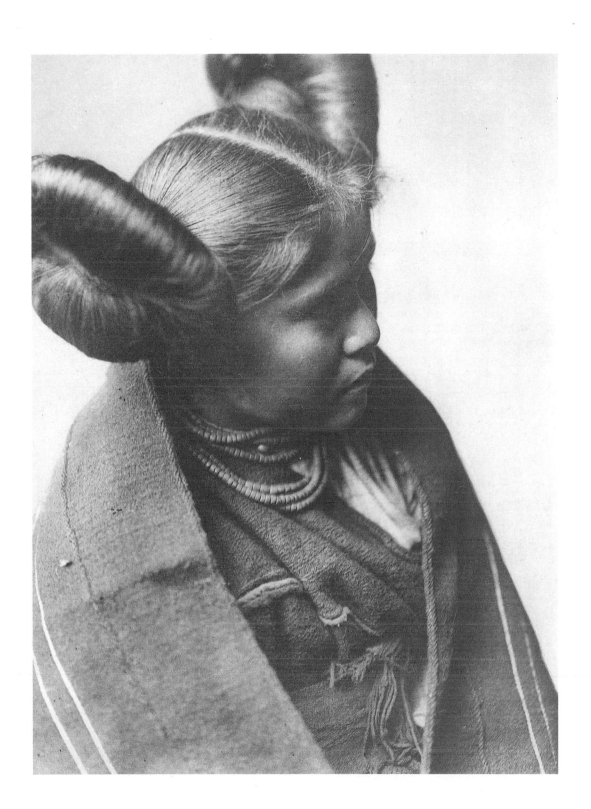

HERBERT LAMBERT
German, 1881 – 1936 lived in England

Preambule, 1924
14¾″ × 11″ silver print
Collection of Mr. and Mrs. Jack Creed

A photographic grace note. Or perhaps something like a pictorial holding of the breath, a suspension.

There is something particularly hallowed about the image of the child, at a threshold, at a portal, going through a gateway. A threshold," wrote the third-century philosopher Porphyrus, "is a sacred thing." The child moving through a portal is moving through experience, transforming. Children are changing all the time, and that changing is poignant and bitter-sweet enough. When the changing is illuminated, contained, by the detachable, inspectable symbolism of architectural space, the moment of transformation can become epiphanic.

This young dancer is a coil of preliminary energy. Her whole body has acquired a torque. Revolving on the axis of her left leg, her body is a wind-up spin of arms and shoulders, led by the incline of her head and the soft follow-up of her hair. When she goes on, out into the public light, she will spin the other way, like a top.

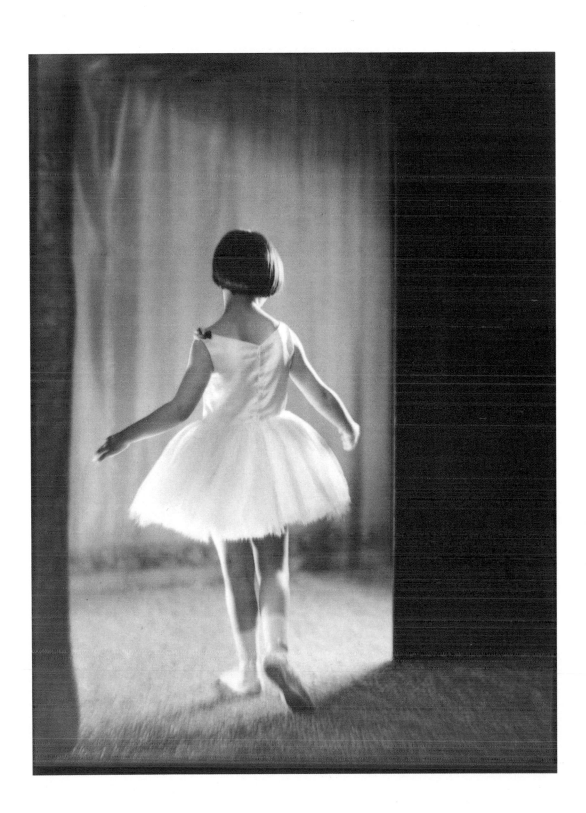

W. R. MACASKILL
Canadian, 1890 – 1956

The Organ Grinder, 1924
8″ × 10″ vintage silver print
Collection of Kathleen Maclellan and Walid El-Alaili

The photographer who might legitimately lay claim, in the eyes of many of his admirers, to having been the world's finest marine photographer was a native of Cape Breton named Wallace MacAskill. Most of MacAskill's career was centered about his office in Halifax, Nova Scotia, from which he made his forays, during the 1920s and '30s, to the harbor, to Peggy's Cove, to locations along the Nova Scotia shoreline and, when it was possible, out to sea in pursuit of an ongoing documentary record of the ocean and the men with their great sailing ships who plied it. Until recently (and perhaps even now), virtually every Halifax business office had a Wallace MacAskill on its wall. Indeed, most Canadians have a MacAskill in their pockets, as journalist Harry Bruce pointed out in *Canadian Geographic* magazine in 1986. It was in 1937, that Canada put a MacAskill photograph of the *Bluenose* on its 10-cent piece. "It's still there," writes Bruce, "49 years later, and the coin remains the most beloved in Canadian history." Before he was 40 years old, MacAskill was already sufficiently celebrated as a photographer of ships and the sea that a New York publishing house put together a limited edition of his prints in 1937 called *Out of Halifax, A Collection of Sea Pictures*. It sold out at $15 per copy, at the height of the Depression.

MacAskill's land-locked photography, which is lesser known, has a charm (however inadvertent) and an innate compositional rightness that is reminiscent of some of Lewis Hine's work or even, in the case of *The Organ Grinder*, the photographs John Thompson made for *Street Life in London*. Here, the organ grinder himself is less interesting than the children—the most interesting among them being the kid second from the right who is meeting the gaze of the photographer.

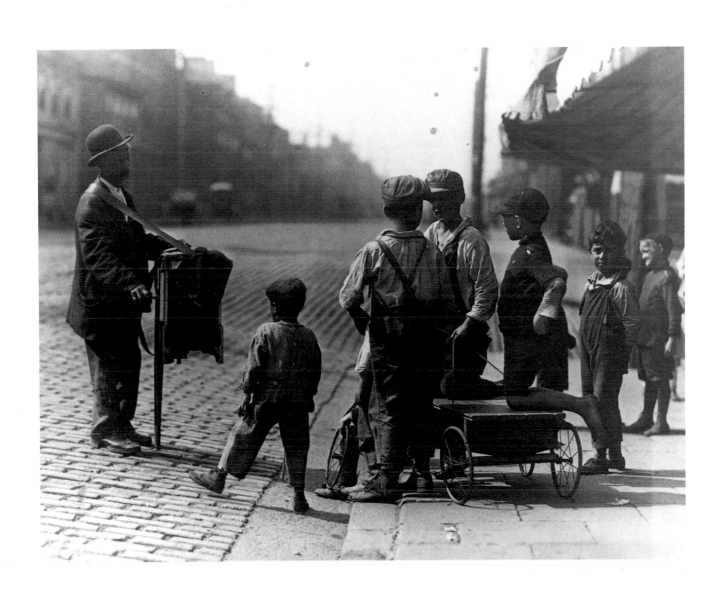

ANDRÉ KERTÉSZ
American, born Hungary, 1894 – 1985
worked in Paris 1925 – 1936, New York from 1936

The School Children Looking into my Camera, April 10, 1925
1½″×2″ vintage silver print
Collection of Jane Corkin

This tiny early photograph (a contact print) by André Kertész, made in his native Hungary the year he left to take up residence in Paris, touches two different poignancies within the enterprise of photography: the convention of the photographer photographed (here, the photographer's camera photographed) and the never-fail wonder of the photographic miniaturization of the world at large. Photographs of photographers at work are invariably intriguing because they make us forget that a photographer took the picture we are looking at. In a photograph like this one, the children are so delighted by the opportunity to look at the world through the lens of Kertész's camera that the pictorial energy within the work is spread sideways between the twin poles of the camera and the kids. Both the viewer and the photographer himself can share a strange sense of being adjacent to the events of the picture, at cross-purposes with it. The photograph is self-isolating and at a remove that is not so much exclusive as essentially peaceful.

What the children are presumably seeing, through the ground glass of the camera, is the world in miniature turned upside down. This is the world the children have always known but which is now oddly transformed. Here, in this granular, jewel-like translation of their shared experience is their familiar world transformed into what Gaston Bachelard, in *The Poetics of Space* (1964), calls a universe concentrated "in a glass nucleus."

JOSEF SUDEK
Czechoslovakian, 1896 – 1976

Freiluftbungen (Dancing Girls), c. 1925
7″×9½″ vintage silver print
Collection of Ezra Mack

Czechoslovakian photographer Josef Sudek, the so-called "poet of Prague," is probably best known for his exquisite still lifes, his shimmering gardens (the most resplendent of which is *A Summer Shower in the Magic Garden* from his series *Remembrances, 1954–59*) and his foggy nocturnes of the city where he lived most of his life. Most of Sudek's photographs are devoid of people. "I don't have many people in my photographs," Sudek once explained, ". . .you see, it takes me a while before I prepare everything. Sometimes there are people there, but before I'm ready they go away, so what can I do, I won't chase them back."

His vigorous photograph of six girls high-kicking themselves into virtual buoyancy is, in a sense, therefore, atypical of Sudek's work. On the other hand, he also admitted that in photography, as in life, he sought out "the living, the vital". "Life," said Sudek, "is very different from geometry; simplified security has no place in life."

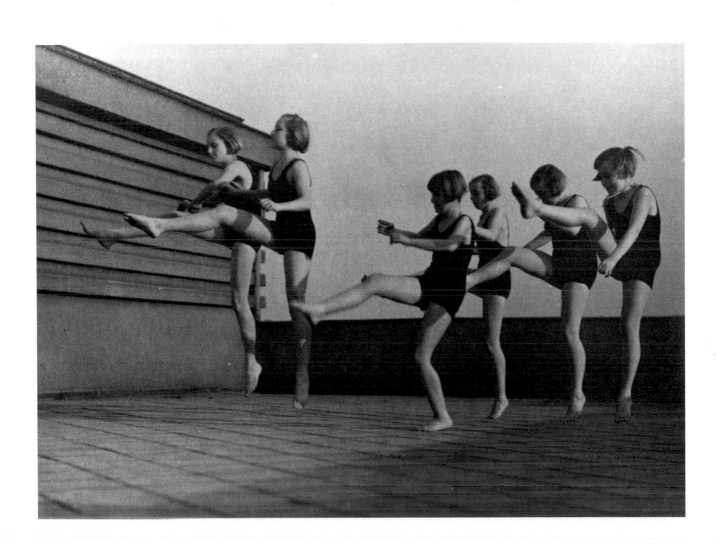

ALFRED STIEGLITZ
American, 1864 – 1946

Yvonne Boursault at Lake George, 1923
3¼" × 4⅜" silver print
Collection of Susan Muir

The law-giving, taste-making, powerfully didactic personality of Alfred Stieglitz—whom Paul Strand characterized, in 1946, as a "great engineer of the soul" (the phrase was originally Stalin's definition of the true artist)—seems scarcely suited to any sympathetic entry into the world of children. One thinks of Stieglitz as constantly having had weightier matters to consider. Without question, Stieglitz saw it as his personal task to guide photography from its early battles for recognition as a fine art (with his Photo-Secessionist gallery, 291, and his influential periodical *Camera Work*, 1903-1917, as pedagogical aids) through an evolutionary refining process that led to the discipline's apotheosis in the production of photographs that were so "straight" and so fully disclosed that they would become irreducible passages of photographic reality. The teaching aid this time was his later gallery An American Place; the laboratory for his own photographic exploration was, increasingly, his home at Lake George, in upstate New York. It was at Lake George that Stieglitz made his epic photo-anatomy of his wife, the painter Georgia O'Keeffe, and it was at Lake George that he made his famous cloud photographs, the "Equivalents."

And so it is all the more disarming to find him photographing a visiting child, and doing it with so much grace and gentleness. *Yvonne Boursault at Lake George* is half structure, half sweetness. Somehow the child is allowed to be utterly herself, while at the same time the photograph is clearly "about" the triple roundnesses of the bowl, the child's head and the bentwood back of the chair, as well as the interaction of the white passages of table and door.

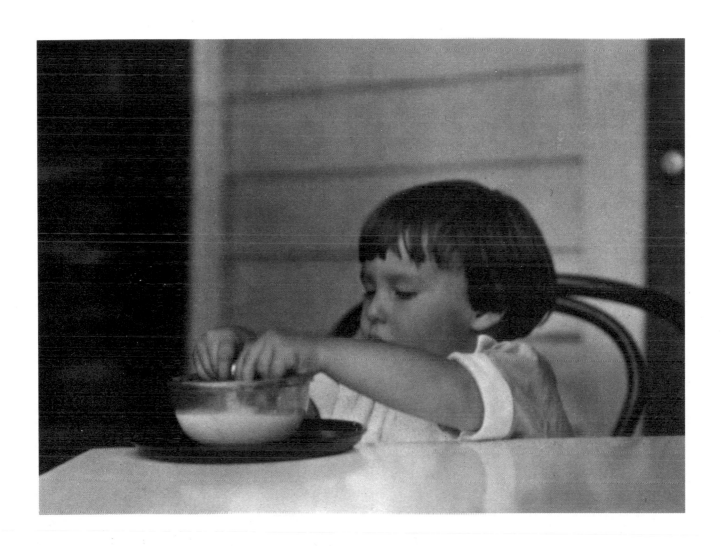

EDWARD WESTON
American, 1886 – 1958

Torso of Neil, 1925
9⅛″ × 5½″ platinum print
Collection of the Museum of Modern Art, New York

Edward Weston's writhing, anthropomorphized green pepper is, despite the photographer's insistence on the resolved thingness of his subjects, an engine of metamorphosis. Energized by metaphor, it rises out of its vegetal inertia and waxes into sexuality. His nautilus shells are transformed by metaphor into pearlescent grails or into scaleless architectural utopias. And yet his photograph of the torso of his son, Neil, made five years before the famous pepper, is not like this. There seems to be no supercharge of metaphor here, no octave of prayer sounding from the picture's depths. Like Weston's amplified beaches and zoological shorelines, Neil's torso seems almost supernaturally itself, "a statement of fact," as John Szarkowski put it in *Looking at Photographs*, 1973. Szarkowski is determined to show how unattached by simile, how unencumbered by metaphor the boy's pale trunk really is: ". . . the boy's flesh," writes Szarkowski, "is not like a stone column or a wineskin or a root vegetable. . ." Neil's torso is apparently irreducible and untransformable.

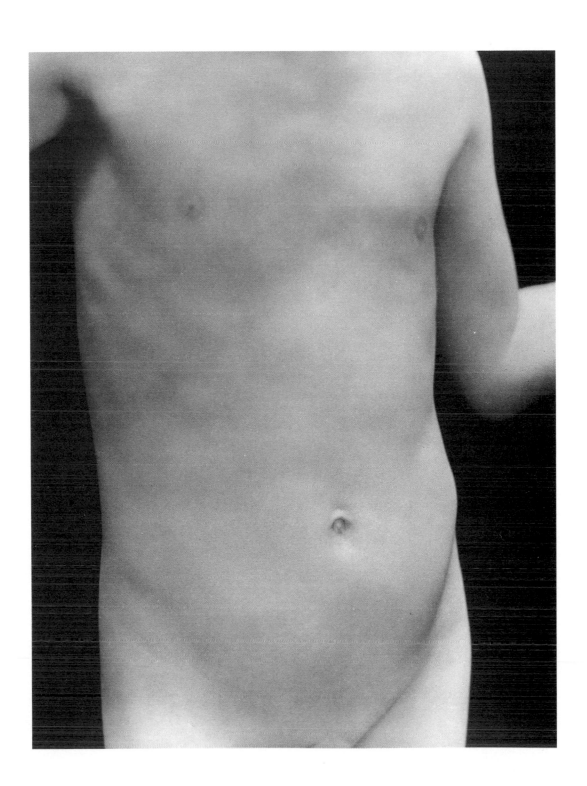

ROBERT BOURDEAU
Canadian, born 1931 –

Untitled, 1966
4″ × 5″ silver print
Collection of the artist

Canadian photographer Robert Bourdeau is best known for his photographic versions of the pastoral world, for his crystalline contact prints of the landscape: distant wooded hillsides tilted up into the lens of his view-camera so they look as crisp and textured as upholstery material; mountain streams running by his camera, frozen like milk by the duration of his deliberations. And so it is unusual to find a human being inhabiting his photographs, especially a child.

On the other hand this boy is Bourdeau's son. A whole world, therefore, unto himself, in the photographer-father's eyes. Uncharacteristic of his work or not, there is much here that is Bourdeauvian: the steady, open confrontation with the subject (here, the subject confronts back); the quiet, defining light; and the careful composing (the boy is relegated—though not confined—to the lower left half of the picture; it gives him room to grow).

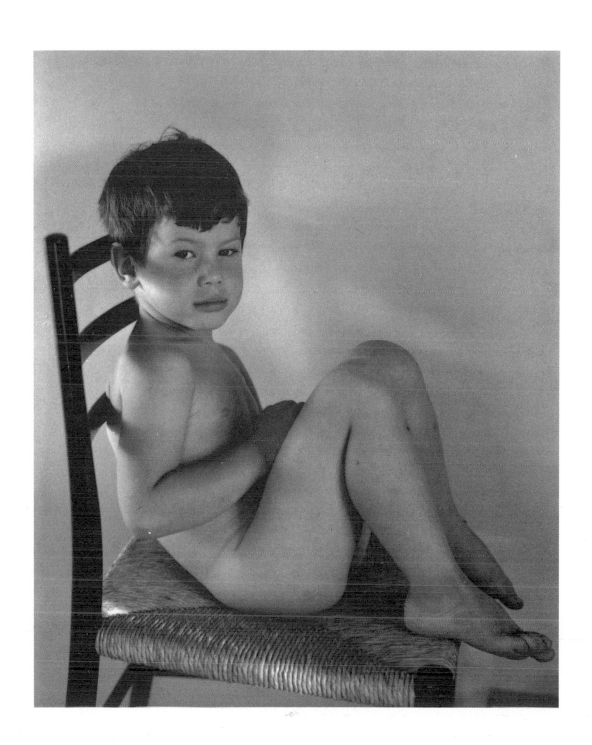

ALEXANDR RODCHENKO
Russian, 1892 – 1956

Untitled, c. 1927
3¾" × 5¾" vintage silver print
Collection of Jane Corkin Gallery

Vladimir Mayakovsky summed up the Soviet avant-garde's dedication to formal clarity in art and, if possible, in life, in his poem to the Brooklyn Bridge: "here's a fight/ for construction/ instead of style." Mayakovsky's friend and collaborator Alexandr Rodchenko believed in similar aims for photography. According to David Travis, author of the essay "Ephemeral Truths" in *On The Art of Fixing a Shadow: One Hundred and Fifty Years of Photography* (1989), Rodchenko acquired his first hand-camera in Paris in 1925, while visiting the epoch-making International Exposition of Decorative Arts and Modern Industry. He became obsessed with this camera, Travis observes, "because it was free of any earth-binding tripod. Tilting his new camera up or down became a kind of sport for him, resulting in what became known in Moscow as 'Rodchenko perspectives.'" By coincidence, his friend László Moholy-Nagy also made his first severely angled, vertiginous perspective photographs while he was in Paris to visit the Exposition. In 1928, as Travis points out, Rodchenko began to receive criticism from his comrades both for his over-use of the radical viewpoint in his photographs but also because it was felt that he had "inched away from the utilitarian and productivist function of an artist." Although Rodchenko continued to maintain that what was important in photography was not what you photographed but how, he seems gradually to have abandoned his innovative photo-montage work and his search for disorienting perspectives for something with its aesthetic feet more securely planted on the ground. This photograph of a group of athletic young women in the midst of a workout bespeaks the ongoing appeal any formal structure had for him, despite, in this case, its having occurred "on the level."

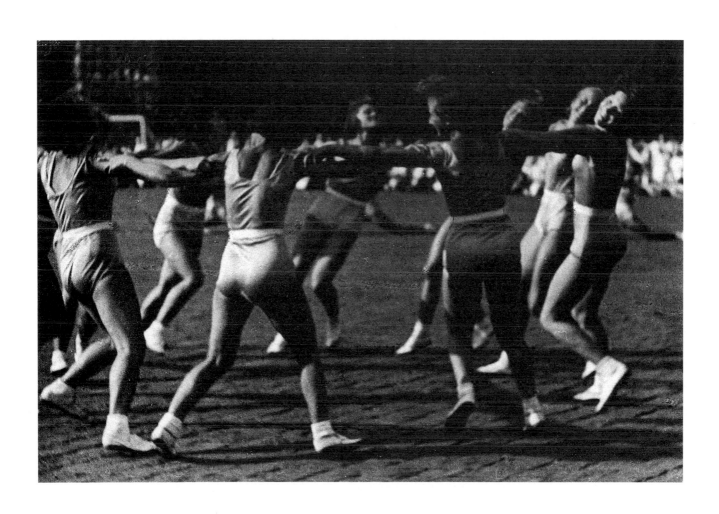

CECIL BEATON
British, 1904 – 1980

My Sister, Baba, 1922
10″ × 9¼″ vintage silver print
Collection of Dr. Arthur Rubinoff

Sir Cecil Beaton, painter, writer, costume designer, set designer and photographer, was, above all, a great dandy, one of the last of a rapidly disappearing breed of English eccentrics. With abilities that pulled so insistently towards the production of style for style's sake, Beaton has been an unlikely candidate for serious consideration as a photographer. And yet he has been a remarkably fine, if often pixillated portraitist and an impressive and frequently moving war photographer.

Beaton grew up surrounded by photographers—enthusiastic amateurs such as his father, whose "lilac coloured prints were received with a certain resignation," and his sister's nurse, one Alice Collard, whose "sepia-toned daylight prints of us—enjoying the pleasures of shrimping, haymaking, climbing apple trees, or visiting the raspberry canes—were acclaimed with a loud jubilation that was one of the chief joys of our annual summer holidays." He was still a child, Beaton recalls, when he bought himself a "postcard-size Kodak" and set up straightway to make himself the new Baron Adolf de Meyer. "My sisters," Beaton has written, "were my often exasperated guinea-pigs. . . "

This delicately wrought portrait study of Beaton's ten-year-old sister Baba (wearing one of her mother's dresses) owes something, as the photographer readily admits, to Whistler, as well as to de Meyer. It owes something to Clarence White, too. All of which subtracts little from its quality as a youthful effort or from its innate and lasting charm.

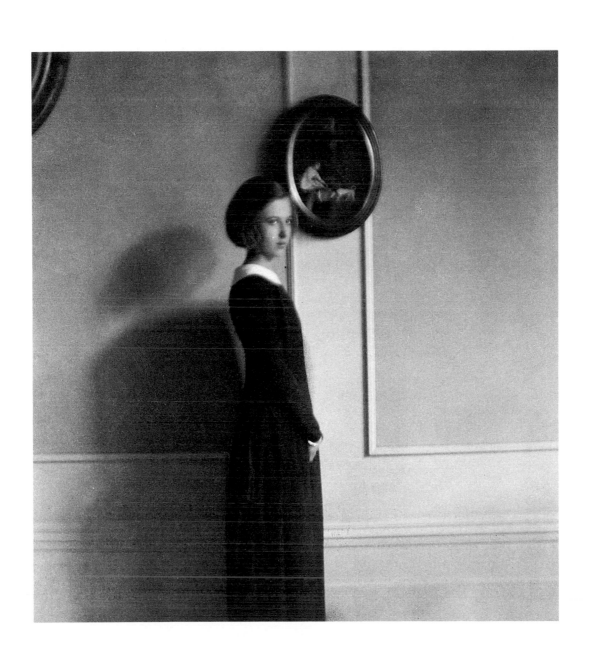

ANDRÉ KERTÉSZ
American, born Hungary, 1894 – 1985
worked in Paris 1925 – 1936, New York from 1936

Luxembourg Garden, 1928
8″ × 10″ silver print
Collection of Edward Ballard

When adults laugh—especially when they laugh immoderately—
one is sometimes unconvinced of the genuineness of it. Adult
laughter is occasionally trotted out, sad to say, for effect. It is
frequently something less than—in Wordsworth's phrase—the
spontaneous overflow of powerful feeling.

Not so with children. When children laugh—especially when
they laugh immoderately—something breaks open in the universe,
some pealing sonic radiance comes flooding down over the
world's conventionalizing *sang-froid*. Kertész, though no stranger
to sadness, to loneliness, to deprivation and loss, remained all his
life the great seeker of innocence and joy. Thus his fondness for
children, his ease with them. It seems inevitable for Kertész to have
been there, in the Luxembourg Gardens, when this great oceanic
surge of childhood joy came brimming up from—what?

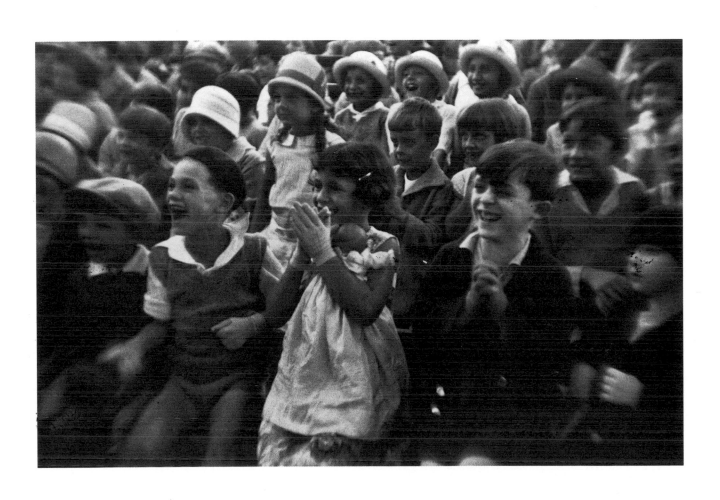

AENNE BIERMANN
German, 1898 – 1933

Mein Kind (my daughter), c. 1931
9⅜″ × 7″ vintage silver print
Private Collection

Of the group of German photographers gathered under the rubric
of the Neue Sachlichkeit, the New Objectivity or New Realism, in
the 1920s, Aenne Biermann was perhaps the one who best
combined a strongly developed and dramatically employed design
sense with an infectious gentleness and humanity. The term Neue
Sachlichkeit, originally coined in 1924 by Gustav Hartlaub, Director
of the Mannheim Art Gallery, to describe the work of a number of
German painters who had fled the excesses of the expressionist
style for the more temperate reaches of neo-realism, was soon
taken over by photographers such as Albert Renger-Patzsch, for
whom Neue Sachlichkeit suggested a concentration upon the
close-up beauty of the forms of the natural and man-made world
shown in as free, open and uncontrived a way as possible. Aenne
Biermann's contribution to this movement, which ran parallel, in
some ways, to the photographic experiments carried on by the
Bauhaus, was to temper the group's largely constructivist vision
with a less armored look at the world around her. Often her
children were her subjects. *Mein Kind* is a good example of her
almost perfect melding of formal control and emotional intensity.

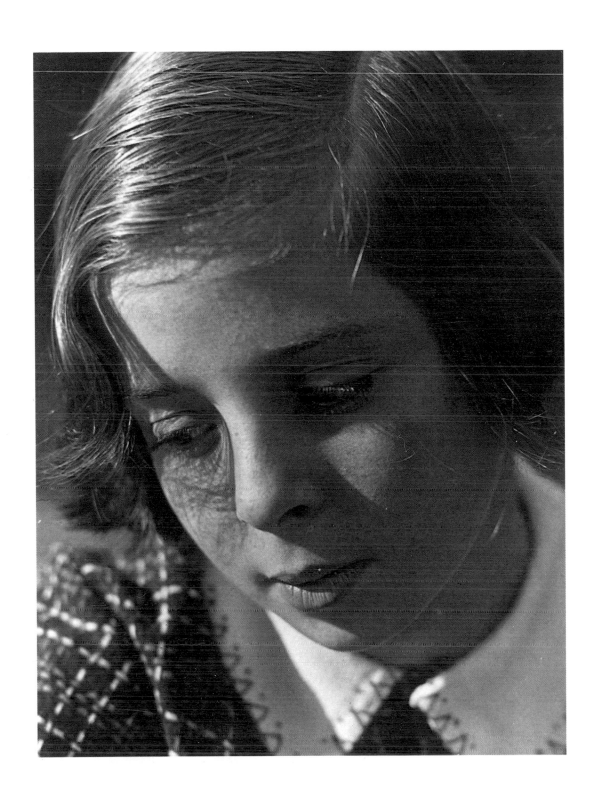

EDMUND KESTING
German, 1892 – 1970

Untitled, 1929
5¾″ × 6″ vintage silver print
Collection of Diane Alan

Divided though they may be pictorially by the edge of the
hammock running up through the photograph from top to bottom,
this sun-dappled mother and her elusive son are linked by
camouflage. The sun's filtering through the knotted strings has lent
their faces a wild, jungle striping that makes them both look
unpredictable and ultimately dangerous—despite the mother's prim
collar and rather sly-boots look.

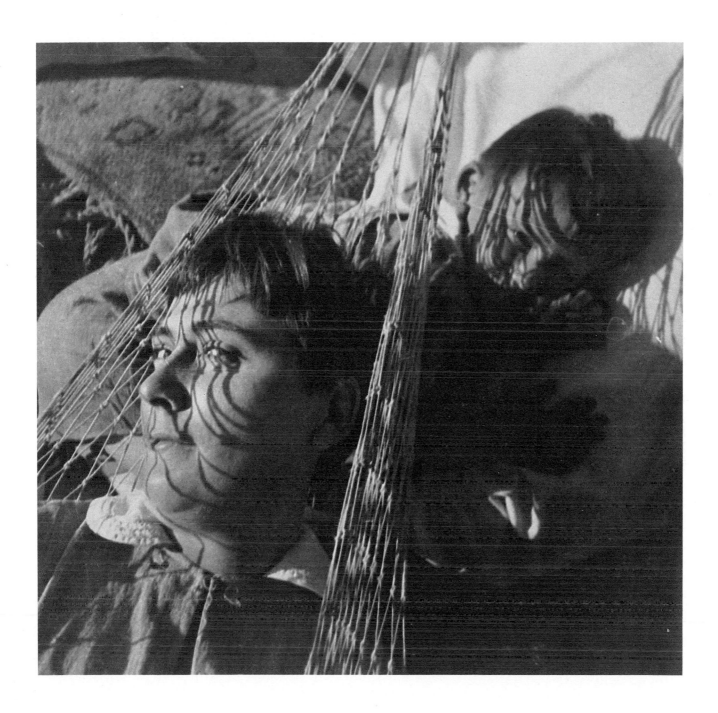

RUDOLF KOPPITZ
German, 1884 – 1936

Bathing Caps, c. 1930
7½" × 8¾" vintage silver print
Collection of Mayer and Mayer

These smiling girls have been pressed into service as design. No doubt attracted by the standardization inherent in the bathing caps' way of supressing, to some extent, individual identity—without being able to see their hair, for example, the girls could be twins— the photographer has set up the conditions for pictorial doubleness, thereby making the image of the girls iconic. Now abstracted, they are no longer two girls in bathing caps merely. They are now available as an idea: as the idea of vitality, or the idea of streamlined modernity, or the idea of youth itself, youth for its own sake.

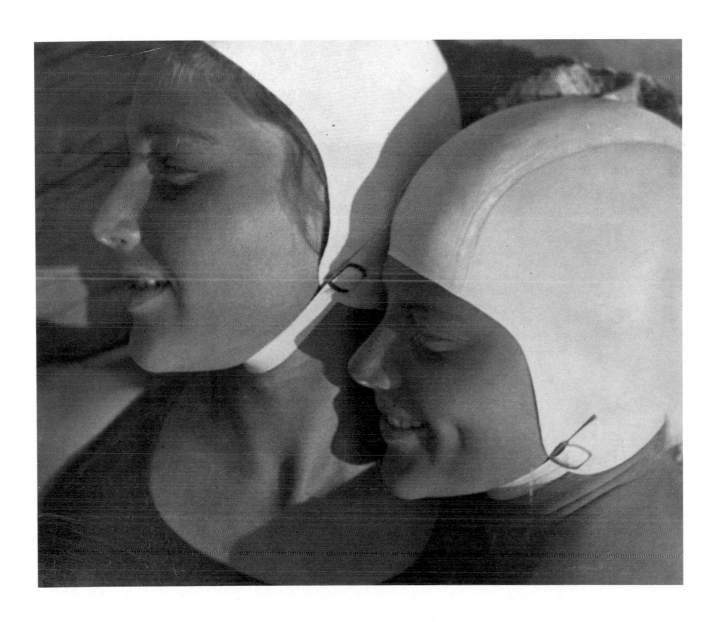

MARGARET BOURKE-WHITE
American, 1904 – 1971

Nursery in Auto Plant, Moscow, 1931
13¾″ × 18¾″ vintage silver print
Collection of Alexandra Marshall

In 1931, Margaret Bourke-White, photo-journalistic heroine of
Henry Luce's *Fortune* magazine and later of his brilliant new *Life*,
made the second of her three journeys to the Soviet Union, her
purpose being to document the explosive progress of
industrialization in the wake of the first Five Year Plan of 1928.
"No one," Bourke-White wrote in her autobiography, *Portrait of
Myself*, 1963, "could have known less about Russia politically than
I — or cared less. To me, politics was colorless beside the drama of
the machine." If one were to understand the nature of a country's
industry, Bourke-White felt, one could then bend close to "the
heart of that people." It is, of course, upon her dramatic, often
luridly illuminated photographs of the brutalist industrial
landscape, of the mega-machine, that much of her reputation rests.
And yet Bourke-White was capable, at the same time, of great
photographic tact and delicacy. This genial tableful of children,
part of the daycare program in a Moscow auto plant, is as subtly
composed and gently lit as one might have expected from the
Margaret Bourke-White who, before finding her subject matter in
the epic monuments of mechanism, had studied at the Clarence H.
White School and had thus acquired the soft-tech tenets of
pictorialism. There is something approaching genuine nobility here
in the infectious contentment of the children, in the ease with
which they meet the photographer's gaze, in the warmth of the
shared refreshment, in the security of the little bright-painted
childrens' chairs, in the gratuitous prettiness of the childish cups.

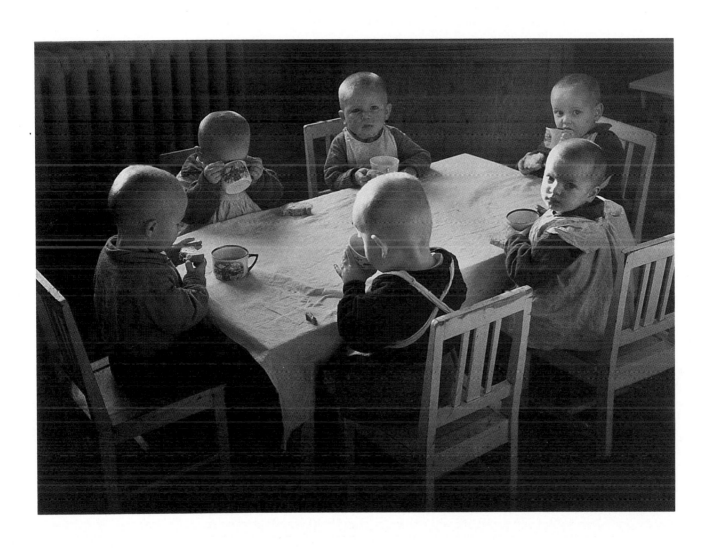

MARGARET BOURKE-WHITE
American, 1904 – 1971

Machine Dance, Moscow Ballet School, 1931
13⅞″ × 19½″ vintage silver print
Collection of Jane Corkin Gallery

During the second of her three trips to the Soviet Union, in 1931, Margaret Bourke-White concentrated, photographically speaking, on a number of aspects of the Russian experience that had, ostensibly, little to do with the industrial phenomena which initially had been the country's main attraction for her. A good deal of the trip—which was to provide material for a six-part series of articles about daily life in the Soviet Union for the *New York Times Sunday Magazine*—concentrated on family life and, in particular, the life of the Russian child.

She was delighted, predictably, by her discovery of a charming example of the Five Year Plan's interface of culture and industry as exemplified by the so-called "machine dances" devised by the Moscow Ballet School. In these dances the participants enacted the functions and behavior of valves, pistons and gear-wheels. "The Soviets send choreographers to the factories," wrote Bourke-White. "Specialists will go to a textile factory and study the interweaving of threads and the motions of the spools and use these forms in designing a dance. An airplane dance has been designed which shows the slow motion of the plane at the beginning, its accelerated motion as it drives across the field and ends with movements which indicate the rise of the airplane into the air."

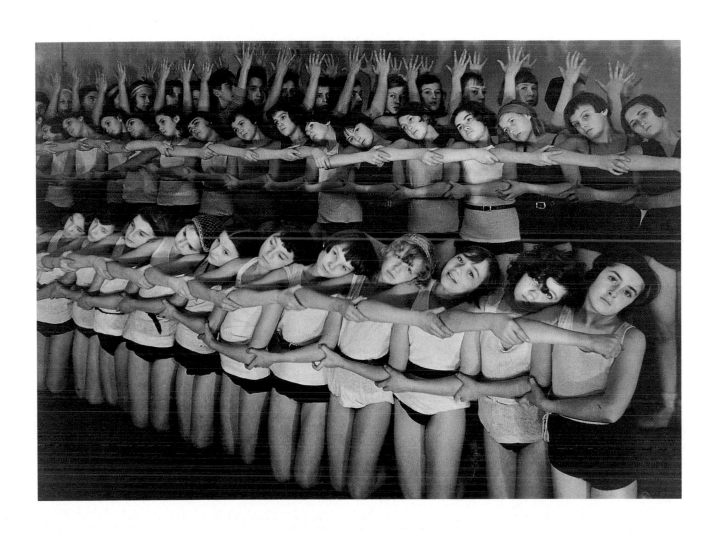

MARGARET BOURKE-WHITE
American, 1904 – 1977

Village School, Kolomna, Volga Region, 1932
13″ × 17″ vintage silver print
Collection of Brian M. Scully

Margaret Bourke-White's experiences in the Soviet Union were summarized in her books *Eyes on Russia* (1931) and *U.S.S.R. Photographs* (1934). In her introduction to the latter, which was a luxurious portfolio of twenty-four gravure reproductions on "antique tone" paper, limited to one thousand copies and signed by the artist (it sold, in 1934, for $15), Bourke-White wrote: "Three trips to the Soviet Union taught me it is more than a land of windswept steppes, villages gathered into collective farms, rising factories and growing power dams. Behind the machines stand men and women . . ."

And children. Bourke-White was a remarkably sensitive photographer of children—oddly so, in a way, for a photographer whose reputation had been made photographing steel mills and the vertiginous views from the tops of Manhattan's newest skyscrapers. This class of boys at a rural school are set up like bowling pins— though that is the extent here of the employment of her forceful design sense. In the end, each of the boys is allowed a particularized visual eloquence. Although they are photographed together as a class, each boy remains memorably and hauntingly himself.

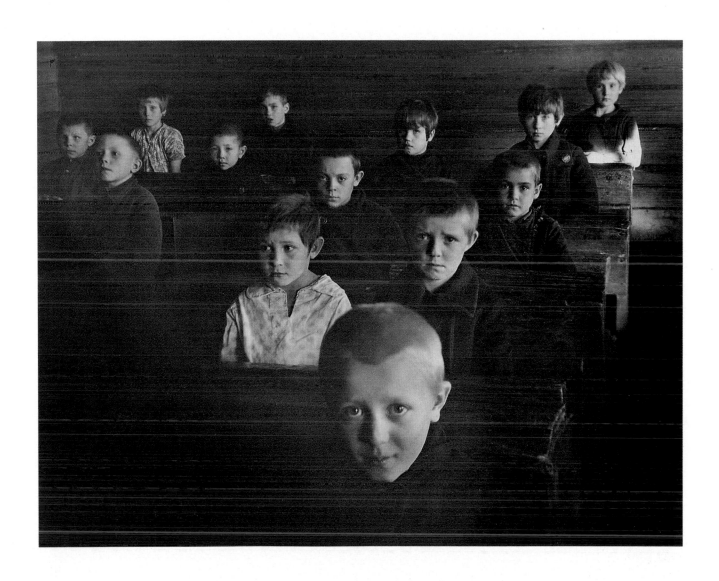

MANUEL ALVAREZ BRAVO
Mexican, born 1904 –

Senorita Juane, 1934
10″ × 7¾″ vintage silver print
Private Collection

Bravo's treatment of the people in his photographs is unwaveringly respectful and compassionate. And unlike the practice of his muralist friends Rivera, Orozco, Sequeiros, it is scarcely ever romanticized or heroicized. His portrait of Senorita Juane is a case in point. The girl is photographed in total confrontation, squared up to the camera, her gaze meeting the impassive blankness of the lens head-on. She is so symmetrically located within the space of the picture she is in danger of losing her reality and turning instead into an emblem. That this does not happen is a tribute to Bravo's refusal to impose "art" upon the girl's being. The result of this restraint on Bravo's part is, paradoxically, that the girl attains *by herself* the nobility, the heroism, she might otherwise have been robbed of and then modulated back into. It is true that Bravo does not romanticize his subjects. In this case, however, he has gently allowed the girl's innate romantic spirit to emerge—which seems like a greater accomplishment.

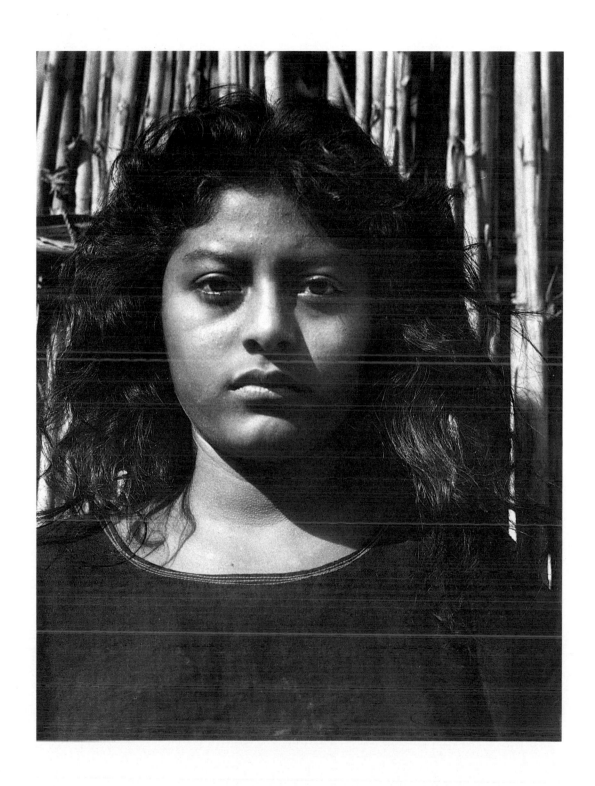

MANUEL ALVAREZ BRAVO
Mexican, born 1904 –

El ensueño (the daydream), 1931
10″ × 8″ silver print
Private Collection

Much of the dignity and often the majesty of Manuel Alvarez
Bravo's photographs stems from a melding of his mastery of
photographic form with what Jane Livingston, in her catalogue
essay for the retrospective of Bravo's work held at Washington's
Corcoran Museum in 1978, calls his "ancient, essentially
unselfconscious approach to representation which is integral to his
heritage," a heritage that includes a sensitivity to all of the
lifestreams within modern Mexican bloodlines, and especially to
that of the Indian of the "pre-Columbian native archetypes." Bravo
felt himself to be closely allied, as well, to folk art and, more
particularly, to the proletarian fervor of the work of his friends
José Clemente Orozco, David Alfaro Siqueiros and Diego Rivera.
 The girl of the daydream is the child of timelessness. Her
reverie lifts her out of the temporal onto some plane of meditation
where every dreamer goes. She seems ideally located, spatially
speaking, for the act of dreaming: she is almost at a decisive point
in space, the apex formed by the triangulation of the wrought-iron
railings. A gulf as wide and deep as imagination opens out at her
feet. Her shoulders and the hem of her dress re-enact the angling
of the railings, making her congruent with her place in the world.
Gaston Bachelard, in his *The Poetics of Reverie: Childhood,
Language, and the Cosmos* (1969), puts it memorably enough:
"What a cosmic being the dreaming child is!"

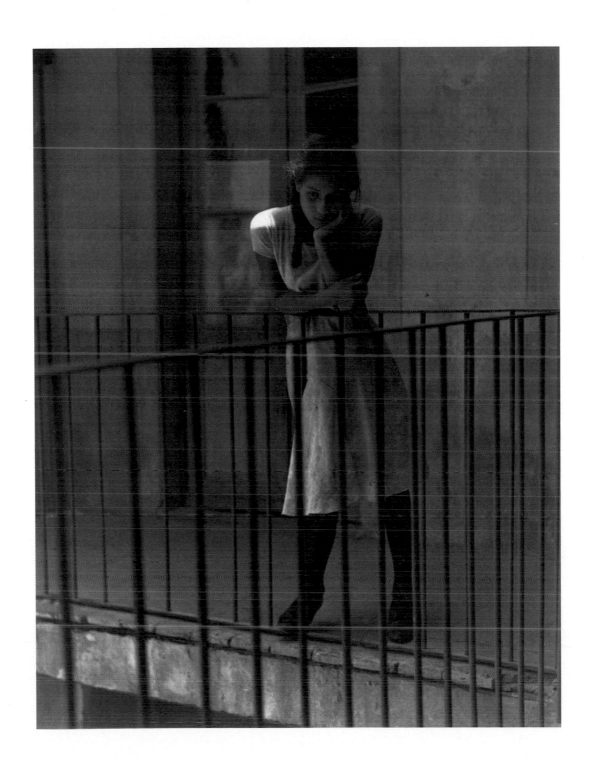

BILL BRANDT
British, born Germany, 1904 – 1983

Dancing the Lambeth Walk, 1933
13½″ × 11½″ gelatin silver print
Collection of Susan Muir

English photographer Bill Brandt's work modulated from an early interest in social documentary (as evinced most clearly by his *The English at Home,* 1936, and its more romantic sequel, influenced to some extent by Brassaï, *A Night in London,* 1938) to a concern for a more private, more purely lyrical and essentially surrealistic mode of expression, the best known manifestation of which is his extraordinary sequence of hallucinatory changes wrought optically upon the female nude (collected in his *Perspective of Nudes,* 1961). Later work witnessed his departure from photography entirely, as Brandt began making strange, enigmatic, rather Joseph Cornell-like collages of doilies and jewellery and the wings of butterflies and moths.

This robust girl dancing the Lambeth Walk before an enthusiastic crowd of younger admirers is from Brandt's London documentary period. The vigor of this strapping teenage girl (with her saucy heels) seems, in Brandt's celebrational treatment, like a tribute to what he thought of as the natural resilience of the working class.

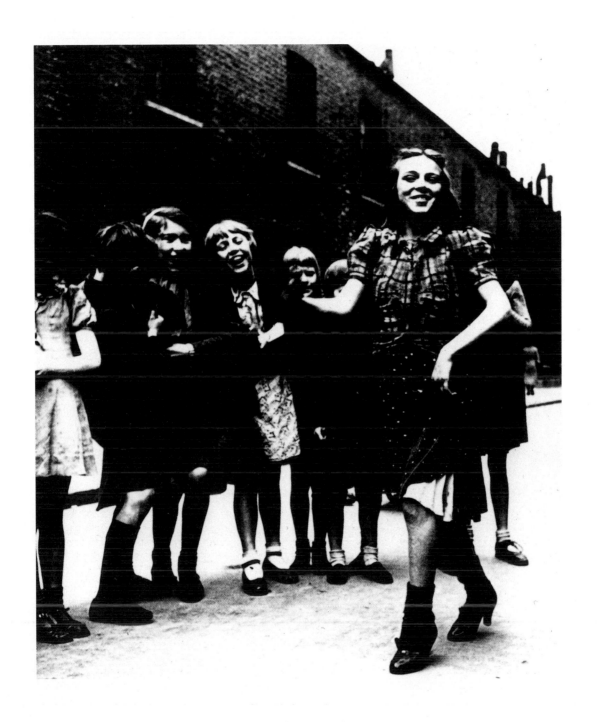

FRANCES FLAHERTY
American, 1886? – 1972

Untitled, 1936
15″ × 19″ vintage silver print
Collection of Winnipeg Art Gallery

After having made *Nanook of the North,* 1922, and his flawed epic documentary *Moana,* 1926, about life in the South Seas—the film for which John Grierson coined the term "documentary"—Robert Flaherty put in a disappointing sojourn in Hollywood before leaving finally for Europe with his wife, Frances, in 1930. While Flaherty had made still photographs, principally before *Nanook* and occasionally afterwards—as a sort of photographic storyboard for his films—he eventually left the making of stills to Frances.

This photograph is from a series Frances made in Ireland while her husband was engaged in the filming of *Man of Aran,* 1934. According to David Livingstone, writing in *ARTnews* about an exhibition of the photographs, Frances once explained that their subjects were chosen "strategically." "We select a group of the most attractive and appealing characters we can find, to represent a family," wrote Frances Flaherty, "and through them tell our story. It is always a long and difficult process, this type-finding, for it is surprising how few faces stand the test of the camera."

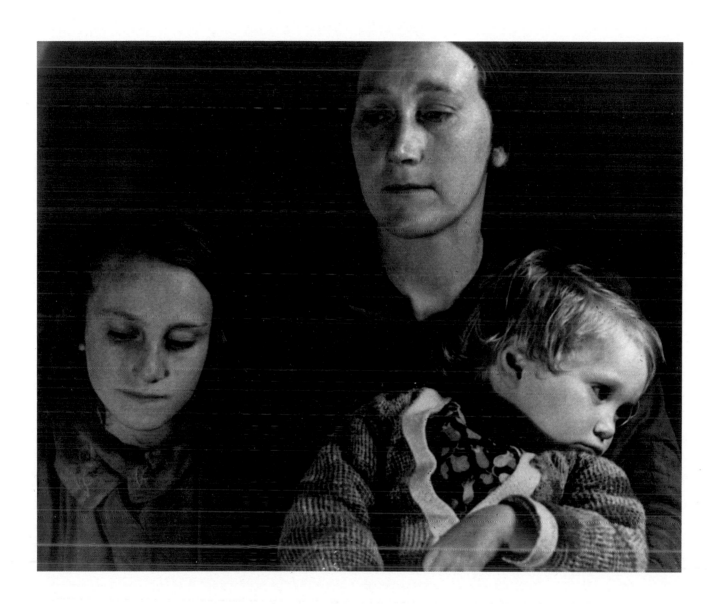

FRANCES FLAHERTY
American, 1886? – 1972

Untitled, 1936
15″ × 19″ vintage silver print
Collection of Edward Ballard

So here we are, with an idyll of artifice on our hands. Graham Greene is reported to have said about Robert Flaherty's films that "he lays 'beauty' on inches thick." Such is certainly the case with his wife's photographs. On the other hand, the temptation to ask So What is insistent. Take this rime-tossed, foam-flecked reverie. Art-directed though the shot may have been, the lowering, filtered sky full of scudding North Atlantic clouds and the breakers pounding in upon the rocky shoreline are assuredly Ireland's own, however much they have been midwifed into photographic existence by Frances Flaherty. In essence, this is a constructed photograph, a personal vision—an outsider's vision at that—of what life in the Aran Islands was supposed to be like (a Scottish equivalent might be a scene from Lerner and Leowe's musical *Brigadoon*). This photograph is to the experience of a real boy fishing more or less what the music of Delius is to the genuine experience of a summer's morning or to a sudden cloudburst. There is, in other words, a sort of benign spuriousness to it. Given the age of relentless and depleting irony we live in, however, the world of Robert and Frances Flaherty looks pretty good.

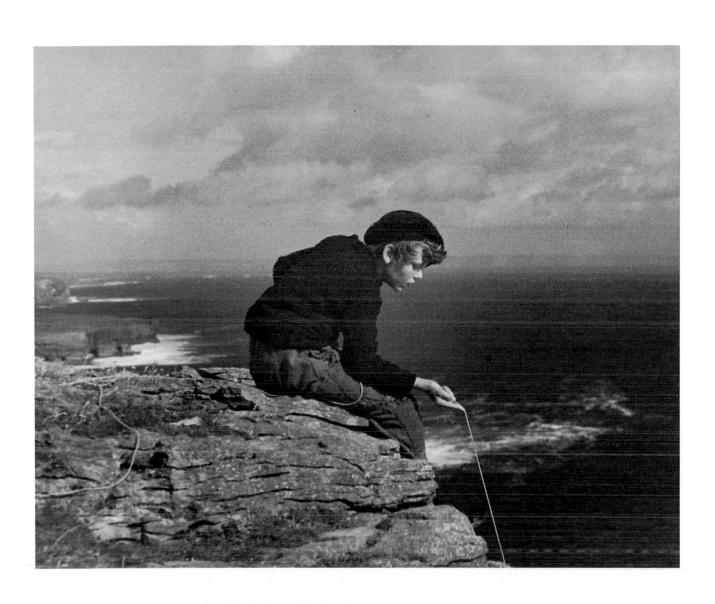

ANDRÉ KERTÉSZ
American, born Hungary, 1894 – 1985
worked in Paris 1925 – 1936, New York from 1936

Children Playing, 1936
13 ¼″ × 10½″ vintage silver print
Private Collection

This winsome photograph, made for *Harper's Bazaar* the year
Kertész moved to New York, makes use of a number of the
photographer's favorite graphic devices: punctuating structures
within the photograph (the fence running along the upper border
and the rungs and supports of the backyard gym set) and
organizational shadows. The radical cropping of the child on the
play-gym and the goofy upside-down-ness of the kid with his head
on the grass may be a wry allusion to the severe angling of the
structurist photographs of such artists as Moholy-Nagy and
Rodchenko.

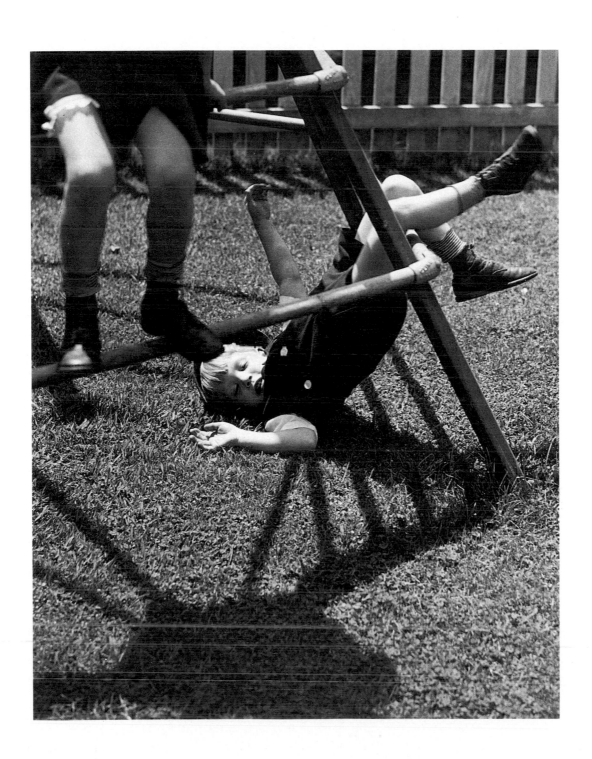

JOHN GUTMANN
American, born Germany, 1905–

The Sharpshooters, Harlem, 1936
11″ × 14″ silver print
Collection of the artist

The photographs of the remarkable John Gutmann are too little known, despite a substantial number of exhibitions over the years, including a retrospective at the San Francisco Museum of Modern Art in 1976 and a comprehensive survey of his work at the Art Gallery of Ontario in 1985.

Born in Breslau in 1905, Gutmann studied art with Otto Mueller and by 1928 was himself teaching art in Berlin and exhibiting his paintings. Forced to leave Germany by the rise of Naziism and, equally perhaps, lured there by his utter fascination with "Amerikanismus," the "picturesque myth of the skyscraper-*cum*-cowboy civilization" that held so many young German intellectuals in thrall, Gutmann journeyed to America, to San Francisco, in 1933. He took up photography seriously in the U.S. (he had done a little in Berlin) primarily to make a living as a photojournalist. His images, astonishingly fresh and immediate, were in some measure a preview of the work of the so-called "street photographers" of the 1950s and '60s, artists like Robert Frank, Lee Friedlander, Garry Winogrand. As Maia-Mari Sutnik points out in the catalogue to her AGO exhibition of Gutmann's work, a photograph like his *Guns For Sale* (1936) "prefigures the thrust found in Frank's images of America. . .partly blurred, moving, and precarious, broken shadows and filtered light." The motor trip Gutmann made across the United States in 1936 seems like an anticipation of the famous trip Frank would make in 1955-56 that would result in his book, *The Americans*, 1959. As Gutmann acknowledged to Sutnik:

> My work has a very contemporary look, many young photographers like it. And it has anticipated certain photographic practices, but I don't want to take particular credit for it. It's probably the sensibilities of a sophisticated European responding to all the amazing and new experiences. And I have not been afraid of trying anything crazy. . . I discovered most things by playing with my little machine, exploring the medium itself and really seeing what I could do with it.

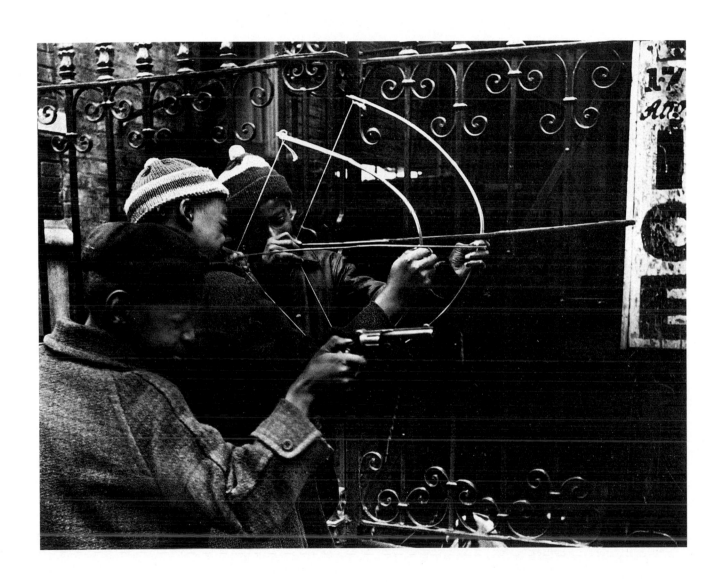

RUSSELL LEE
American, 1903 – 1986

Two Boys Reading Sears Roebuck Catalogue, 1937
9½″ × 7″ vintage silver print
Collection of Mr. and Mrs. Jack Creed

"Hope springs eternal in the human breast", wrote poet Alexander Pope in his *Essay on Man* (1733). The second line, which everybody forgets, runs "Man never is, but always *to be,* blest." This was certainly true in 1937, at the height of the Great Depression. And it is certainly true for these children, for whom the shining articles in the Sears Roebuck catalogue could scarcely have been more than fantasies.

During the late 1930s, in an attempt to aid the country's rural poor, the American government set up the Farm Security Administration, one branch of which was the FSA's photography project. Its task, which enlisted the talents of such photographers as Walker Evans, Dorothea Lange, Ben Shahn, Arthur Rothstein and Russell Lee, among others, was to use photography as a means of making visible the economic plight of migrant workers, sharecroppers, displaced families and victims of catastrophic ecological disasters such as the drought that reduced the American mid-west to dust.

These children, unlike, say, the girl in Dorothea Lange's *Damaged Child, Shacktown, Elm Grove, Oklahoma,* 1936, are not suffering; they appear to be in no physical danger. Their interest for Lee seems mostly to lie in the poignancy and the futility of their hapless faith in America's capitalist dreams, in their having unconsciously bought into the daydream that things can make you free. Lee's picture is remarkably artless. But this artlessness gives it power, as if the naïveté of the children could only be contained and transmitted by a similar kind of ingenuousness.

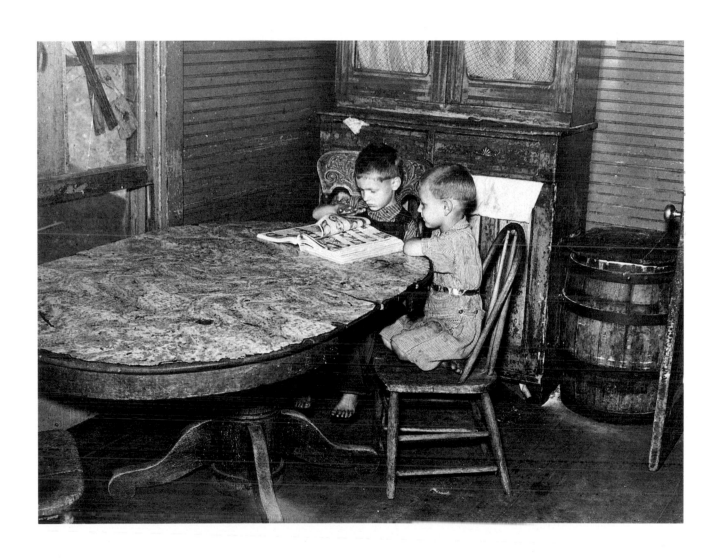

ARTHUR ROTHSTEIN
American, 1915 – 1985

Dust Storm in Oklahoma, 1936
9″ × 9″ vintage silver print
Private Collection

There is a verbal equivalent to this plague of dust and wind and deprivation in the rolling, biblical prose from which novelist John Steinbeck erected his masterpiece, *The Grapes of Wrath*, published in 1939 just as the onslaught of war finally brough the Great Depression to an end.

> The doors of the empty houses swung open, and drifted back and forth in the wind. Bands of little boys came out from the towns to break the windows and to pick over the debris, looking for treasures. . .When the folks first left, and the evening of the first day came, the hunting cats slouched in from the fields and mewed on the porch. And when no one came out, the cats crept through the open doors and walked mewing through the empty rooms. . .When night came, the bats, which had stopped at the doors for fear of light, swooped into the houses and sailed through the empty rooms, and in a little while they stayed in dark room corners during the day, folded their wings high, and hung head-down among the rafters, and the smell of their droppings was in the empty houses. . .One night the wind loosened a shingle and flipped it to the ground. The next wind pried into the hole where the shingle had been, lifted off three, and the next, a dozen. . .And on windy nights the doors banged, and the ragged curtains fluttered in the broken windows.

John Steinbeck

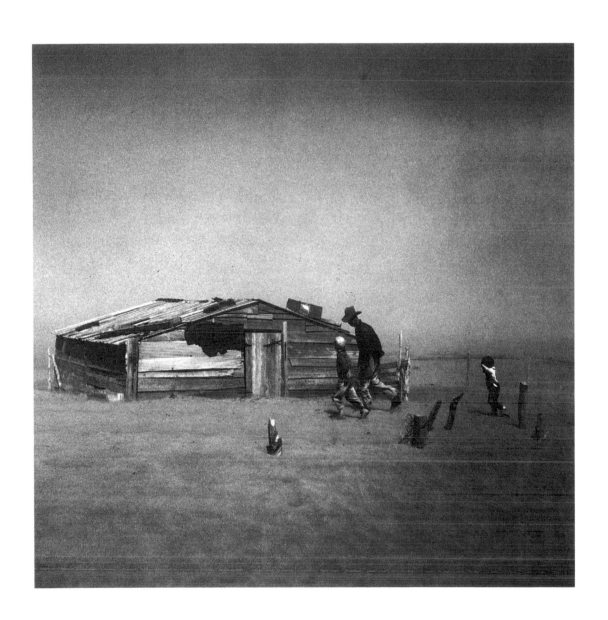

HELEN LEVITT
American, born 1918 –

Untitled, (Home Team the Reds), c. 1942
5½″ × 7½″ vintage silver print
Collection of Edward R. Downe, Jr.

American photographer Helen Levitt was only 22 years old in 1940, the year she began making her splendid photographs of children on the streets of New York City. An admirer of Cartier-Bresson and an enthusiastic believer in the photo-intimacy achievable through the use of the miniature camera, Levitt captured in her work, according to Susan Kismaric (*American Children*, 1980), "more of the nature of childhood than any [body of pictures] made previously." Adults, Kismaric contends, present themselves in socially accepted ways, whereas children, caught up in an innocent self-absorption, do not. This self-absorption, Kismaric argues, "eliminates their self-observation, revealing a type of self-direction and autonomy known only to those whose fantasies are central to their daily life: children, eccentrics, psychotics." James Agee, who had written an essay about Levitt's photographs in 1946 which eventually became the preface to her book *A Way of Seeing*, 1965, explained her photographic freshness in simpler, less sociological terms: for him, Levitt's fluidity and conciseness were functions of "a simple liveliness of soul and talent." David Travis, writing in *On the Art of Fixing a Shadow*, 1989, characterizes Levitt's photographs as possessing "a graceful new coherence of aggregate motion out in the open," a statement that certainly speaks directly to this action-packed vacant-lot vignette of three boys brandishing their three sticks (one brandishes an entire branch). The kinetic crackle of the photograph is infectious—especially the euphoric Nijinskyesque exit of the dark, arrow-slender boy on the right.

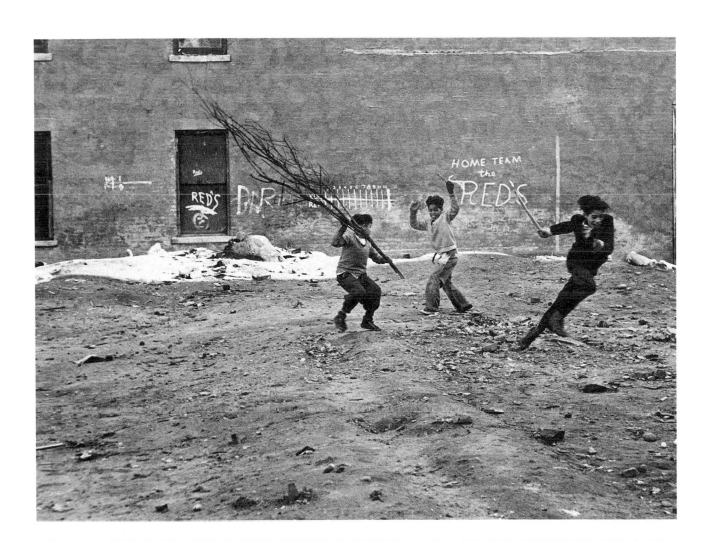

HELEN LEVITT
American, born 1918 –

New York, © 1942
16″ × 20″ gelatin silver print
Collection of Edward R. Downe, Jr.

Helen Levitt's photographic world of children is a double-sided world of both riveting ordinariness and offhand theatricality. When you first look at any of her artfully controlled photographs, you see nothing that seems significant enough to constitute a picture. But, as John Szarkowski points out in *Looking at Photographs* (1973), what is remarkable about them is the way they reveal the "immemorial routine acts of life, practised everywhere and always," to be full of "grace, drama, humor, pathos, and surprise." What Szarkowski also finds remarkable about Levitt's work is that these apparently casually harvested tableaux are "filled with the qualities of art, as though the street were a stage, and its people were all actors and actresses, mimes, orators, and dancers." This, for example, is a quite theatrical photograph. The five characters who inhabit the front steps and who have arranged themselves between the carved pillars of the door-frame that acts as a proscenium arch are, deliberately or not, carefully placed and dramatically disposed. The kid with half a face, down in the extreme lower-right, is perhaps a chorus, a guide. The white kid in the foreground embodies an ease which offsets the stylized mysteriousness of the two black kids with their shirts over their mouths who are definitely players in some childhood drama or other. The elder coming through the door behind them projects a preoccupied everydayness that serves to make the children, with their self-choreographed attitudes, all the more distinctive and aesthetically separate.

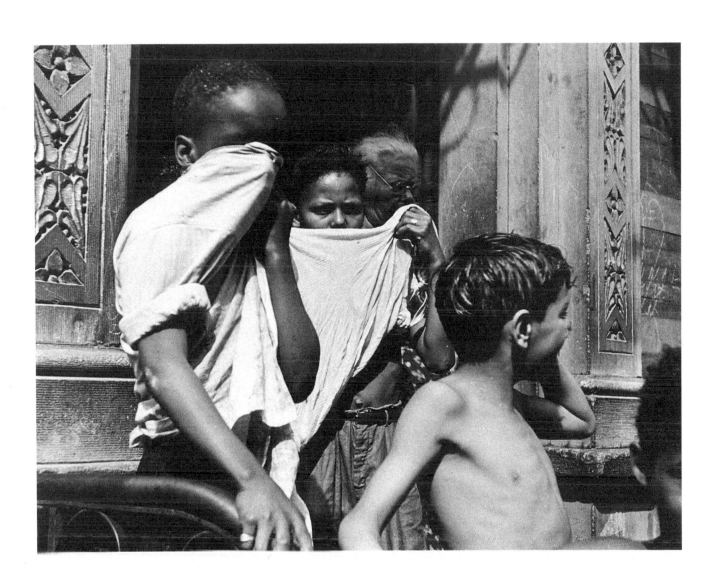

HELEN LEVITT
American, born 1918 –

Untitled, 1942
8″ × 6¼″ vintage silver print
Collection of the National Gallery of Canada

One of the things photography does well is to isolate and clarify certain apparently ordinary, transitional moments so that they may be seen as significant building blocks in the edifice that is everybody's life. In this photograph, Helen Levitt has frozen what is, for the most part, the casually enacted return of the child to the mother. The mother is on the stoop of the home. The child is coming in out of the undifferentiated spaces of the world-street. The mother's hand is stretched out in encouragement and welcome. The little girl is like a sailboat moving back in to harbor. The photograph which is forever tuned to this eternal return gradually attains the state of the archetypal and the ritualistic: in the photograph The Child Comes Back.

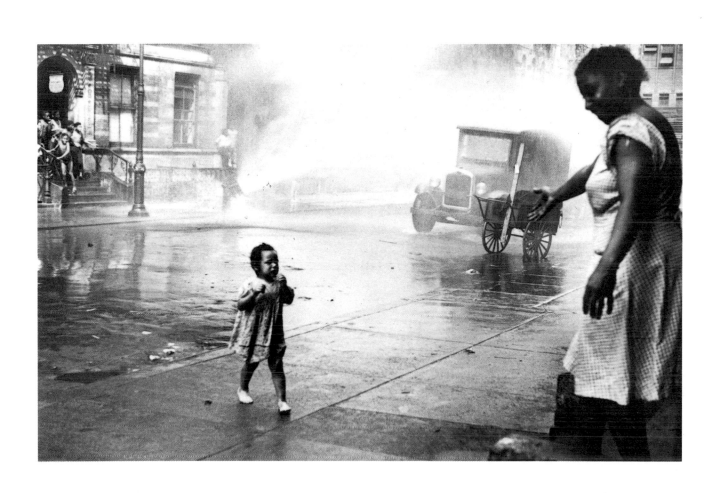

MORRIS HUBERLAND
American, born Poland, 1909 –

———————————————

Hell's Kitchen, 1948
22″ × 18″ gelatin silver print
Collection of the National Gallery of Canada

The face of this boy is old before its time. The boy is like a little old man. Too much of the world has entered his large eyes.

———————————————

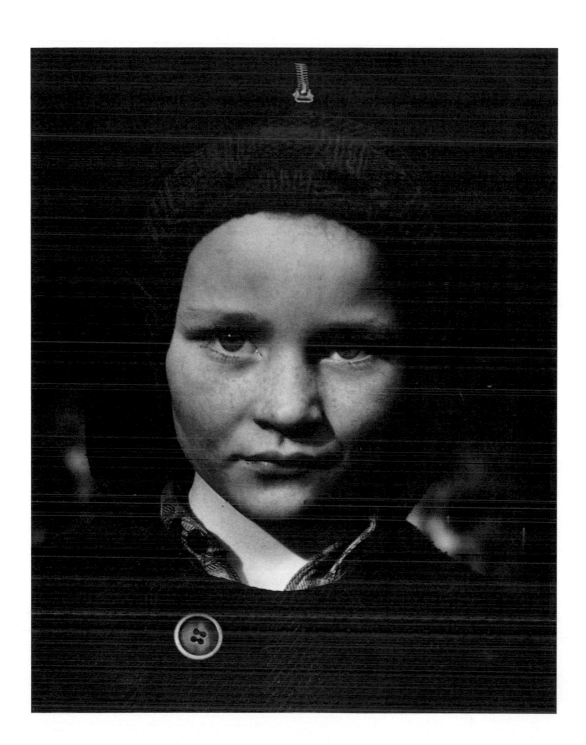

WEEGEE
American, (born Arthur Fellig) Austria, 1899 – 1968

Waiting for Frank Sinatra, Palace Theatre, 1944
11″×14″ vintage silver print
Private Collection

Weegee was the name the girls at Acme Newspictures gave him. It was a derivative of "ouija" as in "ouija board," and was a tribute to the psychic powers that seemed the only way to explain the young freelance newspaper photographer's uncanny arrival at the scene of some grisly New York City crime about the same time as the police did. His real name was Arthur Fellig. He liked the name Weegee (which he always pronounced "Weechee"), however, and kept it for the rest of his career. The stamp on the back of his photos read "Credit photo by Weegee the Famous."

Weegee's intuitions about upcoming crimes were wonderfully aided by the police radio he somehow managed to have installed in his maroon-colored Chevy coupe. The mercurial Walter Winchell was the only other reporter who had one. Weegee wrote in his autobiography (1961), "While not riding in my police-equipped short-wave car, I waited in the lobby at police headquarters in Center Street. I had my favorite easy chair right near the elevator and smoked my cigar. When I got sleepy, I retired to the Missing Persons office for a little snooze, leaving word with the cop at the information desk not to disturb me unless something really hot came over the teletype. It was like room service in a first-class hotel." Weegee recalls that during these times (the late 1930s, the early 40s) there was a murder every night in New York. He figures he covered about 5000 of them all told.

Eventually, Weegee fell upon good times. In 1945 he published *Naked City*, which became a bestseller and a movie and, much later, a TV series. He got work from *Life, Look* and *Vogue*. He worked in advertising, went to Hollywood, wrote more books. He even acted in and helped to film some movies. His heart, however, remained in the mean streets of New York City—which was where all his best work was done. This photograph, taken outside the Palace theatre on Broadway, shows a bunch of young people waiting for a glimpse of Frank Sinatra.

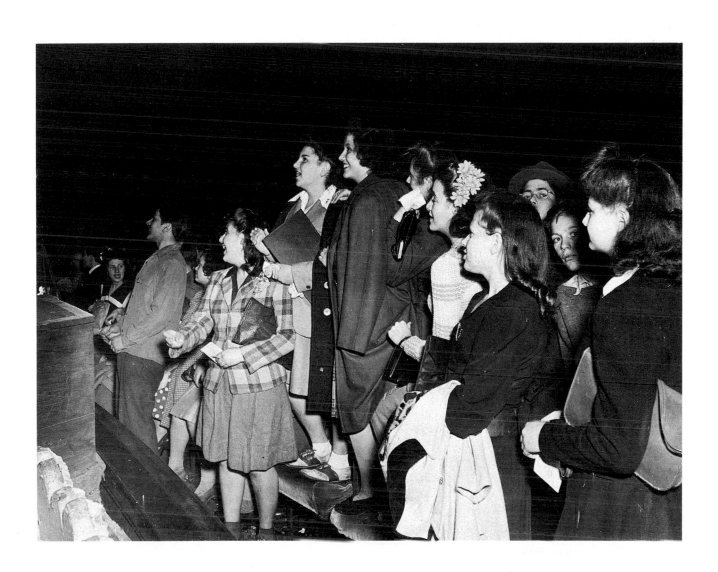

WEEGEE
American, (born Arthur Fellig) Austria, 1899 – 1968

Hollywood Premiere, 1950
11″×14″ vintage silver print
Private Collection

Despite the originality of his fashion photography and the bizarrerie of the madhouse-mirror effects he could get with the trick lenses he became so addicted to at the end of his career, it is Weegee's crime reporting that made his reputation and constitutes much of his best work. As Bruce Downes writes in an afterword to Weegee's autobiography, the hard-bitten photo-journalist covered so many sensational crimes that he became known as the official photographer of Murder, Inc. "The 'boys' often tipped him off," Downes writes, "when and where important gang killings would take place." At one point, Weegee even complained to the gang leaders that all of their hit cars were black limousines and that his Speed Graphic flash bulbs wouldn't pick up the blackness in his photographs. "I suggested a light gray would be much better," Weegee recalls, "then the car would stand out in my photos. This was taken care of."

Given this unblinking matter-of-factness in the face of what was becoming routine violence in Weegee's life, it is remarkable that his other great subject was the people of New York themselves, and people everywhere. In the sequel to *Naked City*, a volume of photographs simply called *Weegee's People* (1946), a tender tribute to human variousness, Weegee points out that all he did was "be where the people were." "The pictures that I enjoyed taking the most," Weegee writes, "were the ones in the chapter, 'Saturday Night.' Couples drinking, making love, and having a good time. . .the things for which I yearned myself. My subjects and I were really having a wonderful time. This was the life, far better than being out in the cold, photographing a five-alarm fire." One of Weegee's favorite ploys was to turn away from the purported center of the action to photograph gathered spectators.

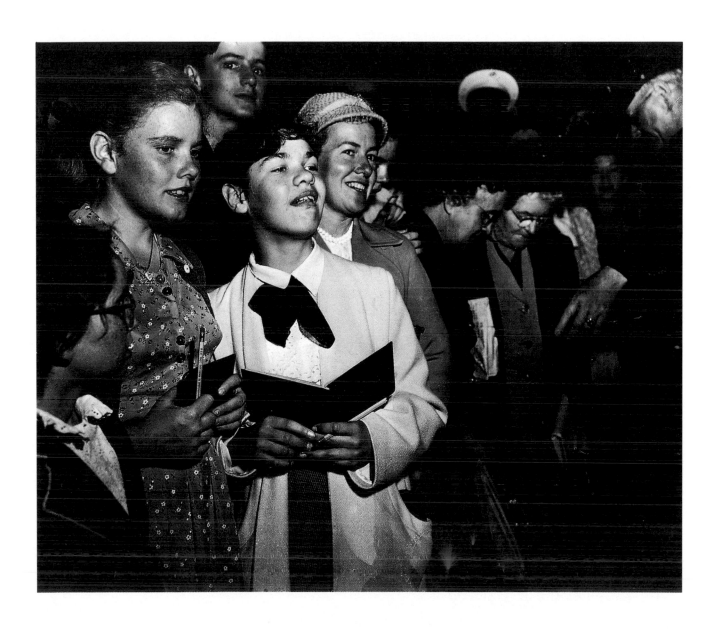

HORST
American, born Germany, 1906 –

Diamante Buschetti at Villa Maser, Ruspoli, Italy, 1947
6½" × 5¾" vintage silver print
Collection of the artist

Best known (like Cecil Beaton) as a photographer of high fashion and as an accomplished portraitist of the fabulous faces of the 1930s, '40s, and '50s, Horst has had a good deal to do with defining style for the first half of this style-obssessed century. Apprenticed to Le Corbusier in Paris in 1930, Horst eventually turned to photography after having served as both a model and as an assistant to the flamboyant French *Vogue* photographer Baron George Hoyningen-Huene. Such a connection led inevitably to his acceptance by the *beau monde* of Paris and the beginning of his own career as a photographer. For most of the 1930s, Horst divided his time equally between New York and Paris, between American *Vogue* and French *Vogue*. In 1962, American *Vogue* editor Diana Vreeland commissioned from Horst a series of photographs of well-known personalities to be taken in their own elaborate homes and gardens. For Horst it was a refreshing change of photographic venue and he rose admirably to the task, changing the direction of the photographing of interiors forever by the simple act of photographing the telling details of a room rather than the whole of it, as was usual. "You never see everything in a room at once," Horst explained. "Your eye goes from object to object."

It is always a surprise to realize that Italy's majestic palaces and villas might actually be inhabitable—especially by children. One thinks of them more often as vast mouldering containers for decorative bronzes and emplacements of massive furniture. Horst's photographing a child in these noble surroundings gives the photograph a faintly surreal mystery.

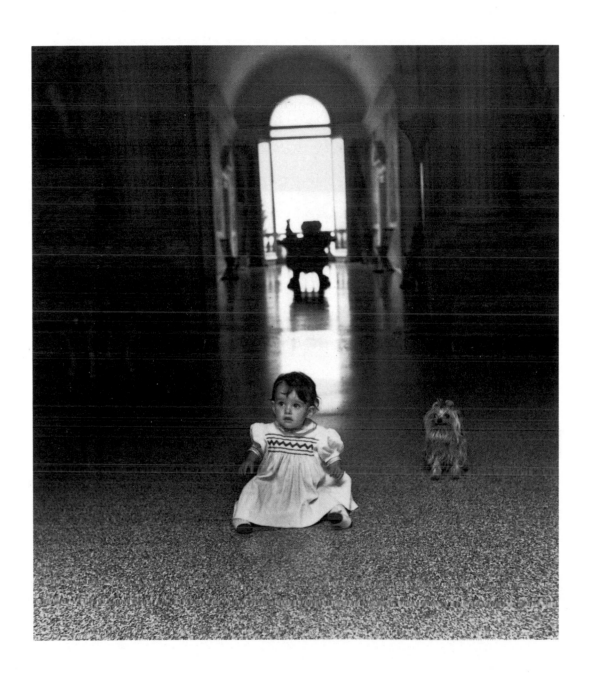

IRVING PENN
American, born 1917 –

The Mountain Children, Cuzco, Peru, 1948
19½″ × 19½″ platinum/palladium
Collection of Dr. and Mrs. Hugh E. Scully

In *Worlds in a Small Room* by Irving Penn (1974), the artist recounts the week he spent, the Christmas of 1948, high in the Peruvian Andes in the little village of Cuzco, photographing the people of the town, descendents of the Incas. "From the very first glimpse the look of the inhabitants enchanted me," writes Penn, "small, tight little 3/4 scale people, wandering aimlessly and slowly in the streets of the town. Because of everyone's small size, it was difficult to guess ages. . . " The photo sessions took place, amazingly enough, in an old photography studio Penn came across and was able to rent for a few days (". . .a daylight studio! A Victorian leftover, one broad wall of light to the north, a stone floor, a painted cloth backdrop. A dream come true. . ."). Penn says his best subjects were country people who, like this brother and sister, had come into Cuzco to do some Christmas shopping ("At Christmas there is simply a great market, mostly of toys and sweets for the children"). Many of his subjects had never seen a camera before and their bodies became "rigid with fear" at the prospect of being immortalized. Naturally, Penn's command of their native language, Quechuan, was not great. "I posed the subjects by hand," Penn recalls, "moving and bending them. Their muscles were stiff and resistant, and the effort it took on my part was considerable." All in all, the trauma of it seems to have worn off pretty quickly. Penn says he was surprised and touched to find, the mornings of the second and third days of shooting, that his courtyard was filled with his previous subjects, all anxious to repeat the strange experience.

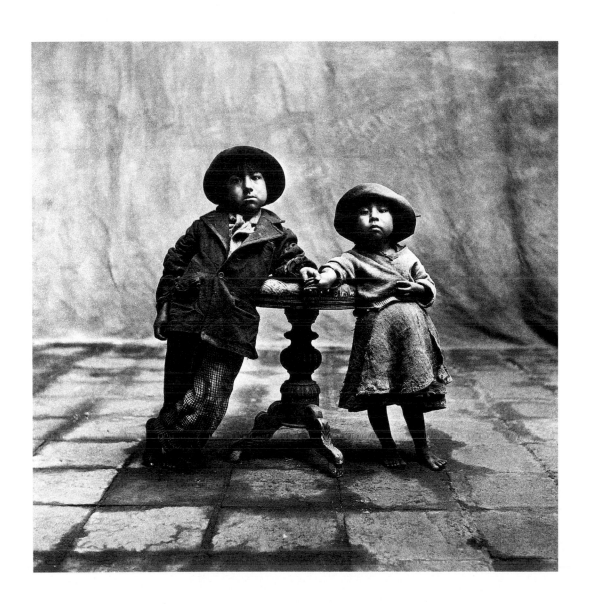

RICHARD AVEDON
American, born 1923 –

Boy & Tree, Sicily, July 15, 1947
14″ × 11″ vintage silver print
Private Collection

In discussing the early Avedon's penchant for motion in photography, John Szarkowski (*Looking at Photographs*, 1973) suggests waggishly that "It is possible that Avedon was in fact one of the architects, unwittingly or otherwise, of the Jet Set concept, which was based on the premise that people with style do not alight." Szarkowski also goes on to note Avedon's famous later reversal of this attitude, which resulted, of course, in his powerful and relentless—sometimes harrowing—use of full frontality. Some of these faces, caught in the glare of Avedon's headlight lens bearing down on them, look, as Szarkowski puts it, "like faces illuminated by a catastrophic explosion, the significance of which has not yet registered in their expressions."

 Boy & Tree, Sicily has the frontality we are used to in Avedon. It also has the bright wash of light—though, granted, the light here has an eerie, omnidirectional, Mediterranean luminescence that seems to come from all around rather than from the divided assault we expect from the photographer. And there is more in the photograph than the squared-up little boy alone. There is that odd toy tree: part tree, part cloud, part ominous light event, a fairy tale, never-never tree. All of which goes to make this Avedon a good deal more tender and lonely and bewitched than is characteristic of him. One tends to think of Avedon as romantic but unsentimental. Here he is both—which is a mild shock.

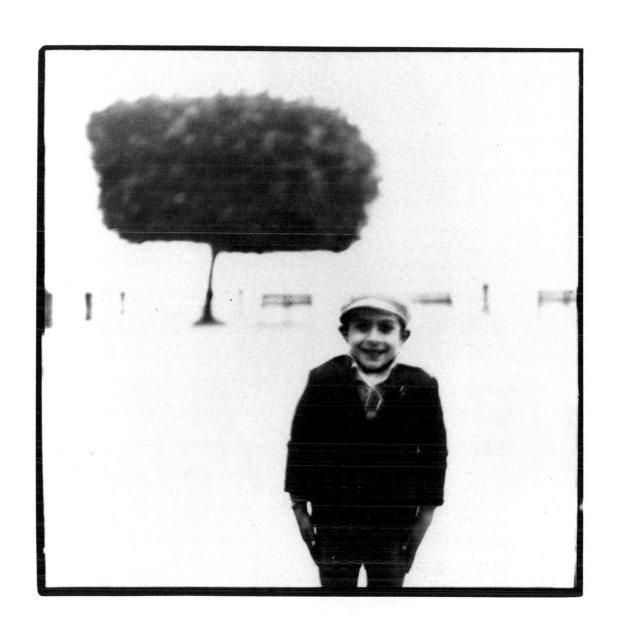

W. EUGENE SMITH
American, 1918 – 1978

The Walk to Paradise Garden, 1946
12″ × 10″ vintage silver print
Collection of Alexandra Marshall

One of the greatest photo-journalists of the century and one of the indisputable masters of the photo-essay (most of which were made for *Life* magazine), Eugene Smith has been a "concerned" photographer on a heroic scale. *The Walk to Paradise Garden,* unlike the rest of his photographs in its sentimentality, is so frequently misread, so often regarded as a passage of prime kitsch, that it urgently (and continually) needs recontextualizing. It is Smith himself who does this best:

> "The children in the photograph are my children, and on the day I made this photographic effort, I was not sure I would be capable of ever photographing again.
>
> There had been a war—now it seems a long time ago, that war called World, volume II—and during my 13th Pacific invasion, shell fragments ended my photographic coverage of it. Two painful, helpless years followed my multiple wounding, during which time I had to stifle my restless spirit into a state of impassive, non-creative suspension, while the doctors by their many operations slowly tried to repair me. . . But now, this day, I would endeavor to refute two years of negation. On this day, for the first time since my injuries, I would try to make the camera work for me, would try to force my body to control the mechanics of the camera; and, as well, I would try to command my creative spirit out of its exile.
>
> Urgently, something compelled that this first photograph must not be a failure. . .
>
> Eugene Smith

Desperately wanting a result that was "more than a technical accomplishment," Smith willed into being a photograph that would somehow "speak of a gentle moment of spirited purity in contrast to the depraved savagery I had railed against in my war photographs—my last photographs." This day was to be, wrote Smith, "a day of spiritual decision." The result was *The Walk to Paradise Garden.* It was something to shore against the ruins of war.

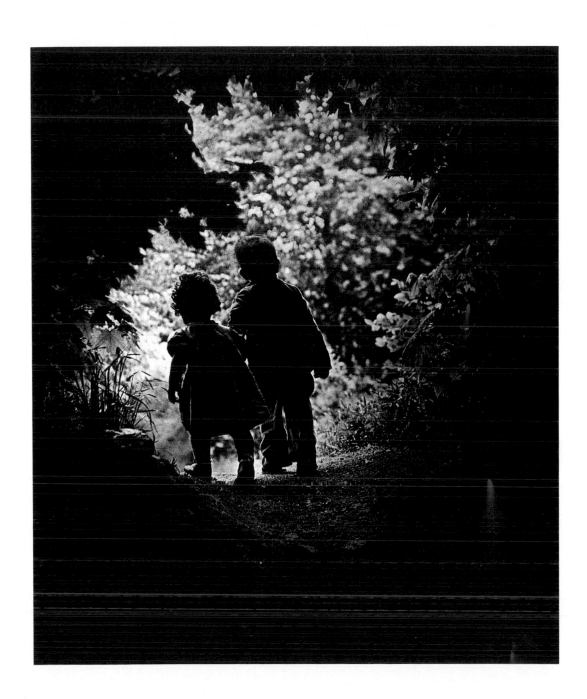

JOHN GUTMANN
American, born Germany, 1905–

Machine Gunners, San Francisco, 1950
11″×14″ silver print
Private Collection

While it clearly reflects Gutmann's fascination with America's love affair with machinery and, lamentably, with guns—it is remarkable, is it not, how sanguine we appear to be, as a culture, about the appeal guns have for children, especially male children?—*Machine Gunners* is a late echo in Gutmann's work of an earlier interest in Constructivism. As Maia-Mari Sutnik points out in her catalogue *Gutmann* (The Art Gallery of Ontario, 1985), "Gutmann's interest was not in exploring the uses of abstract geometric forms in space inspired by the modern machine esthetic and espoused by the movement in Russia. Neither did he subscribe to the 'socialism of vision' declared by László Moholy-Nagy. Gutmann's interest was in formulating a dialogue with space that would humanize the austere geometry which was the essence of technology. . . " *Machine Gunners* employs a severe, Rodchenko-like angling in which the smooth, riveted, bomb-shaped kiddie war-machines make their circumscribed way through the grey, absorptive space of the photographic plane.

The whole meaning of the work is concentrated on the face of the kid just left of centre, whose flint-eyed visage is pictorially wedged between his own aerial engine of mock-destruction and the one just ahead.

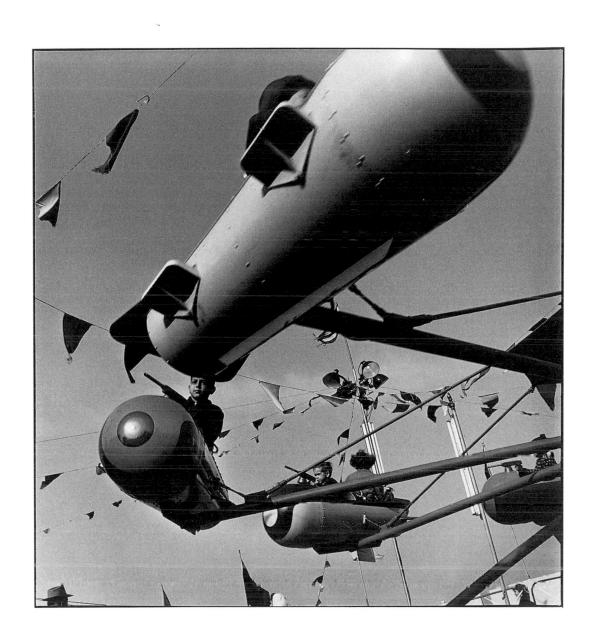

GREY VILLET
American, born 1927 –

Ginny Nyrall, 1956
16″ × 20″ silver print
Collection of Jocelyn Hammond Corkin

Kids still cleave to the telephone, but there is something quint-essentially telephonic about kids in the '50s. There's something very *Bye-Bye Birdie*, something very Annette Funicello/Frankie Avalon, something *My Three Sons*-ish about the '50s phone. One wonders if the '50s-familiar image of the teenage kid sprawled inventively over the furniture, phone welded to ear, is not some minor manifestation of the new space-directives put in place for the post-war North American family. The family of the '50s, it will be recalled, was no longer able to get away from itself. Nobody lived in rooms. Instead there were living-areas, vaguely defined zones more or less devoted to certain activities—eating, sleeping, watching TV. Sprawling over a chair was continuous with sprawling about the house. Only the telephone, with its earpiece-intimacy, offered any privacy.

DOROTHEA LANGE
American, 1895 – 1965

Mother and Child, San Francisco, 1952
9 5/16″ × 7⅜″ vintage silver print
Collection of the Museum of Modern Art, New York

The Farm Security Administration was the product of the shuffle of government agencies conducted by FDR's New Deal in an attempt to revive America's wounded economy. The so-called Historical Section, the official name of the FSA photography project, organized in 1935 by Roy E. Stryker, eventually amassed, over the seven-year period of its existence, more than a quarter of a million negatives, most of which were made as a way of documenting and understanding the plight of the farmers, sharecroppers and migrant workers of the drought-stricken midwest. Of the many memorable images generated by the project, Dorothea Lange's were among the most distinguished. Some of them, like her *Migrant Mother, Nipoma, California,* 1936, have attained the status of moral touchstones.

After her years with the FSA, and her social-documentary of the war years at home, Lange suffered a prolonged bout of ill health, which kept her from photography for three years. When she picked up her camera again, in 1951, she began to make images which were utterly different from anything she had done before, images in series with titles like *The Walking Wounded, Consumers,* and *Relationships.* "In the past," wrote Lange, "events have always played a major role in the work I've done. First there was the depression, then the dust-bowl, then the war. All of these were big, harsh, powerful things, and it was in relationship to them that, as a rule, I tried to photograph people. Now, however, I'm trying to get at something else. Instead of photographing men in relation to events, as I have, today I'm trying to photograph men in relation to men, to probe the exchanges and communications between people, to discover what they mean to each other and to themselves." Gone were the large, epic effects. What had replaced them were gestures, nuances, "things you have to look very hard to see, because they have been taken for granted not only by our eyes, but, often, by our hearts as well."

EUGENE HARRIS
American, n.d.

The Piper, c. 1955
3½″ × 5¼″ vintage silver print
Private Collection

Was it naiveté of belief in the ultimate goodness of man which promted Eugene Harris to conjure *The Piper*? Exhibited as a central element in the publicly praised but critically panned exhibition *The Family of Man* at New York's Museum of Modern Art in 1955, *The Piper* has been dismissed in some quarters as a paen to high-minded idealism, to things as they should be rather than as they are. That view was predicated on the gulf which existed even then among the enormous cast which lives the human condition.

Some 35 years after the fact, when history and events have combined to infuse a hard edge of cynicism into values and belief, *The Piper* stands as a joyous rendering, a beacon to the potential for excellence in man, despite his widely dissimilar social and economic stations.

Rather than cheap sentiment, it is an ennobling testament, one which points to hope, to better, to tomorrow.

HARRY CALLAHAN
American, born 1912 –

Chicago (Mother and Child), c. 1953
7⅝″×9½″ vintage silver print
The Sandor Collection

The trouble with Harry Callahan's photographs—and the glory of them, according to John Szarkowski (*Callahan*, 1976)—is their lack of vulgarity. What Szarkowski means by "vulgarity" is the identifiable presence in a work of art of "those humanistic referents that have not been wholly subjugated to the interior requirements and rhythms of the work, and which leave a slightly gritty precipitate, extraneous to the solution of the artistic problem." In Callahan's photographs there is no trace whatsoever of a gritty pictorial "precipitate." Callahan's nudes, Szarkowski points out, "do not propose lust; his forests are free of insects; the pedestrians on his city sidewalks suffer not as you and I, but as the saints and warriors that are seen in old museums."

The point is that Callahan's photographs are no less fine for it. They present, on the contrary, a clean, brilliantly clarified view of the world that energizes everything. His photographs are like demonstrations of the poet William Blake's assurance that if our lenses of perception were cleansed, everything would appear as it really is—infinite. The mother and child shown here, standing quietly in a shaft of backlighting, prevail against a stygian darkness that seems too velvety and unrelieved to be a truly urban darkness; they could be players in some expressionist drama, standing in a set, illuminated by spotlight. Callahan's light is not naturalistic but lyrical. His mother and child are thereby transformed into Mother and Child—the central duo, the archetypal bonding, of human existence.

ROBERT DOISNEAU
French, born 1912 –

Used Car, 1944
15¾″×12″ silver print
Collection of the artist

Doisneau is at his most gentle photographing children. Indeed, were he not as witty as he is, his photographs of children might well fill up with nostalgia and sink into sentimentality. It is his gaiety that keeps them buoyant.

The children re-animating the decrepit shell of an automobile in *Used Car* ("used" barely begins to describe its condition) are observed with an enviable clarity and are convincingly particularized. The handsome, vigorous boy perched on the hood is obviously a natural leader of men—or will be. He has an easy superiority that is infectious, as does his pal behind the wheel (or behind where the wheel would have been). It must be just a little tedious only to have those cute little kids in the back seat to be heroes for and to show off to. On the other hand, the two little tads in white are satisfyingly worshipful. The admiration in the eyes of the kid at the very back is no small thing.

The boy up on the roof is, emotionally speaking as well as pictorially speaking, a loose cannon. He seems strangely detached from all the rest of the children, intent upon some eccentric manipulation of the length of wire in his hands. The radical sharpness of his nose and his rather beady fix upon the distance ahead dehumanize him, turning him into a sort of living hood ornament.

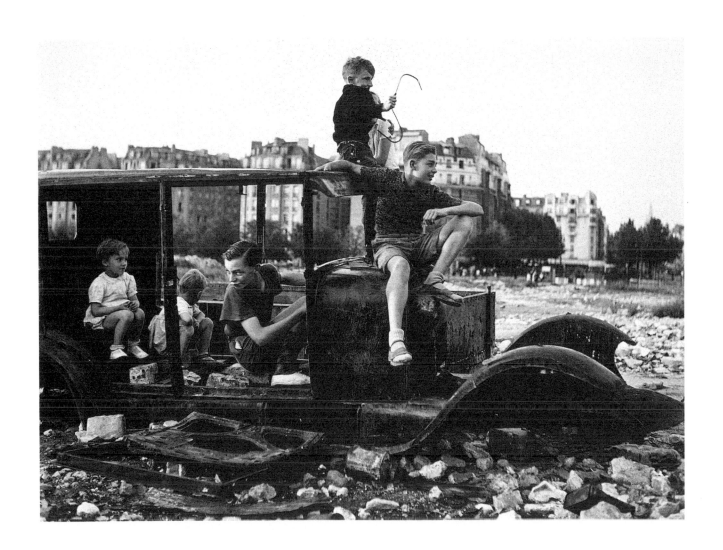

WILLIAM KLEIN
American, born 1928 – living in France

Seesaw, New York, 1954
16″ × 20″ silver print
Collection of Edward Ballard

One of the great badboys of contemporary photography, William Klein's straight-from-the-hip images marshall movement, blur, searing glare and obfuscating shadow into a jazzy, pictorial cacophony that has been enormously influential in kicking the envelope of modernist photographic practice. Klein's photographs, like the prose of fellow New Yorker Henry Miller, elevate rawness into transcendence, pushing aside agreed-upon canons of taste in search of some greater urgency, some sharper, perhaps more painful truth about the nature of our lives as they are actually lived. Like Miller, Klein has spent much of his life in self-imposed exile, abandoning his native New York for Paris. A painter and film-maker as well (in this he presents an absorbing parallel to the other great, gritty, photographer of our time, Robert Frank), Klein invariably used his earnings from the fashion work he did for magazines such as *Vogue* to fuel the making of what he has always considered his own work — as academically unacceptable as it has often been deemed. Brilliantly, exuberantly personal, the photographs Klein made during the four years of his life he devoted to photography are harsh, direct, spontaneous and honest. The black children of his *Seesaw,* photographed in New York in 1954, are angry, vital, stoic, fearless and coiled with energy. The black diagonal of the seesaw cuts through them like a cancellation.

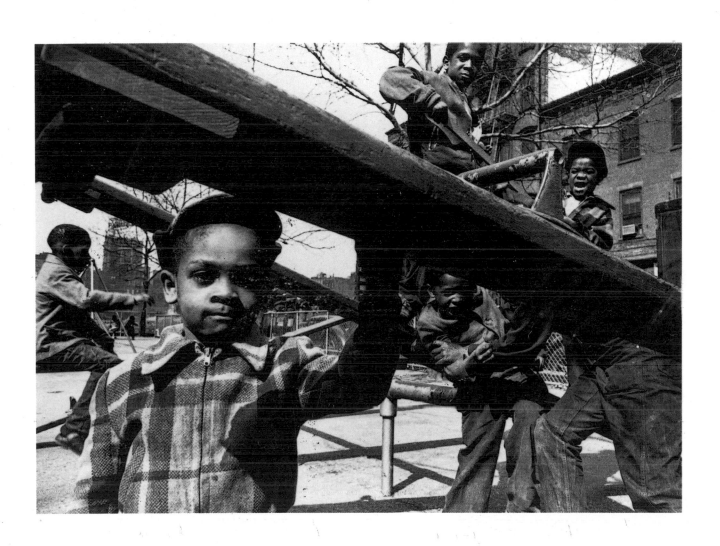

GEORGE ZIMBEL
Canadian, born United States, 1929 –

Jack Ryan and Son, 1958
17½″ × 11¾″ silver print
Collection of the artist

The cosmic image, writes Gaston Bachelard, in *The Poetics of Reverie* (1969), "is immediate. It gives us the whole before the parts. In its exuberance, it believes it is telling the whole of the Whole. It holds the universe with one of its signs. A single image invades the whole universe." This is an ecstatic photograph. The man's pleasure in his son is so intense, his laugh is immense, part outburst of joy, part prayer of thanks.

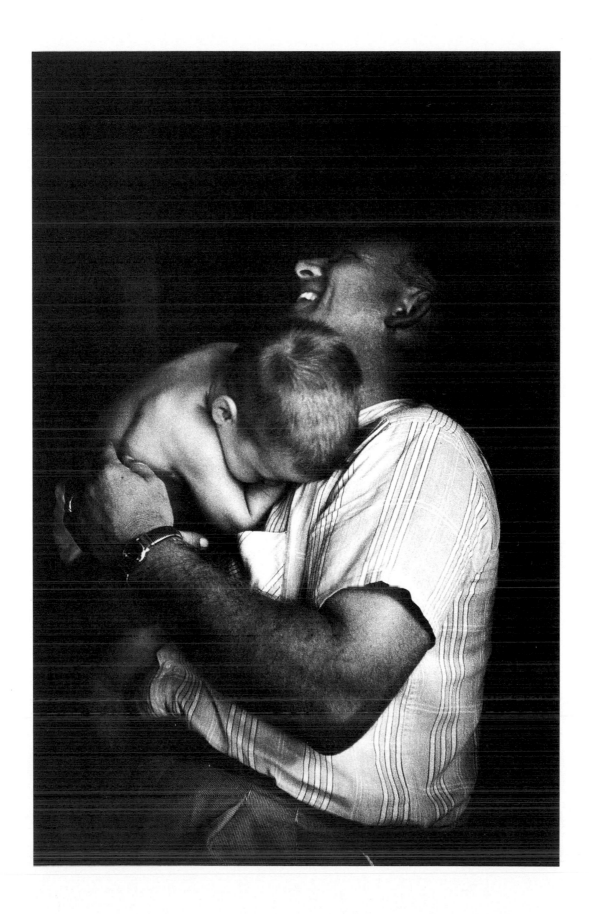

GEORGE ZIMBEL
Canadian, born United States, 1929 –

Black Boy and Great Dane, Harlem, c. 1960
11¾″ × 17⁵⁄₁₆″ silver print
Collection of the artist

When you're small, everybody else is big. This is enough of a given that, like the weather, one cannot really do anything about it. This little kid, alone (and short) in a sea of adult verticality, has, however, acquired a Familiar, a four-legged support system in the shape of gigantic Great Dane that acts, in some measure, as an equalizer. The child still looks a little tentative, a bit uncertain about his place in the world. The dog, however, is seeing to that. It is the dog, for example, not the kid, which confronts the photographer. Don't mess with us.

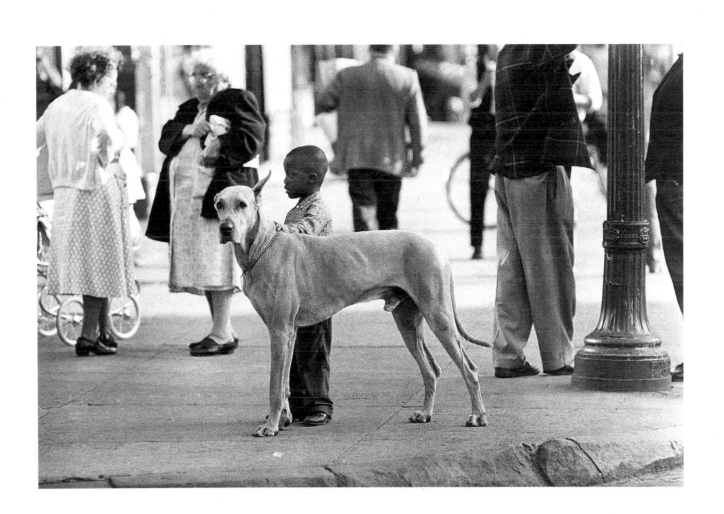

MICHAEL SPANO
American b. 1949 –

Eastern Parkway, Brooklyn, New York, 1981
24″ × 55″ silver print
Collection of the Artist

While it is not physically a dyptych, this panoramic photograph by Michael Spano, taken in Brooklyn in 1981, splits vertically just to the left of the middle, cleanly dividing the lateral sprawl of the photograph into two discrete but related areas (the axis runs down the edge of the building in the distance, an extension of the back of the white T-shirt). On the left, a couple of guys are loitering around doing masculine things like squinting into the middle distance. The way they are positioned, they form a sort of living gateway to the street as it heads off into its vanishing point. The two shadows leaning away down the road reinforce the men's doubleness and their roles as guardians, of a sort, of the street. On the right, the kids mount truncated brick pedestals to even up the differences in height and importance between themselves and the big guys. This is an artificial way to seem bigger and the only thing that happens is they end up looking like sculptures, flanking the entranceway. Someday, these ornamental children will have dibs on the streets too and be grown up. It's not all that great an aim, but try to tell that to a kid.

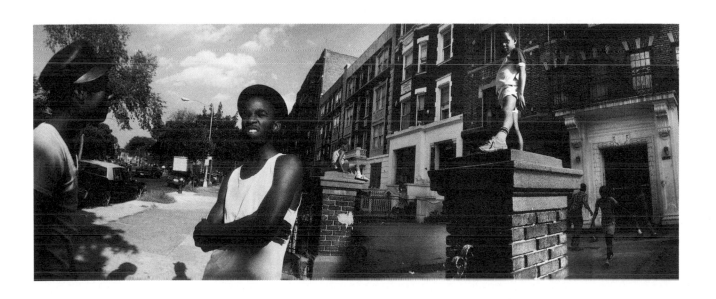

ANDRÉ KERTÉSZ
American, born Hungary, 1894 – 1985
worked in Paris 1925 – 1936, New York from 1936

Acapulco, 1952
8″×10″ silver print
Collection of Rebecca Edwards

There are photographs provocative enough that it seems
permissible to misread them— or at least to make so fast and loose
with the possibilities that come tumbling in that you end by piling
up "meanings" the photograph may or may not reasonably sustain.
Such a photograph is Kertesz's extraordinary *Acapulco, 1952.* What
can be going on here, in this disturbing picture? The naked child
seems utterly, distressingly alone. It is a little boy, is it not? Though
the child's hips are girl-like. It is androgynous, then, an Everychild,
childness generally. The child is in shadow, displayed on the tile
ledge like an article of merchandise, like some exquisite but unsold
terra-cotta sculpture, the last one. The child's raised arm is like the
arm of a drowning child, raised in futile supplication out of the
water. At the left of the photograph, in the sunlight, there is a
passageway—a passageway through normality. A mother and her
child have just gone by, linked and belonging to one another. The
naked, shadowy child is, as a result, more alone than ever.

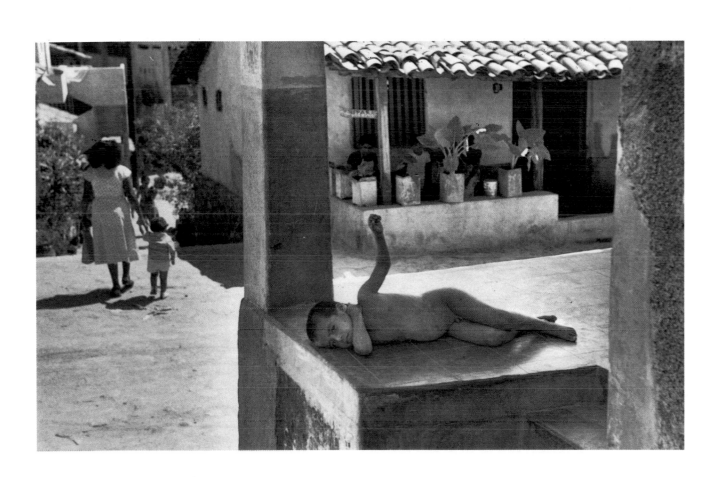

HENRI CARTIER-BRESSON
French, born 1908 –

Rue Mouffetard, Paris, 1954
13¾″×9¼″ silver print
Private Collection

"What is more fugitive," asked Cartier-Bresson, in the preface to
The World of Cartier-Bresson (1968), "than a facial expression?"
This entire photograph is made up of facial expression. Everything
else—the streetful of people (all admirers of this competent young
man's bringing home of the wine), the corner that is being
rounded, the blankness of the windows behind the boy, acting as a
backdrop that isolates him in a way his sense of accomplishment
deserves—everything else is secondary to the boy's beaming,
puckish, infectious self-consciousness. How is such a photograph
made? Isn't it true that we have heard so much about the "decisive
moment" that it means nothing real, nothing truly methodological
any longer? How can such an image actually have come into
being? According to Cartier-Bresson himself, photography requires
certain "powers of concentration combined with mental
enthusiasm and discipline. It is by strict economy of means," writes
the artist, "that simplicity of expression is achieved." "You hunt for
the solution," writes the maestro. "Sometimes you find it in the
fraction of a second; sometimes it takes hours, or even days. There
is no standard solution, no recipe; you must be alert, as in a game
of tennis." All of which continues both to beg the question and, at
the same time, nourish the enigma.

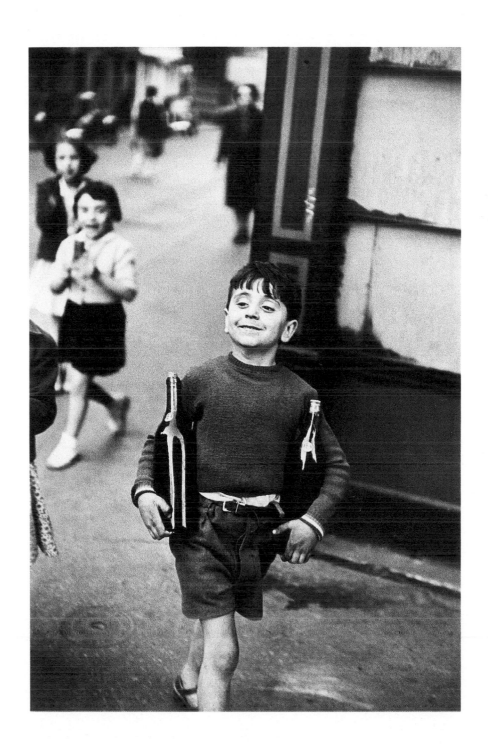

HARRY CALLAHAN
American, born 1912 –

Untitled, 1957
6½″ × 6½″ vintage silver print
The Sandor Collection

Under the impress of Harry Callahan's clean, constructivist vision, this baby's head has been so centralized it has turned into an articulated sphere—a planet—floating against a chaotic sea of undifferentiated blanket. The infant's hair looks like atmosphere, like cloud cover, seen from far out in space. In many respects, the baby's head resembles *Earthrise* by William Anders of the 1968 U.S. Apollo 8 mission, the famous "big blue marble" photograph of earth hanging in space over the horizon of the moon. If this is a conceit, it is a conceit that makes a certain amount of sense as an exercise in microcosm/macrocosm transformation. An infant's head is just about as complex as a planet. One thing is for sure. The photograph is massively *about* the baby's head and thus demonstrates Callahan's belief that "It's the subject matter that counts. I'm interested," wrote Callahan in 1962, "in revealing the subject in a new way to intensify it." There have been few photographs which have so much subject matter.

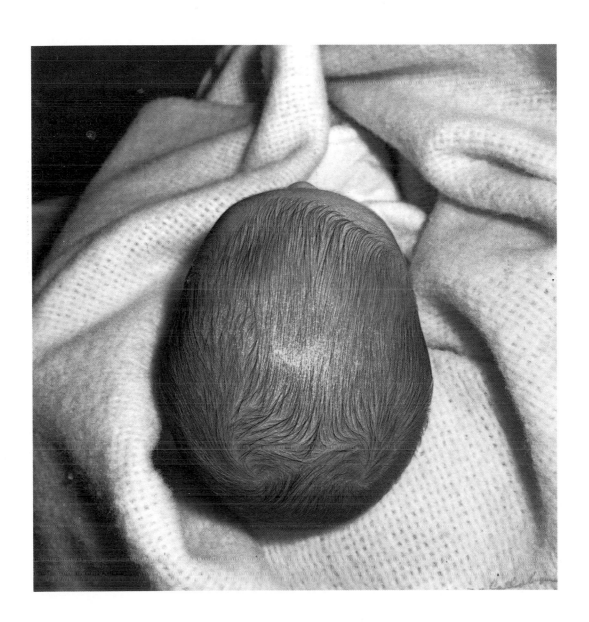

GARRY WINOGRAND
American, 1928 – 1984

Untitled, c. 1960
13″ × 8¾″ silver print
Collection Fraenkel Gallery

This child is a study in contradiction, a living oxymoron. Children
are free or if they're not, they long to be. Sunglasses are agents of
order, purpose, goal. They are at odds with boydom. Sunny
though it obviously is, there is something confining about the
boy's wearing sunglasses — sunglasses possessed of such formal
force, at least. These sunglasses look correctional, rather than
ameliorating. They look like blinkers on a horse. Probably it was
his mother who insisted he wear them — his mother or whoever
that person is with the ring and the long, redundant gloves. The
boy's mouth, an extraordinary mouth in the dip and curve of it, in
its chilling chiselledness, is going into a pout. And why not?

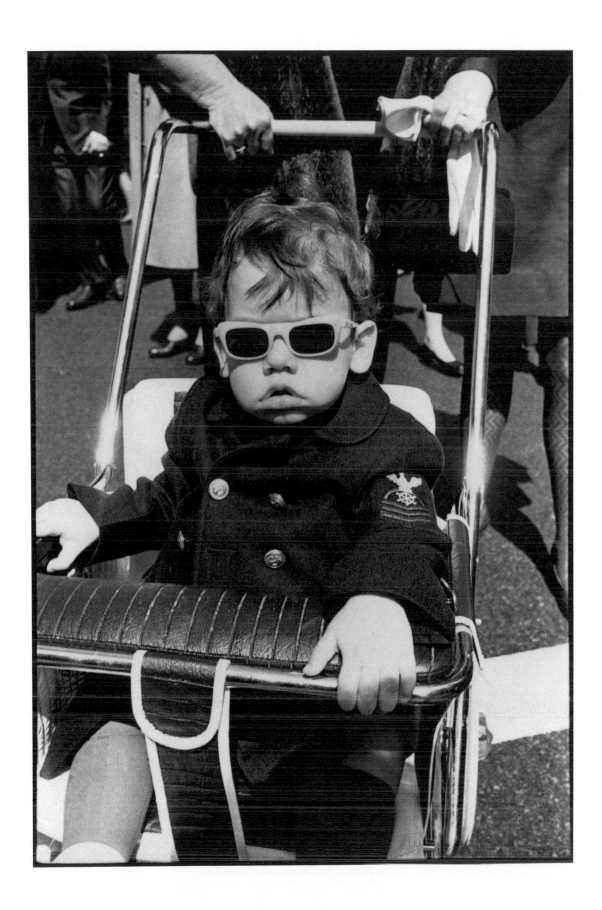

WILLIAM KLEIN
American, born 1928 – living in France

Majorettes, New Orleans, 1963
20″×16″ silver print
Collection of Susan Muir

The distorting lens used by William Klein to encompass this idyll of homespun Americana seems to be in competition with the very empowerment the girls' uniforms bring to them. The lens pulls them into a kind of warping absurdity; their own pride in their glitzy majorette outfits pulls them back from it. Let's make no mistake. Despite the undertow of the photographer's technical entrapment of them, these chubby, staunchly good-humored girls remain something more than a collective prepubescent joke. Here is an instance wherein innocence flies the nets of satire.

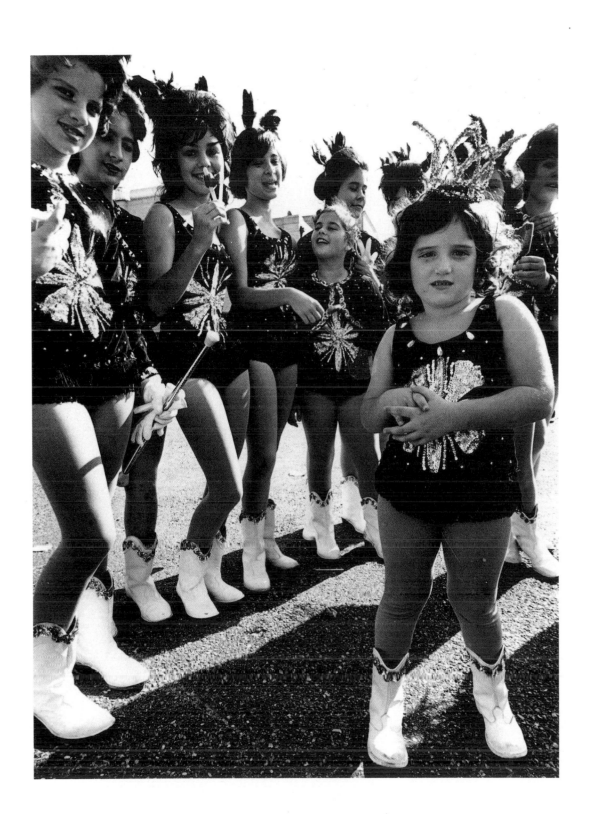

DIANE ARBUS
American, 1923 – 1971

Child with a Toy Hand Grenade in Central Park,
New York City, 1962
8½″ × 7¼″ vintage silver print
Collection of Robert Koch Gallery

After an early sojourn in the realms of photographically "grainy things," Arbus says she began to want to see real differences. "I wanted to see the difference between flesh and material, the densities of different kinds of things: air and water and shiny. So I gradually had to learn different techniques to make it come clear. I began to get terribly hyped on clarity." The clarity she achieved was often a frightening clarity—the riveting clarity of what she has called "off-limit experiences."

Arbus' famous photograph of the enraged boy with the toy hand grenade is scary because the child is scary. All she appears to have done is foreground him (he is as firmly rooted to the spot—out of anger—as the trees over his shoulder are) and focus him. There is an often told story that the child looks as hysterical as he does because Arbus had been following him around Central Park for hours, snapping photographs of him. Which is almost certainly apocryphal. Arbus was a too-deliberate photographer for that. What is it, if it isn't Arbus, that makes the child look so crazed? The wild eyes that stare like automobile headlights. The pressurized clamp of the lips. The touching, too-tight pants, with one shoulder strap coming down (the boy is coming apart). The claw-hand. The boy looks as if he's going to explode if the grenade doesn't. The people coming down the walk pushing the baby carriage look wonderfully normal by contrast. But they're a long way off.

170

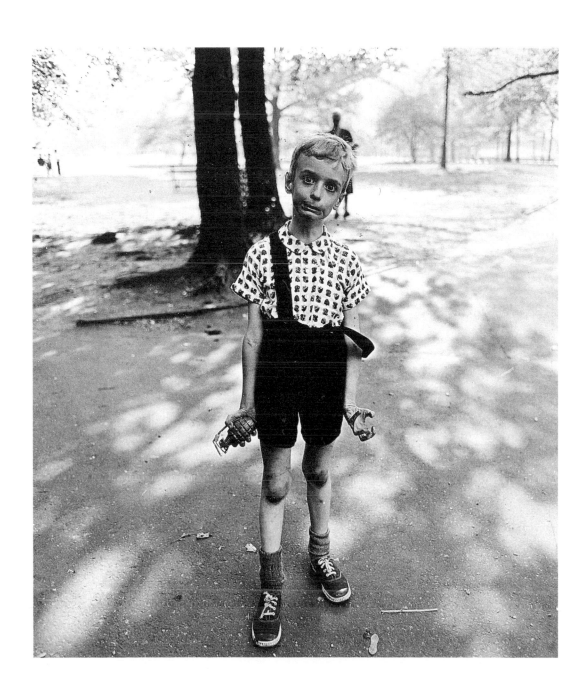

DIANE ARBUS
American, 1923 – 1971

Identical Twins, Roselle, New Jersey, 1967
22″ × 18″ gelatin silver print
Collection of the National Gallery of Canada

Twins appeared to take their place, for Diane Arbus, in the gallery of oddnesses and grotesques she also populated with nudists, transvestites and other deviations from the human norm. For her, twins seemed to be freaks just as fully as freaks of a more theatrical nature. Perhaps for Arbus the trauma and anguish of living were doubled by twin-ness.

What people seem to have resented in Arbus' photographs (some viewers actually spit at them when John Szarkowski first showed them at the Museum of Modern Art in 1965) has been their apparent lack of compassion. As Susan Sontag pointed out in *On Photography* (1977), "The authority of Arbus' photographs derives from the contrast between their lacerating subject matter and their calm, matter-of-fact attentiveness." For Arbus, as Sontag notes, there was "no decisive moment." This impassive attentiveness has of course been interpreted as exploitation—an exploitation bordering on cruelty. For Arbus, however, it was more a question of her having adopted a scrutiny that lay beyond matters of taste, beyond convention, beyond protection, either of her subjects or of herself. There was, oddly enough, a sort of love in this, of the world and its demonic variousness.

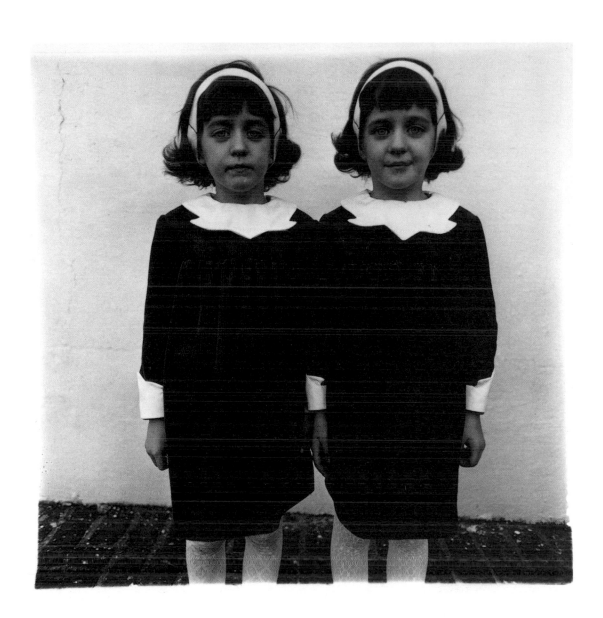

BIRGITTA RALSTON
American, born Sweden, 1933 –

Two Sisters from Ferney, Voltaire, France, 1978
4½" × 4¾" silver paper
Collection of the artist

Birgitta Ralston's imperturbable subjects, two sisters, are equally
endowed with freckles—to a degree that looks almost
mathematically exact. Because of the neutralizing similarity of their
bodies and their poses, and because of their near-symmetry within
the picture-plane, the girls look more as if they were on display
than they might otherwise look if their positioning were a little
more casual, if they were a bit more differentiated. As it is, we
stare at those freckly faces. Nothing wrong with that, presumably.
Except that it pushes the girls—who otherwise seem so normal—
right to the edge of a Diane Arbus-like inspectability.

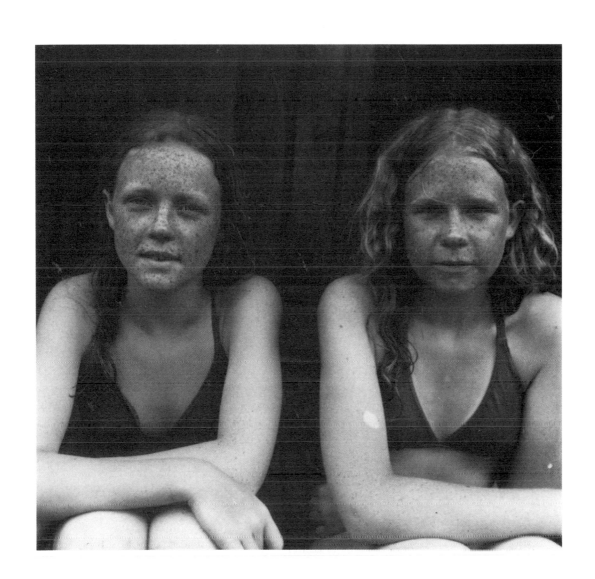

ANDRÉ KERTÉSZ

American, born Hungary, 1894 – 1985
worked in Paris 1925 – 1936, New York from 1936

New York, New York, 1966
10⅛″ × 7⅞″ vintage silver print
Private Collection

André Kertész was the undisputed father of what has come to be known as "street photography." His pioneering use (as early as 1932) of the miniature camera as a serious tool for making photographs was a revelation to photographers like Henri Cartier-Bresson. It is not far-fetched to maintain that Kertész virtually laid the groundwork for modernist photographic practice.

Among the many modalities of his mastery lies a graphic virtuosity that led him to seek out and make lyric use of lines in space — the rococo whirl of wire chairs in parks, the wire frames of eyeglasses, the iron bars of gates and fences — a linear alphabet of decoration.

Here, a Kertészian fence acts as a filter through which it is possible to see shards of an enactment — or perhaps two enactments. The right side of the photograph seems to be the site of a game of some kind. The stance of the boy who is pictorially run through by a shaft of wrought iron would indicate baseball or perhaps a game of catch — except that there is no ball or bat anywhere. On the left is what looks like the beginnings of a scuffle. Has the right side of the photograph degenerated into the left, or was there never any game at all, just volatility? Whatever is going on, we are kept from it, collaborators in photography's aloofness, the third point in its triangulated stance opposite the nature of reality.

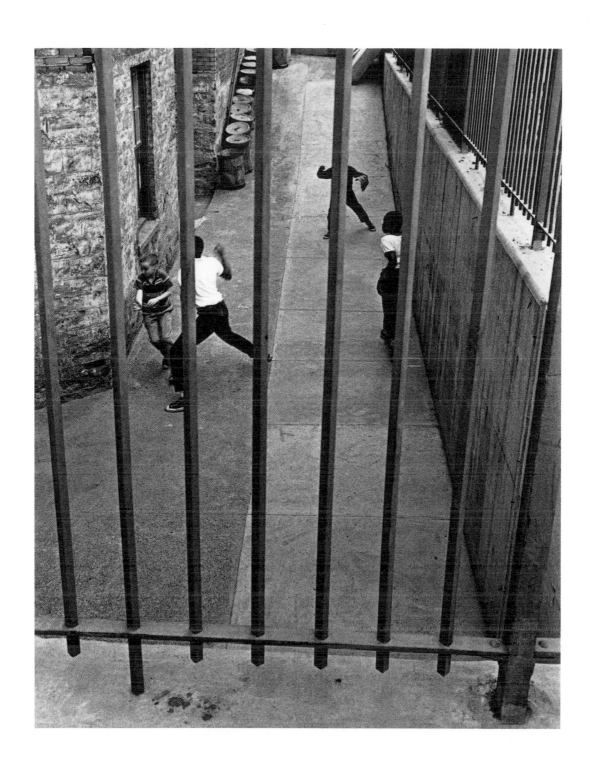

TONY KING
Canadian, born 1934 – living in the United States

Father & Son, c. 1972
9″ × 13″ silver print
Collection of the Winnipeg Art Gallery;
acquired with funds from Hongkong Bank of Canada

The father carries his son into the lake and in so doing re-enacts some ancient and ongoing investiture, a passing on of experience, a nourishing of trust. The child rides just above the horizon line, up in the realms of light (which seem symbolic of his innocence). Above his father's head, the child is all looking, all waiting, all expectation. The slight curve of his shoulders is an eloquent shorthand for his simultaneous eagerness and tentativeness. The child's nakedness is Edenic.

The father has been here before, been everywhere before. The horizon line, where the field of light meets and rests on the field of water, runs through the father's shoulders — a photographic felicity that amplifies the man's worldly strength and lends his body a sort of experiential torque. Soon the child will be in the lake with the father and there will be no division left, no edges, only the bounded wholeness of the water.

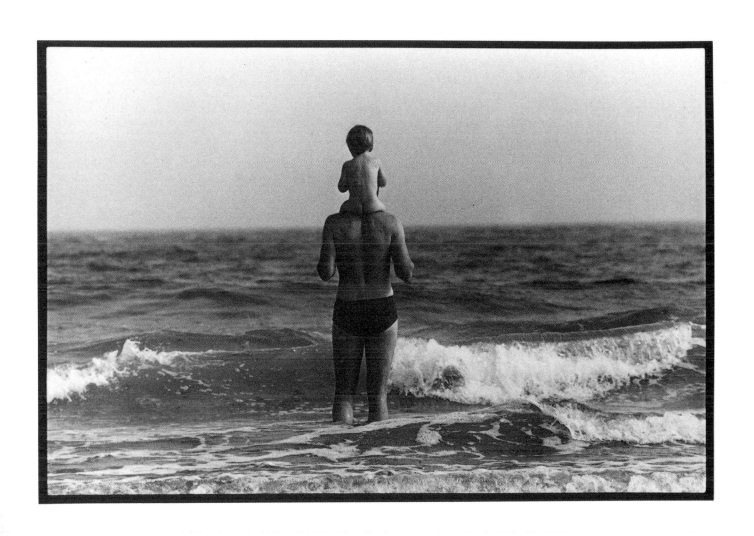

TONY KING
Canadian, born 1934 – living in the United States

Tide Dance, c. 1972
13 ¼″ × 9″ silver print
Collection of the Winnipeg Art Gallery;
acquired with funds from Hongkong Bank of Canada

This dance by the water's edge is so visually open and graphically
inspectable, it is less a depiction of a relationship than a
demonstration of an activity, and less that than a passage of
photographic calligraphy, as if the children were dancing an
utterance or shaping themselves into a gestalt we could read aloud.
Taken all together, four limbs and their four reflections, the effect
is to enact something like a large illuminated letter of the alphabet
in space which will then begin a long, absorbing tale.

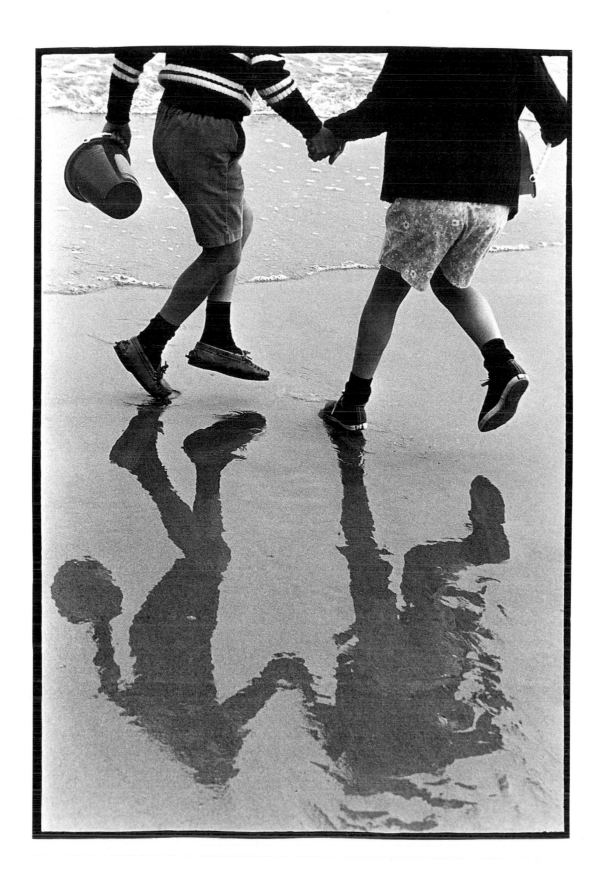

CANDACE COCHRANE
American, born 1947 –

On the Community Stage
Will, Joe, Byrne & Kenneth, 1973
11″×8½″ silver print
Collection of the artist

American photographer Candace Cochrane began exploring
Newfoundland in 1967, working as a volunteer summer recreation
teacher in one of the outports. Eventually, with the outport of
Conche on the Northern Peninsula as a base, as a kind of
quintessential Newfoundland (the province and its people in
microcosm), she took photographs and collected stories and
comments and, as far as she was able to, the folklore of the area,
over a period of thirteen years. One of the products of this
diligence was a superb book called *Outport: Reflections from the
Newfoundland Coast*, published in 1981. This photograph is taken
from it. "It seems like everyone that comes here likes this place
and likes the people," says one of the men of Conche that
Cochrane got to know. "There's a reason somewhere. Probably we
don't see it, not as quick as you'd see it or some other stranger. I'm
born and reared here, and whatever I got around me is me
own. . . ."

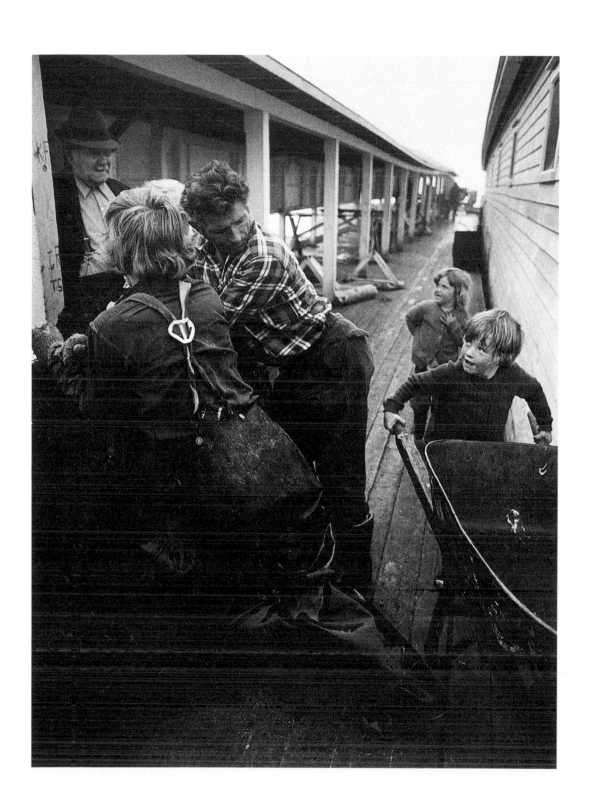

JOHN REEVES
Canadian, born 1938 –

Child Wearing Donald Duck Sunglasses,
Igloolik, Baffin Island, N.W.T., 1971
7¾″×11¼″ toned silver print
Collection of the Winnipeg Art Gallery;
acquired with funds from Hongkong Bank of Canada

Canadian photographer John Reeves journeyed to the Arctic twice, in February 1968, and again in April 1971, "to photograph Inuit artists and the circumstances in which they lived and worked". A good many of the photographs generated by those two visits came together in a major exhibition in 1981 called *Inuit Art World*, the exhibition from which this beguiling image has been taken. These symmetrically positioned children seem to crystallize the juxtaposition of the old and the new ways of the Innu: one child wears a knitted hat, goofy duck sunglasses and a lavishly carved and decorated parka; the other child is an angelic little wet-nosed creature engulfed in a penumbra of fur from the nesty depths of which he gazes at us with dark, limpid eyes. What gives the picture its energy is not just the atmospheric difference between the children. It lies, rather, in the queer way in which the more earthy child on the right plants himself more solidly into the photograph and weights it.

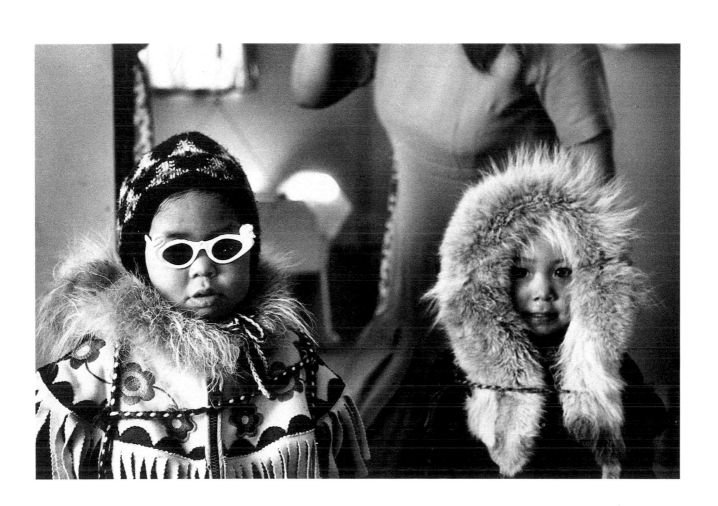

SIMEON ALEV
Canadian, born 1956 –

Blind Girl Learning to Swim (#3), 1986
9¼″×9¼″ silver print
Collection of Jane Corkin

The blind girl's faith in her giant, shadowy teacher fills the photograph with a luminous dignity. The instructor's hand on the girl's head is a careful, nurturing hand. Its presence and its position help to bring about a metamorphosis within the photograph whereby the swimming lesson is pictorially transformed into what could be some variant of a creation myth, with the girl rising from the water into the light in order to be born. It may be that the girl's instructor is, in fact, pressing her slowly down into the water. No matter. Given the trust on her face, her incandescent peacefulness, the girl is rising.

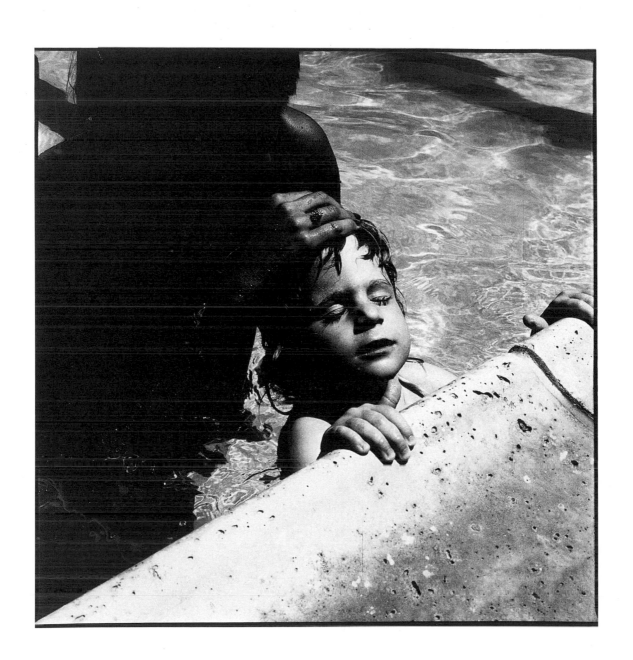

GILLES PERESS
American, born France, 1946 –

Belfast, Northern Ireland, 1972
18½″×12½″ silver print
Collection of the artist

One of the most gifted and imaginative photographers associated
with the international photo agency Magnum, French photographer
Gilles Peress has won two prestigious awards named for two of his
heroes—both Magnum photographers: the Robert Capa Gold
Medal Overseas Press Club Award and the W. Eugene Smith Award
for Humanistic Photography. Peress became associated with
Magnum in 1970, when he was only twenty-four years old. He
made a number of trips to Northern Ireland, beginning that year,
one of which produced this distressing look at the obscenity of
religious/ideological war. The wounded child is all the more
isolated in her pain and shock by being held diagonally, like a
negation, across the direction the four others are travelling.

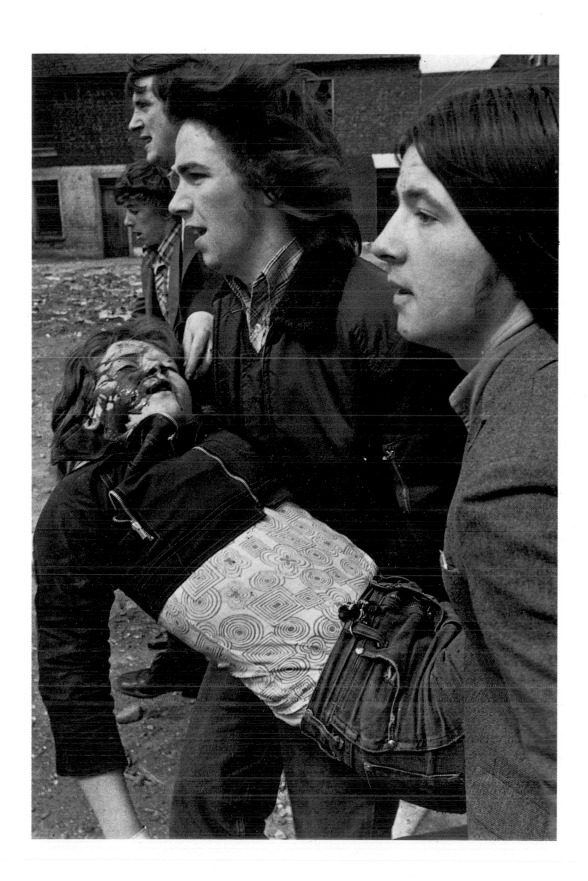

EDOUARD BOUBAT
French, born 1923 –

Girl in Confirmation Dress, 1976
14″ × 9½″ silver print
Collection of the artist

French photographer Edouard Boubat shares, with two other great French photographers, Henri Cartier-Bresson and Robert Doisneau, a predeliction for and a faith in that careful, hallowed moment of form-generating unity of photographer and subject that Cartier-Bresson characterized as "decisive." As Boubat himself put it, the photographer "has to perceive the image and select the best vantage point in one and the same moment, and for this he needs the speed of a hunter." Only the speed, presumably. Not the terminating will. It is odd to hear Boubat, whom Jacques Prévert once referred to as a "peace correspondent," employing the hunter image to clarify the nature of his quest for form-holding moments; most discussion of Boubat's work centres around his gentle wit, his delicacy, his innocence, his benign and often roseate view of the human condition which, through Boubat's lens, seems constantly transformable into a full-blown *comédie humaine*.

The girl in her confirmation dress is a case in point, a photograph entirely typical of Boubat's work: a flutter of feathery wings on a sun-dappled lawn, a tiny soul struggling along under the sublime burden of her own buoyancy. This little radiant burning-bush of a girl is an *étude* of contradiction — she is a fallen female angel; she is encumbered with the trappings of her own ascendency.

PAMELA HARRIS
Canadian, born United States, 1940 –

My Mother/My Daughter, Toronto, Ontario, 1976
8¼″ × 12¼″ silver print
Collection of the artist

Pamela Harris' photograph of her mother and her daughter is rapidly becoming a classic study of the profundity and gentleness of maternal and grand-maternal love. The graphic isolation of Harris' mother and her infant daughter against a plane of undifferentiated velvety blackness makes all the more touching their being bundled together by the creamy white wave of the knitted blanket or shawl that engulfs them both. The baby's hat makes petals around her face, turning her into a bright, sentient flower. Harris herself has written about the picture:

> This photograph is of two of the people I love best in the world: my mother and my eldest daughter. My daughter had just woken up after being taken out for a walk. She looks at the world, and her grandmother looks at her. The faces, at either end of the generational stream, make a circle, or one loop on a spiral. On the most personal level, I am there too, invisible in the middle. What is important to me in the photograph is the love that flows from the elder woman to the younger, the understanding in her face, contrasted to the open gaze with which the baby sucks in the world and makes it all anew.

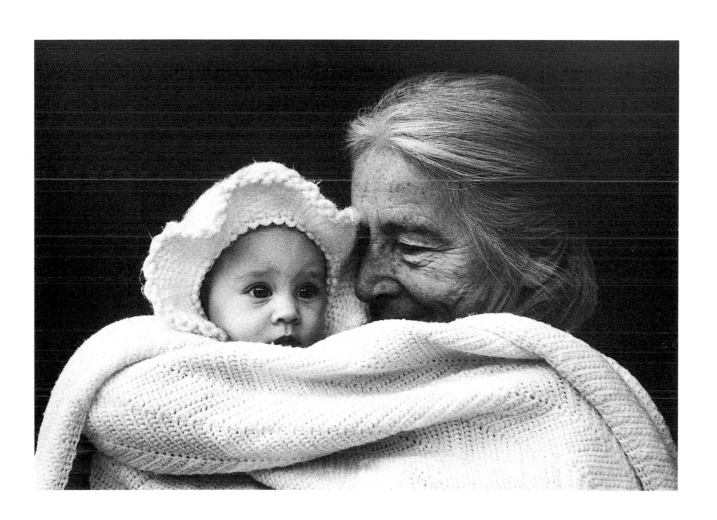

IRVING PENN
American, born 1917 –

Hippie Family F, San Francisco, Aug/Oct, 1967
20¾″ × 19½″ platinum/palladium
Private Collection

Irving Penn's foray into the wilds of San Francisco's Haight-Ashbury area in 1967 was a sort of anthropological parallel to his journey up the Andes to Cuzco. Penn had heard about certain "new ways of living that were exotic even for California" taking place on the coast and had decided to bring it all back home, photographically speaking, to *Look* magazine before the whole hippie phenomenon came apart in the glare of media scrutiny (of which, it must be noted, Penn was a part). The photographer had two kinds of subject in mind when he rented a vast, makeshift studio in a warehouse in Sausalito: hippies and rock groups on the one hand and members of the Hells Angels motorcycle club (with their bikes) on the other. Getting the Angels to sit was easy. Penn offered to pay them "a stiff fee" and that was that. It wasn't so easy with the hippie families Penn wanted to shoot. With them it took "endless conversation and tests of good faith."

The couples Penn decided upon seem remarkably self-possessed and assured. Penn even succeeds—though you'd imagine it would be antithetical to what he'd want—in making his subjects look sort of spiffy and well turned-out. On the other hand, the aim here is clearly aesthetics as much as sociology. These are, invariably, "beautiful young hippie families." This particular couple and their cool, nonchalant baby, lived, according to Penn, a domestic existence in a charming tiny house "filled with cuvios and cult symbols."

ROBERT MINDEN
Canadian, born 1941 –

Doukhobour Women and Children, 1978
12½″ ×19½″ cibachrome
Collection of the artist

During the six-year period from June 1973 until June 1979, Canadian photographer Robert Minden worked on an ambitious project involving the documenting of the way of life of the members of the Doukhobour communities in the southern interior of British Columbia, between Grand Forks and Nelson and up into the Slocan Valley. The work was exhibited in 1979 and published in book form by the National Film Board as a catalogue entitled *Separate From The World: Meetings with Doukhobour-Canadians in British Columbia*. As Minden wrote in his introduction to the exhibition, "The people pictured here, along with their parents and relatives, are connected to [an] enormous and now shattered experiment in shared living. Overall, the images. . .describe solitude. Their basic rhythm derives from memory and a deep sense of loss. . ."

And yet in this particular photograph, that pool of memory, that sense of loss, is tempered, as it must always be, by the here-and-now vitality of the children—who will inherit and inhabit another kind of world. Even on this bright sunny day, the five women manage somehow to look as if they have been clipped from an old photograph and stuck onto this one. The child running past them seems scarcely to notice their august presence. The other children swinging amidst the foliage of the trees are in a world of their own—a world that legitimately belongs to all children.

ANDRÉ KERTÉSZ
American, born Hungary, 1894 – 1985
worked in Paris 1925 – 1936, New York from 1936

Gypsy Girl, Arles, 1979
8″ × 10″ silver print
Collection of the Winnipeg Art Gallery; Anonymous Gift

The photograph is subtly structured, albeit academically so: divided into vertical thirds and, more or less, horizontal thirds by the masonry. If you draw a diagonal across it from the lower left corner to the upper right, you find that all the children are gathered into the right half, an ascending arrangement reaching from the little dark-haired boy at the left, through the gypsy girl— whose photograph this is, by virtue of both her comeliness and her compositional place in the picture—to the staunch verticality of the boy with his arms folded and the children cropped over at the right, finally leading the eye out of the photograph.

All of this satisfying structure, condensed within the photograph during, one can be sure, a single moment of poised vision, plays no important purpose beyond its showcasing of this lambently beautiful gypsy child. She stares up through and out of the picture plane as if she is absorbed by something the others have not seen or cannot see. The crooking of her right arm is absurdly graceful and lends her a meditative privacy that is almost other-worldly.

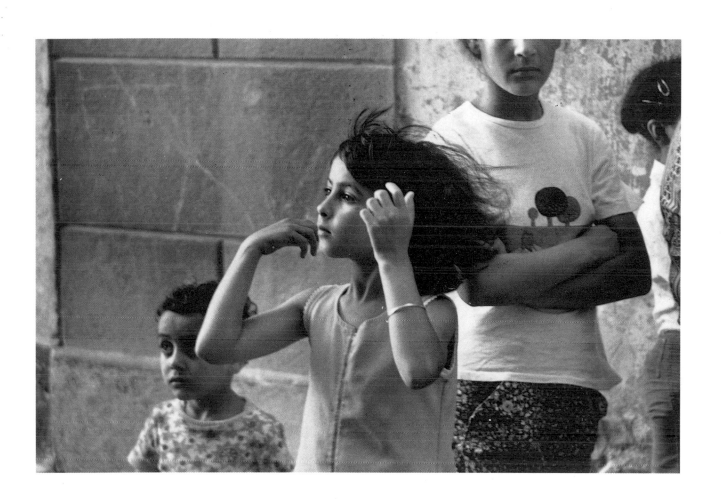

JUDITH CRAWLEY
Canadian, born 1945 –

Conchita and Lulu, 1979
16″ × 20″ silver print
Collection of the artist

Motherhood is undeniably rewarding. It is also exhausting. A child keeps you admirably rooted to the here and now. A child also hurtles you through time as it kicks the envelope of history in order to make a place for itself.

This photograph is among the studies of mothers and their children made by Canadian photographer Judith Lermer Crawley and shown in Montreal in 1985. The catalogue for the exhibition is a book-length collection of photographs and text (much of it consisting of interviews with the subjects of the photographs) called *Giving Birth is Just The Beginning: Women Speak About Mothering*. The book is divided into sections devoted to birth itself (A Rude Awakening), single parents (from which the photograph here is taken), unpaid labour, role-modeling, and an excoriating photo-essay called "Women Are Going on Strike." In an essay at the end of the book called "Reflections on Motherhood," Greta Hoffman Nemiroff tells how a group of students from her Women's Studies group at The New School of Dawson College in Montreal visited her and her five-year-old daughter Rebecca at her home. It became clear, during a discussion about the option of having children, that not one of the young women in the group ever intended to have any. "The discussion flowered with mutual reinforcement," writes Nemiroff, "until Rebecca's voice piped up: 'You're all wrong,' she said firmly, 'us kids are the best.'"

This confident young girl standing in the light bears it out. Her eyes are still in shadow, but see the resolution in the set of her mouth. The key around her neck is probably the key to the house she shares with her mother who has brought her up by herself. Here, in the light, it becomes an insistently symbolic key, a key to the kingdom of her own future womanhood. Her mother is shadowy, uncertain, wary, out of focus as if it is experience that has unfocussed her.

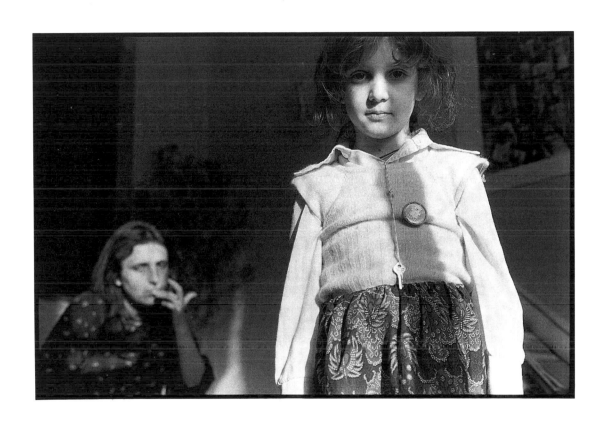

RAY VAN DUSEN
Canadian, born 1949 –

Untitled, 1980
8¾″×13″ ortho print
Collection of J. Zachary Corkin

A pictorial centrifuge. Except for the boy in the centre, whose eyes confront the camera with suspicion, everyone else in the photograph is bent away from the middle. One young man hurtles into the water in the upper part of the picture (the truncated shadows of his legs look like the speedy direction lines that unfurl, in cartoons, behind rapidly disappearing characters). Another leans to the right (through the irresistable pull of the photographer's warping lens) and another to the left (the dark, crouching figure over by the white leg that looks like driftwood). All of this flyaway movement sets up a genuine torque in the photograph that turns about the axis of the centrally located boy and his stalwart, faceless friend.

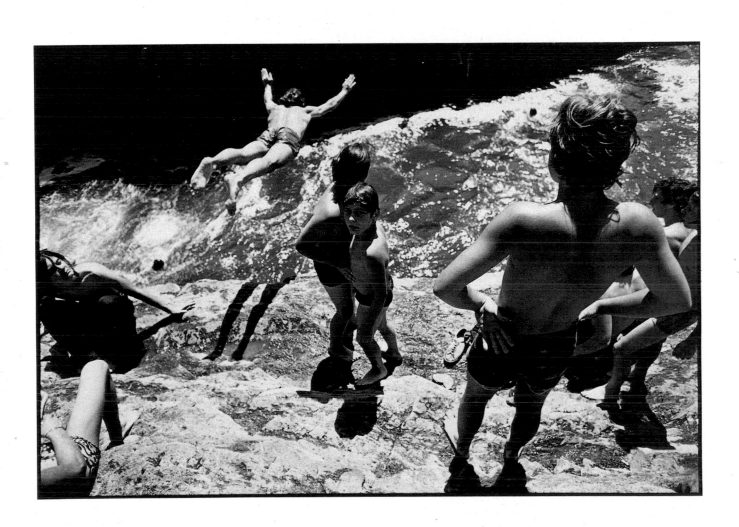

MICHAEL KLEIN
Canadian, born 1959 –

Baltimore, 1982
16″ × 20″ type 'c' print
Collection of the artist

The world of childhood is, spatially speaking, a low-down world.
It is easy to forget that, as adults, we inhabit the upper air. It is
easy to forget that for the child, the landscape is populated by legs
and feet, shoes and boots, the bottom half of everything. This
child is speeding across a terazzo plaza, arched sideways in its
stroller the better to observe the skyscraper trousers, the billowy
sails of dresses, the click and scuff of a thousand pairs of alien feet.
Small wonder children love to be picked up.

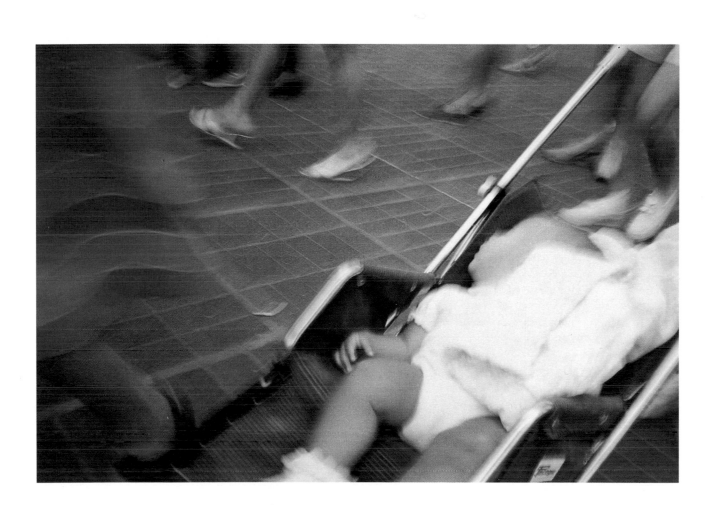

JOANNE JACKSON JOHNSON
Canadian, born 1943 –

Untitled, Inukjuak, Quebec, May 1982
14″×14″ ektacolour
Collection of Jake Averill Corkin

In 1982, Winnipeg photographer Joanne Jackson Johnson travelled with four members of the Manitoba Puppet Theatre to the Innu community of Inukjuak on the eastern shore of Hudson's Bay. For five weeks, the group gave workshops for the children of the area—who, Johnson was surprised to note, counted for over fifty per cent of the population. This photograph shows two of the puppets that were made in the workshops and two of the puppeteers. Altogether, the arrangement looks like a spray of bright flowers.

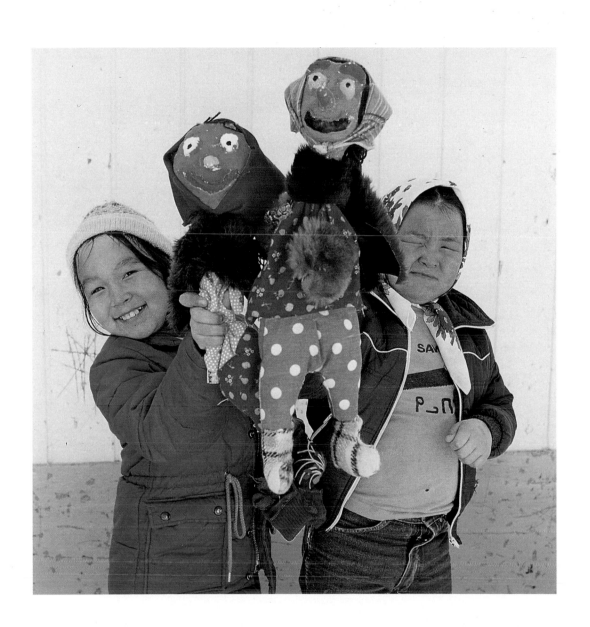

ROGER P. MULLIGAN
Canadian, born 1955 –

Pam at the Rink, 1978
11″×14″ silver print
Collection of the Winnipeg Art Gallery;
acquired with funds from Hongkong Bank of Canada.

Here is the kind of gee-whiz, girl-next-door, that Norman Rockwell used to immortalize on the covers of the *Saturday Evening Post.* Here is the essential look of a kid who is wondering What Next? The heavy, seven-league, all-Canadian touque is an important part of the photograph graphically and also as an emblem of a certain kind of bracing, youthful unselfconsciousness, a reminder of the days in which all of us were happy to wear hats like this. There is graffiti on the concrete walls behind the girl's head. Typically raucous stuff, hockey arena stuff, school corridor stuff: the white noise of childhood.

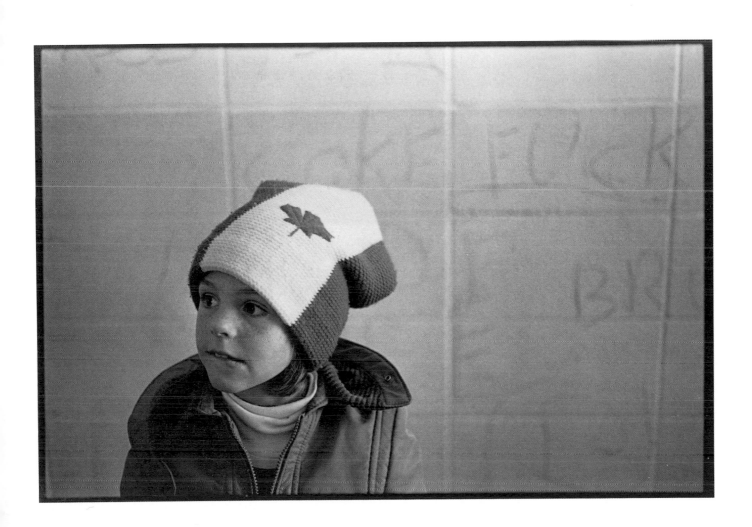

NICHOLAS NIXON
American, born 1947 –

Covington, Kentucky, 1982
8″ × 10″ silver print
Collection of Nina and Norman Wright

The experiment Nicholas Nixon undertook in 1977, to find out if he could use the 8-by-10-inch view camera to make photographs of people that would be as spontaneous and as psychologically acute as those captured by photographers using far less obtrusive 35 mm cameras, not only produced character studies of a penetrating kind; it also produced prints that positioned Nixon's subjects (they are so fresh and mobile, one can scarcely refer to them as "sitters") within a sensuous envelope of rounded, sculpting light that lends remarkable immediacy and vitality to the mise-en-scène. Peter Galassi, in his introduction to Nixon's *Pictures of People,* 1988, writes: "Like the hand-camera tradition it extends, Nixon's work is not a matter of shapes artfully arranged but of characters precisely described, as individuals and in relation to each other. . . " Robert Adams has noted that among Nixon's galleries of people caught so deftly by his big, claiming view camera, "there is not a face that is uninteresting. . . " Such is certainly the case here, where each child is so thoroughly observed one almost feels it has been photographed separately and then assembled into the final composite picture. Except, of course, that the fluid, spatially coherent flow of light that binds them all together precludes any such interpretation. The end result, for example, is that the child expansively catching a few rays is the featured player in a mini-drama in which the supporting players are the critical, considering child at the door jamb, the jaunty commentator in the window over at the right and the kids in the door frame, absorbed by the photographer.

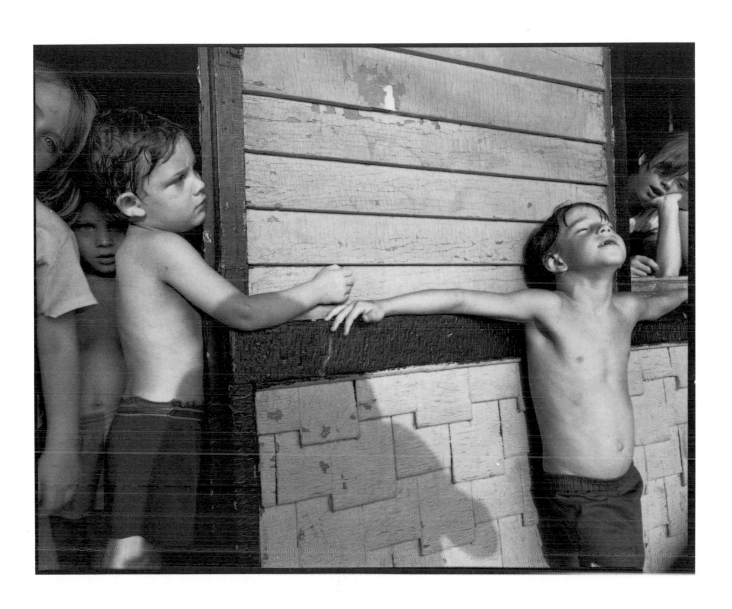

NICHOLAS NIXON
American, born 1947 –

Tennessee Street, Lakeland, Florida, 1982
8″ × 10″ silver print
Courtesy Fraenkel Gallery

The roundness, the almost three-dimensional effect Nicholas Nixon achieves by his use of the large-format camera is well-demonstrated here in this almost enterable photograph. The shade within the porch is a haven of chiaroscuro effects. Hot slivers of light fall against the family, outlining them, assigning them positions in space: the girl in the immediate foreground is carved away from her place and defined by a thin, persistent rivulet of light tracing the edge of her face; the old man, almost a silhouette flattened against the sun, is bound finally by the light on his braces and on his hat. The girl at the left is acknowledged mostly by the bonfire of light in her hair. The lattice-weave of their gazes also lifts the photograph out of flatness by binding the tableau into something structural.

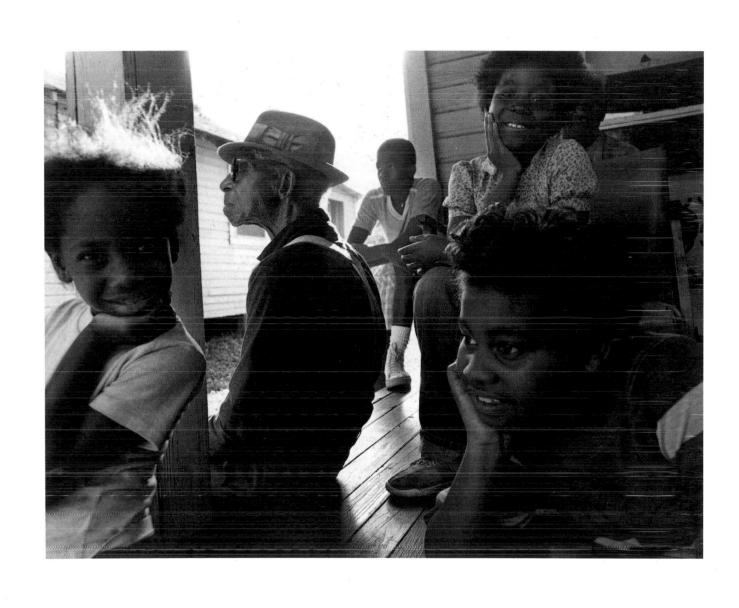

ANDREAS TRAUTTMANSDORFF
Canadian, born 1962 –

Flying Shovel, 1989
8½″ × 12½″ silver print
Collection of Zachary C. Kennedy

Andreas Trauttmansdorff's experience as a film cameraman may help to explain both his fascination with movement within his photographs and his deftness at entrapping it. Were it not for the trajectory of the airborne shovel, which arches through the plane of sky and connects the boys at opposite ends of the picture, this classically balanced beach scene might well take its place with the minimalist beach studies of Harry Callahan, where the extended horizontality of sand and sky, pierced by the horizon, is broken only by the momentary verticals of people on the beach—like notes on a music staff. Trauttmansdorff's introduction of a slivery arc of motion draws the photograph part of the way back from becoming an outdoorsy still life about the perfection of placement.

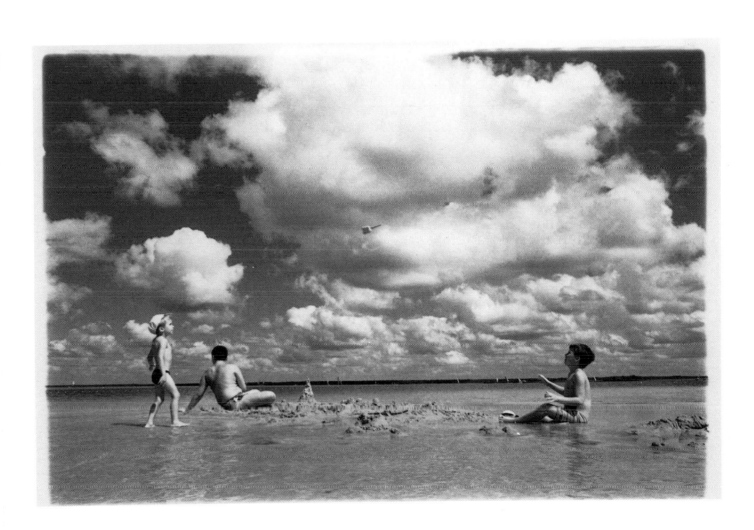

ANDRÉ KERTÉSZ
American, born Hungary, 1894 – 1985
worked in Paris 1925 – 1936, New York from 1936

Jardin des Tuileries, Paris, 1980
8″ × 10″ silver print
Collection of Winnipeg Art Gallery; Anonymous Gift

The preface to *André Kertész: Sixty Years of Photography, 1912 – 1972* (Grossman, 1972) consists of a prose-poem by Dada poet Paul Dermée which had originally appeared as the preface to Kertész's first solo exhibition at the gallery Sacré du Printemps in Paris in 1927. Kertész possessed, wrote Dermée, "Eyes of a child whose every look is the first." Kertész's eyes, Dermée went on, marvelled "at the all-new pictures that create, without malice, three chairs in the sun of the Luxembourg Garden, Mondrian's door opening onto the stairs, eyeglasses thrown on a table beside a pipe. No rearranging, no posing, no gimmicks, nor fakery. Your technique," he wrote, addressing Kertész directly, "is as honest, as incorruptible, as your vision. In our home for the blind, Kertész is a Brother Seeing-Eye."

In 1980, when this photograph was made, Kertész was eighty-six years old. Clearly, the vision of Brother Seeing-Eye had not dimmed with age. Here, still, is the wire chair casting its swooping baroque shadow. And here is the Kertészian child, endearingly awkward as she is caught in the act of separating from the adult— who is no more than a vanishing leg— and striking out into her own world.

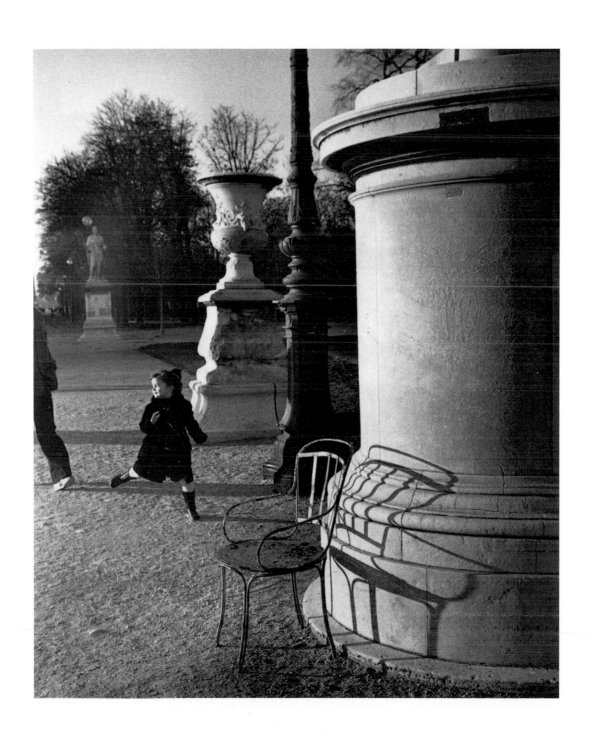

DEBORAH SAMUEL
Canadian, born 1956 –

Beauty, 1987
19″ × 16″ silver print
Collection of the Winnipeg Art Gallery;
acquired with funds from Hongkong Bank of Canada

Like much of Deborah Samuel's portrait studies, *Beauty* conveys an array of signals. Appealing, almost hypnotic, the child in the photograph nonetheless appears profoundly disquieting. The composition's ephemereal allure, its use of light and shadow to induce an apparition-like quality, seems riddled at the same time with a far more provocative element. At the very least, the child's gaze, with those wizened, tired-with-it-all eyes hints at a life lived well beyond her years. But there's something else as well. A profound unease settles over the frame, a suggestion here of darker undercurrents, mystery perhaps, a sense of malevolent foreboding or even fear.

Beauty is illustrative of a recurring theme which runs through Samuel's adult portraiture, the enduring dilemma of attempting to get back to looking at the world through the prism of a child's eyes—to find wonder in the universe—but being burdened at the same time with the realities of experience, the dashed dreams, thwarted expectations and other wild cards in the game of growing up.

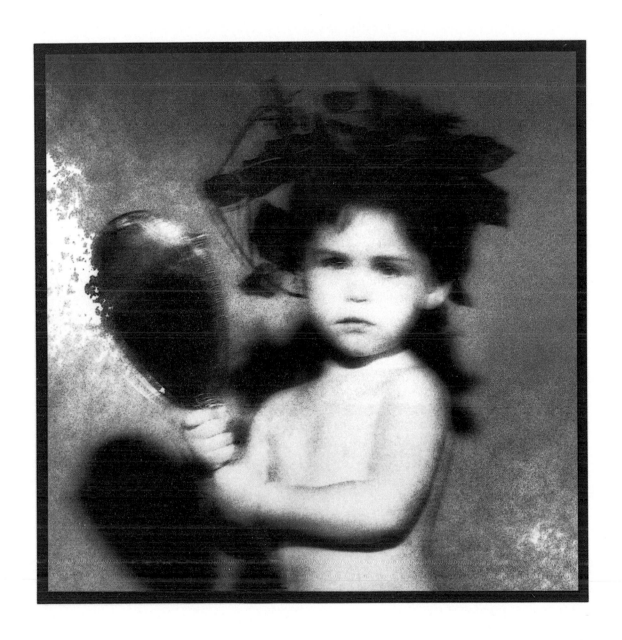

HELEN HEIGHINGTON
Canadian, born 1944 –

Dreams, (From the Joy Series), 1987
10¼″ × 8¼″ photocollage
Collection of Alyse Jane Kennedy

To make the image you want, you use any method you need.
Photography has always played a central part in furnishing the
images required by the artist and the altered, constructed,
expanded photograph, in turn, has provided even more of them.
Heightington's use of the expanded photograph extends into color
photocopy and collage. Her employment of language (here, a jar is
identified as "joy" and the ring you reach for on the merry-go-
round is labelled "dreams"), while minimal, is a reminder that the
picture can be read as well as looked at and that the two
experiences are more intermingled than we often acknowledge. As
a result of collage, a new landscape is born, one in which it is no
more surprising to find a carousel juxtaposed to a table set for tea
than it is to discover a couple of fairy-tale girls dressed in their
Edwardian best, strolling through some dimension just millimeters
away. It's a sort of contemporary Land of Counterpane.

FRANCESCO SCAVULLO
American, born 1930 –

Tara D'Ambrosio, 1983
20″ × 30″ silver print
Collection of the artist

To some of his critics, Francesco Scavullo seems grounded in the 70's, high priest and high-salaried proponent of a synthetic (and outmoded) attitude toward photography as manifested in high-gloss, commercial and often chauvinistic product, the man behind an endless succession of Cosmo covers.

But as Tara D'Ambrosio shows, Scavullo is considerably more interesting than that. Wide-eyed, petulant and piercing, her romantic curls cascading gently down around her shoulders, the child exemplifies that quest for affirmation and approval found in so many of her pre-pubescent contemporaries, a desire to entice, capture and hold the attention of adults.

To be sure, Scavullo has capitalized on her beauty, amplified her appeal and given us a hint of how she may appear in womanhood. But the essentials remain: that vulnerability mixed with guile of children seeking to belong in a world peopled by ubiquitous and infinitely more powerful elders. Do they know instinctively or do we teach them this intricate dance of emotional manipulation?

CAROL MARINO
Canadian, born United States, 1943 –

Mother and Twins, 1985
13¾″ × 10¾″ toned silver print
Private Collection

Carol Marino's pictures fall clearly into the Imogen Cunningham tradition—the pursuit of the integrity of clarified things and the search for meaning in a world unlocked by the impress of "straight photography." Marino's long series of plant studies and her highly photographic pursuit of the nature of light passing through other glass forms (such as milky, opalescent objects made of Lalique crystal) have taken as their aim—like Cunningham's—the study of light as means of releasing the formal coherence in what surrounds us.

The subject here, too, is light, light that is omnidirectional and continuous—into which have been introduced a preternaturally radiant mother and her twins. The three of them rise up from a little serendipitous carpet that is as ruled, as checkered, as bounded as a game board. The mother's eyes are closed against the light, giving her a Madonna-esque look that is more related to the history of painting than to the urgent present-ness of photography. The twins are, however, two going concerns, their eyes famished for experience, the two axes of their gazes giving the dimensionless centre of the photograph a new openness.

DEBBIE FLEMING CAFFERY
American, born 1948 –

After the Snake Bite, 1985
18⅞ × 18⅞" silver print
Collection of the artist

This impressive photograph carries with it an almost operatic theatricality which, because of the photographer's aesthetic vigilance, never spills over into mawkishness or melodrama. There is a vaguely Faulkner-esque Gothicism to it, a barely controlled intensity that is both stirring and disturbing at the same time (the photographer is Cajun, by the way, and grew up in that most Gothic of American cities, New Orleans).

The diagonal glare of falling light seems to announce the boy's special status, either as victim or as survivor or both. The white lips, the whitened flash of ear, mark him as a mythical boy, as some dark, Pan, some fallen angel, while the all-over dappling of light seems to provide a sense of refuge for the regrouping of his powers. There are great reserves of strength in the easy uprightness of the boy's torso and in the way he holds his shoulders back. The bowed head is not an attitude of defeat, but rather the momentary, temporary accepting of his sufferings. The great smeared medicinal X on his belly is the absolute centre of the photograph, the location of the photograph's greatest density. It is this fatalistic X that the boy will transcend.

JEFF NOLTE
Canadian, born United States, 1950 –

Papal Visit, 1985
12″ × 8″ silver print
Collection of the artist

There's a whole lot of sheer looking going on here. The setting is Nathan Phillips Square at Toronto's City Hall. The occasion is the first visit to Toronto of Pope John Paul II in 1985.

Among the many oddnesses of this photograph is the fact that everybody in it appears to be looking in a different direction. The amusing Ontario periscope props up the center of the picture, but cannot ultimately hold our attention the way the boy's wide-eyed openness to experience can.

LUBO STACHO
Czechoslovakian, born 1953 –

Brothers, 1975/1985
12 ¾″ × 8″ silver print
Collection of the artist

This photographic comparison—two brothers as the parentheses around a decade of time-span—seems at first to be a sort of growth chart. At the outset, we are interested mostly in how each of the boys have changed. Do the boys end up looking anything like the selves they inhabited ten years before? Is there a readable preview in the boy of the man to come? Is there a change in the personality parallelism? Is the one young man to the other young man as the boy was to the other boy, psychologically speaking, or have they moved closer together or further apart? Can we detect any of this for ourselves?

Then there is a sort of sadness. The photograph proves the combustion of time. Experience falls all over itself in its rush to change into history. Nothing stands still except the photograph, the two photographs. "Photography," Susan Sontag maintains, "is an elegiac art, a twilight art. Most subjects are, just by virtue of being photographed, touched with pathos." Either half of this double photograph, viewed apart from the other half, would bear this pathos. Viewed together, however, they release something more than pathos alone. Something sweetly scary about mortality. Everybody wants to be big. Not old. It is interesting to note, by the way, that the photograph of the brothers as older boys is at the bottom rather than the top. It's as if there has been what E.M. Cioran calls a "fall into time" rather than a growing up into it.

DEBRA FREIDMAN
Canadian, born 1955 –

Deadheads, Buffalo, 1985
13 ¾″ × 11″ silver print
Collection of the artist

Debra Freidman's three young women and the celebratory energy
of their clothing and their jewellery, a three-part melange of stripes
and graphics and patterns and tie-dye detonations punctuated with
sparkle and glitz, billow into the space of the picture-plane with a
sartorial *joie de vivre* that is unsubstantiated by the expressions of
the young women themselves. The defiant look of the girl in the
middle seems to mask, ineffectually, a good deal of uncertainty.
The girl at the right is sufficiently cropped that we cannot tell
much about her, except for the fact that her expression is as wary
as her mouth is beautifully shaped. The girl on the left bites her
lips in nervousness. All three of them hold on to each other for
security. It is undeniable that clothes make a statement. In this
case, the statement they make is more forceful than the subject
they're making it about. Which inversion is one of the upsets of
adolescence.

MARTHA DAVIS
Canadian, born 1959 –

Nantucket, 1987
8½″ × 13″ ektacolour
Collection of the artist

Photographer and filmmaker Martha Davis has frozen the image of this boy's torso, as he has come exploding out of the water, into a frame-filling topography that now looks less like the body of any particular boy than it does an independent structure—the product of sculpting in time. The image has thus been given a new meaning of its own; it is sufficiently generalized that it is now without incident, beyond narrative, rhythmically homogeneous, so that it comes to us as a single, indivisible thing. Such an indivisible object as this torso-structure, which begins now to take on architectural attributes, "opens up before us the possibility of interaction with infinity," as the Russian film director Andrey Tarkovsky has put it, "for the great function of [this kind of] artistic image is to be a detector of infinity. . . " Such an image affects us, Tarkovsky maintains, "by the very fact of being impossible to dismember."

BURT COVIT
Canadian, born 1953 –

Sante Fe, 1989
4¾" × 7¼" silver print
Collection of the artist

Children are better at transformation than adults are. Probably because, as children, they are in the thick of it. Growing up makes them masters of metamorphosis. When adults try to turn themselves into something else, it's never very satisfactory. Their wits are sluggish, their bodies and faces stiff and recalcitrant with routine, their imaginations fueled by some constant made-for-TV version of the profit motive (or motif) that runs through their heads like a tune they can't drop.

Children, on the other hand, don and doff identities with an ease that makes you queasy. They manipulate images-for-themselves as if they were selling them to ad agencies (ad agencies swoop down on what children do anyhow and run off with parodic versions of it) and fall about the world holding their sides, fearless about looking funny. All this bravado in the face of becoming anything you want can, of course, backfire. Sometimes, in appropriating the anthropolgical power that comes automatically with some kinds of costume, a kid will recognize a whiff of primitive brimstone released by his get-up. This can make a kid sort of nervous. That's what seems to have happened here. These children are temporary savages, mud men, animal spirits, monsters. It makes them feel strange and hollow.

RICK ZOLKOWER
Canadian, born United States, 1950 –

———————————————

Anna with Braided Hair, Toronto, 1986
20″ × 16″ toned silver print
Collection of the Winnipeg Art Gallery;
acquired with funds from Hongkong Bank of Canada

In the intensely personal realm of creation, all artists impart their own sensibilities and perceptions to what they are about to commit to canvas, on paper or on film. And so it is with *Anna with Braided Hair*, Rick Zolkower's picture image of his daughter which exudes expectation and awe in equal measure. Seemingly stylized, Zolkower's photograph conveys a father's very real wish to celebrate not only the perfection of the child's features, her unblemished beauty, but catch the purity and zest of extreme youth, of an individual poised at the start of life's road. This isn't falseness or an attempt to project onto the child that which isn't there. Rather, it is the power of the photographer meeting with a gloriously intriguing subject and communicating a simple, overwhelming feeling of love.

———————————————

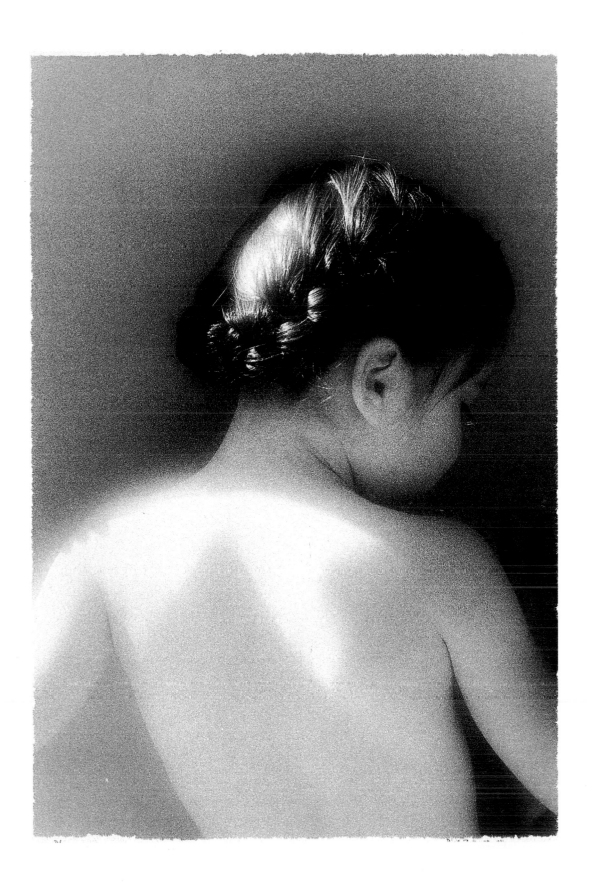

DAVID HLYNSKY
Canadian, born 1947 –

Woman, Child, Strawberries, Poland, 1989
11″×14″ ektacolour
Collection of the artist

The multifaceted, multitalented David Hlynsky is a photographer, a writer, a holographer and a painter. He was president and founder of Toronto's Fringe Research Holographics, Inc. and was centrally involved with its activities during the years 1973-83. From 1972 until 1982, he published and edited an extraordinarily inventive periodical call *image nation* devoted to the publication of experimental photography. Hlynsky has been exhibiting his own photographs since the early 1970s.

Women, Child, Strawberries is part of a documentary photographic project called *Satellites*, the result of a number of recent trips made by the artist behind what was, until the politically astonishing summer of 1989, the Iron Curtain, and into a number of hitherto Soviet-bloc countries—Czechoslovakia, Poland and Cuba. Seeking what he has called an "unadulterated view" of these countries, our knowledge of which has come to us for half a century in the form of clichés and stereotypes, Hlynsky says he travelled half as a tourist, half as an artist, trying to inhabit and transmit some understanding of a "wide spectrum of social landscapes." This is a peculiar photograph, partly because it is so open and disclosed except for the intrusion of the rubber-booted figure entering from the right whose identity we do not know. The figure, however, seems to be wielding no little authority over the old woman and the boy. Because the boot encodes so much psychological power within the photograph, it is on its way to becoming first a symbol and then, when the woman and child are brought back into the mix, the generator of a fable—a fable which could be about intimidation, disruption or even (reading it differently since the summer of '89) the introduction of a new kind of freedom.

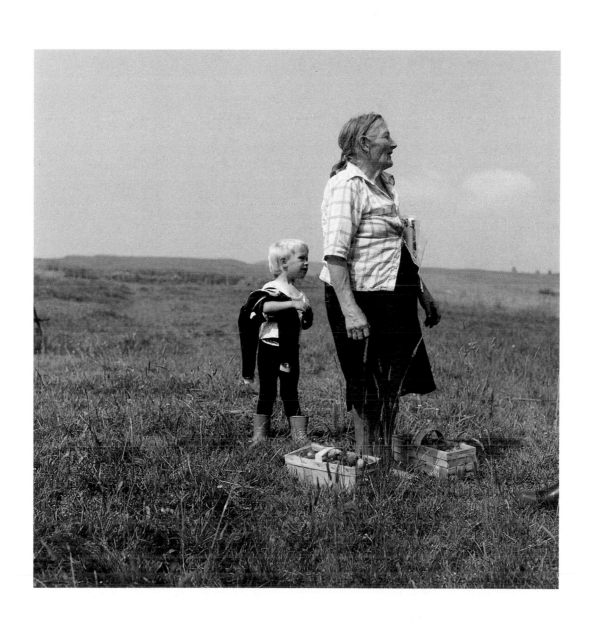

JOAN MOSS
Canadian, born 1931 – living in the United States

The Sublime Lucy, 1986
16″ × 20″ silver print
Collection of the artist

Which one is Lucy? Both of them, woman and child, come across as sublime enough. In fact it could be argued that there is a certain sublimnity, in the proper literary sense of the word, to be found here—a drift of the sublime in the way in which 18th-century political scientist Edmund Burke originally meant it to be understood. The sublime, for Burke, had to do with a pleasurable sense of terror and/or awe generated by the presence of immensity. Alpine mountain ranges might do it, for example, if they rose one upon the other, higher and higher, until human scale was lost. The agoraphobic jails of Piranesi's etchings could do the trick too, with their labyrinthine, existential endlessness. Even Andy Warhol's infinitely repeated Elvises and Marilyns make it into the ranks of sublimnity because their (potential) endlessness is too vast and ongoing for the shaky human space-time imagination to deal with.

Joan Moss has built a model of sublimnity here. The woman with her head thrown back so joyously and the child with its head resting sideways on the woman's shoulder together form something that looks very much like a mountain landscape, an effect emphasized by the scroll of cloud behind them that somehow winds and billows itself into a shape that conforms to them. Together the woman and child are immense, a unit of bonding and care intense enough and vast enough, in the sense of love's energies, to transport them somewhere immeasurable.

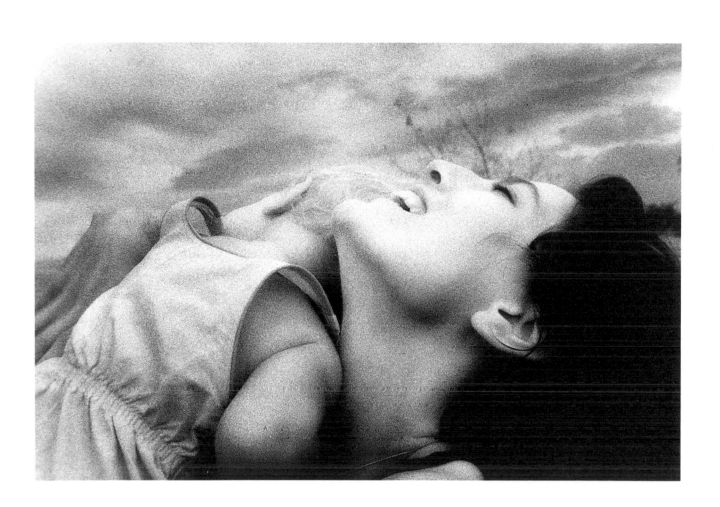

GREG STAATS
Canadian, born 1963 –

She Who Knows, GRPW, SNR, 1988
4″ × 12 ¼″ silver print
Collection of the artist

Like a slow film—a film of which we are able to see only two highlights, before and after moments—the dyptych *She Who Knows* is a gentle recording of a moment of insight and its meditative aftermath. The photograph is beautifully unobtrusive.

Greg Staats is from the Six Nations Reserve. He sees his task as a photographer to document his people, to capture on film their pride and their dignity. "I think a lot of non-Natives have stereotypes about who we are," says Staats. "I want to break those barriers."

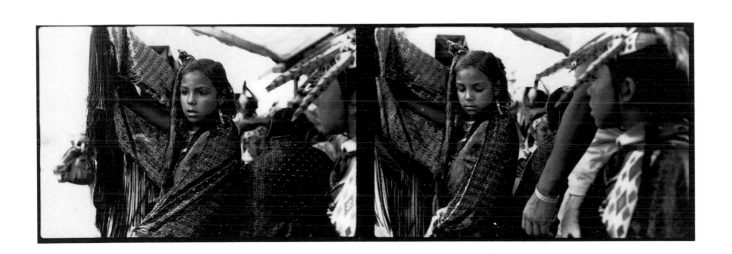

GREG STAATS
Canadian, born 1963 –

Karontose Jacobs and his Mother Mona, GRPW, SNR, 1989
8¾" × 8½" silver print
Collection of the artist

Karontose Jacobs not only bears a name to conjure with, something you can really get your linguistic teeth into, he also possesses a firecracker smile and puckish eyes. The spiky explosion of his hair seems like a function of his high spirits. His mother meets the sweet danger of her son's beguiling ways with a watchful, half-amused love that is infectious. There is also a faint, remote sadness in her look. Karontose Jacobs will have to struggle to keep alive the meaning of his people in a world that diminishes difference while turning everything into mere information. The contemporary world is the world we have made and we must live in it as best we can. "I don't dwell on the past," says Staats, "but you have to understand where you've come from in order to go forward."

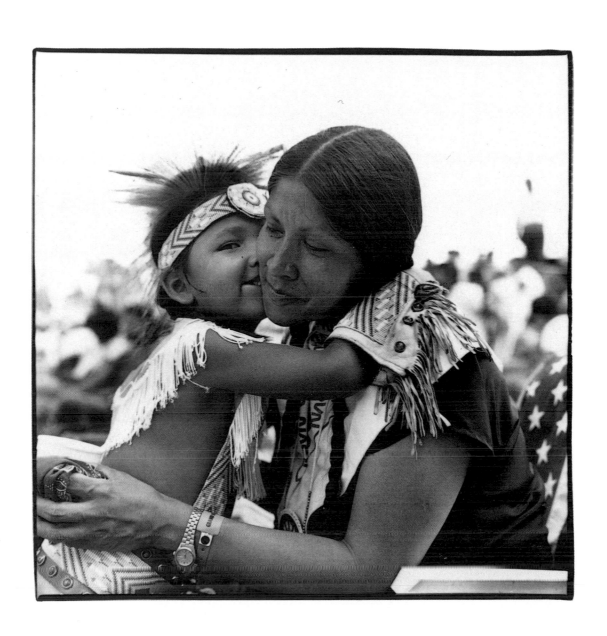

LOUISE ABBOTT
Canadian, born 1950 –

Jessica Benoit with her Dolls, Black Duck Brook,
Newfoundland, 1989
8″ × 10″ silver print
Collection of the Winnipeg Art Gallery;
acquired with funds from Hongkong Bank of Canada

There is a totem-like feel to the arrangement the girl makes. By
holding her dolls up in front of her in order to present them to the
photographer, she has constructed a pillar of representations, a sort
of evolutionary progress upwards from the cute, moronic stare of
the Cabbage Patch Kid, through the more mimetic artifice of the
blonde bombshell doll with the arching eyebrows and the high
forehead, to the tentative, oddly eclipsed features of the girl
herself. It is sad and ironic that, photographically speaking, both
the flat, silkscreened eyes of the Cabbage Patch Doll and the
wobbly glass eyeballs of the blonde have more vivacity than do
the eyes of their owner.

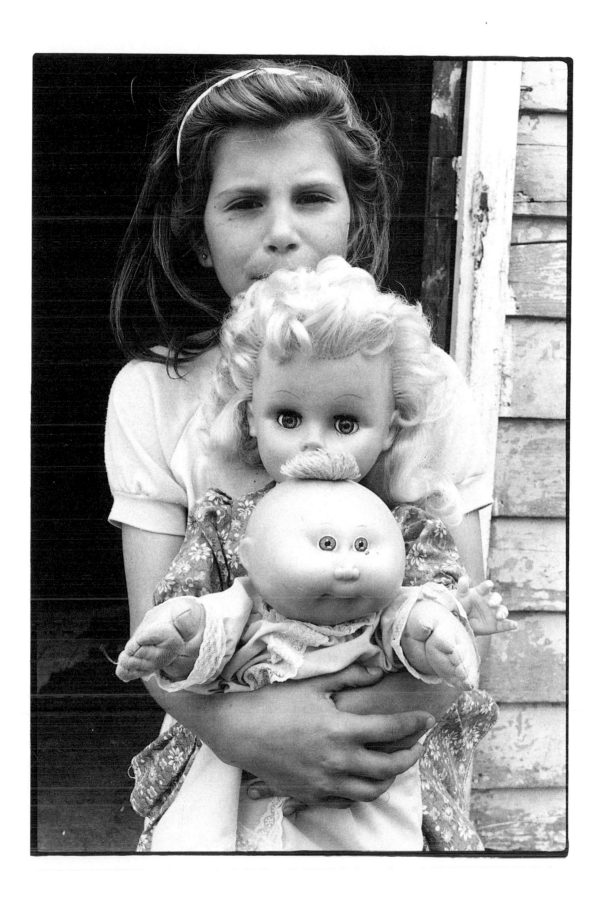

MICHAEL SPANO
American, born 1948 –

Subway, New York, 1978
51½″×21¾″ silver print
Collection of the Winnipeg Art Gallery

Michael Spano's inventive use of the panoramic format turns this crush of subway riders into a visual log jam. By allowing the camera to sweep from his feet up and out into the subway car's middle distance, Spano creates a dizzying interlock of limbs and a disposition of bodies that results in a woven, almost tapestry-like overall configuration within the photograph—an overallness that threatens at every turn to fall back from figuration into an abstracted surface texture. The train, Spano says, was New York City's subway D train to Coney Island. It was—as can be surmised from the photograph—a hot summer day. The two prostrate children in the foreground have been felled by the heat. The X they make with their bodies is a self-cancellation indicating the extent to which they have dropped out of the photograph and into a muggy doze.

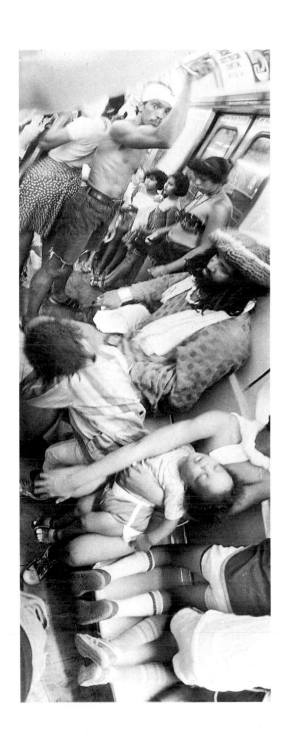

LAURENCE ACLAND
Canadian, born United States, 1949 –

C.N.E., Toronto, 1988
11″×14″ silver print
Collection of Donald Corkin

Now *this* is exuberance, this gleeful child being hoisted up into the navy blue night. Given the nipper's delicious, delerious new prominence in the world—in midair on the midway—it seems right that it should be the equivalent, in size and scintillation, to the sparkling ferris wheel itself.

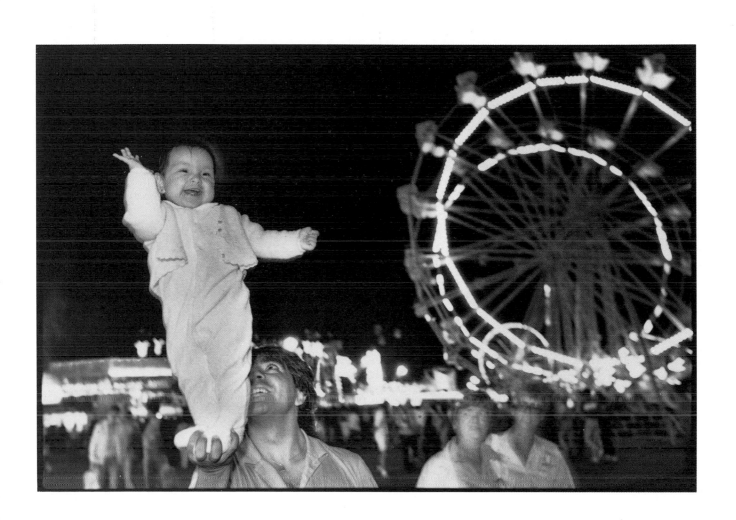

TOM SKUDRA
Canadian, born 1946 –

Three Banman Children, Net – Johann – Jakob, 1988
11″×14″ silver print
Collection of the artist

Net Banman, fifteen, and her brothers, Johann, eight, and Jakob, nine, are Mexican Mennonites, the children of Katerina and Pieter Banman. The Banmans are migrant vegetable pickers, "dirt workers," who come to western Ontario for half the year to pick cucumbers, beans and tomatoes. The Banmans, along with other migrant workers, were the subject of an article in *Toronto Life* magazine in May 1989 by Lindalee Tracey and photographer Tom Skudra. The Banmans work very hard and, as a result, make just enough to live. In a good season, they make about $20,000, "a small fortune," as Tracey points out, "in Mexican pesos... Whatever money they do make," she writes, Pieter "pumps into his dairy farm at the Mennonite settlement in the postcard valley of La Honda, in northern Mexico. Back home, Pieter hires Mexicans to do his stoop work." In Skudra's photograph, Net, Johann and Jakob have finished picking for the day, have washed up and eaten supper and are settling into a little television before bedtime (they rise at 5:30 a.m.). According to Skudra, the small black-and-white TV they are watching barely produced a picture at all. You'd never know it from the enchanted look on Johann's face.

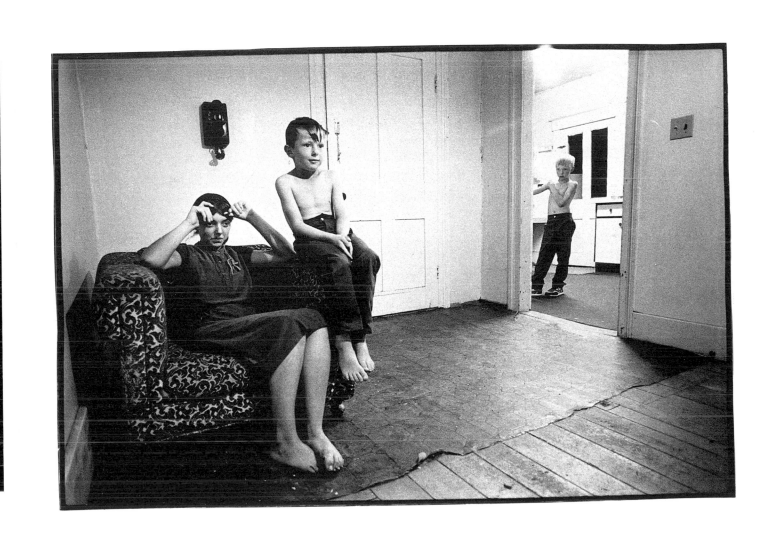

MARY ELLEN MARK
American, born 1940 –

Twin Babies Crying, Kentucky, 1988
16″ × 20″ silver print
Collection of the artist

Mary Ellen Mark, possessor of a photographic eye that has quite rightly been characterized as "unflinching," is an award-winning American photojournalist with a long list of credits which reflect her interest in the lives of those people living on the edge of society—the marginalized, the disenfranchised, the oppressed. She has worked in Turkey, in India and in Ethiopia. Her study of Mother Teresa and *Falkland Road*, a book about the prostitutes of Bombay, were both published in 1981. Her book *Streetwise* (1985), while it was photographed in Seattle, is in a sense no less exotic or distressing than her Third World photographs just for being shot at home. *Streetwise* is a tough, moving exploration of the sad, surreal world of child prostitutes and prepubescent hustlers, the world of the runaway.

Not the least remarkable feature of Mark's photograph of the twin babies crying is the horrifying fact that the babies have yowled themselves into dehumanization. They no longer look as much like human babies as they do drawings by Lewis Carroll illustrator John Tenniel; they look like Tweedledum and Tweedledee, or like the Queen of Hearts, with her heavy bulldog face.

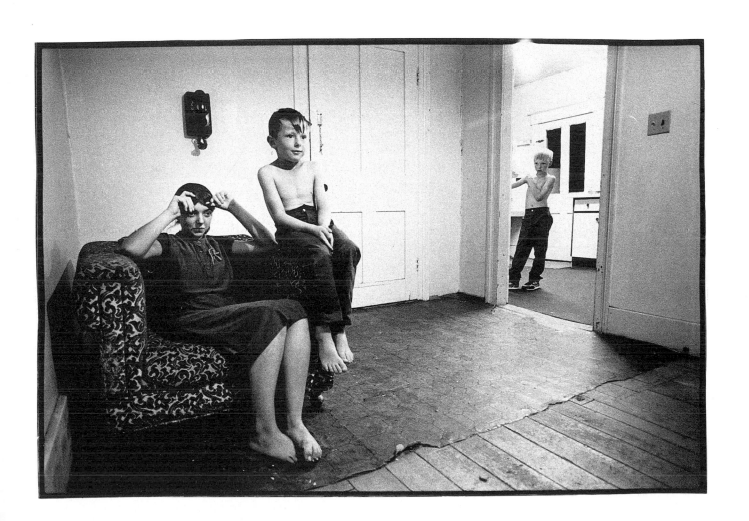

GILLES PERESS
American, born France, 1946 –

Enniskillen, Northern Ireland, 1984
19¾″ × 15¾″ silver print
Collection of the artist

His head is tilted like the head of Christ in conventionalized
paintings of the crucifixion. He smiles bravely, gamely, through his
environment of theraputic equipment. The boy is the inhabitant
and, temporarily, the prisoner of the necessary equipment of
healing and he is making the best of it.

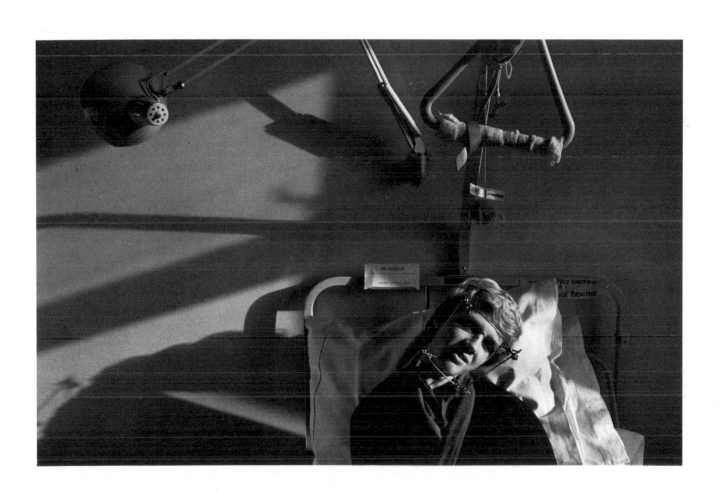

GILLES PERESS
American, born France, 1946 –

Sunday Morning, Belfast, Northern Ireland, 1985
13″ × 19¼″ silver print
Collection of the artist

This not entirely self-assured young woman, emerging tentatively into the streets of Belfast, carries her punkness as a friend. She has prepared a look to meet the looks she will meet, to loosely paraphrase T.S. Eliot. The way Peress has caught her, she has become—joined by the other half of her reflection—a Rorschach test, an enigma born out of deliberation, from which almost anything can be made.

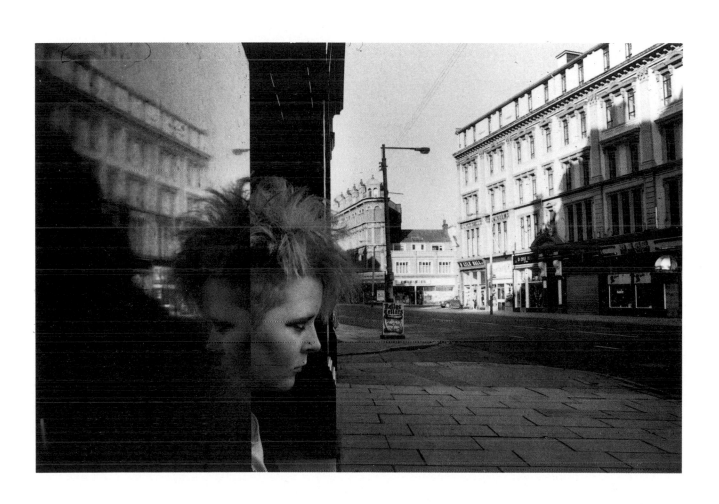

GILLES PERESS
American, born France, 1946 –

Dunville Park, Belfast, Northern Ireland, 1988
13″ × 19½″ silver print
Collection of the artist

A snowfall of kids. Or a garden of white child-flowers.

The rhythmic distribution of the whites on the (playing) field of grey, already formally engaging, is a ground over which has been layered a system of diagonals—the bars and chains of the swings—which are gathered up into the top of the photograph and held there, giving the whole scene a buoyant, suspended quality that nicely conveys the boisterous high spirits of the children at play. The huge close-up hand steadying the metal leg of the swing seems to be a controlling image, an assurance of some kind that the conditions we see in the picture will prevail.

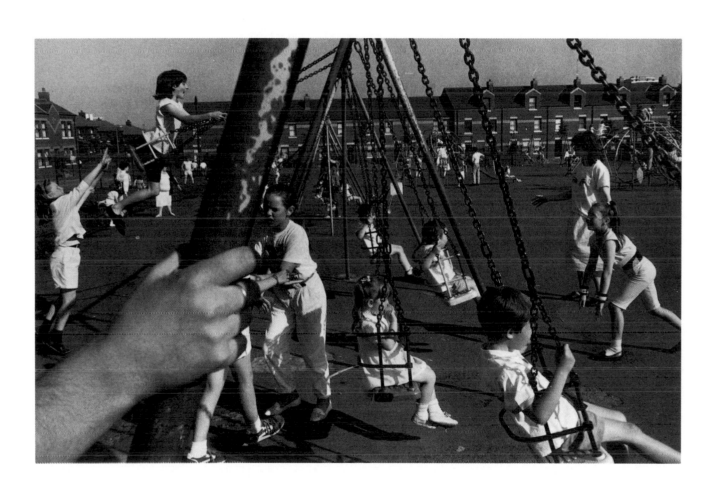

ARLENE COLLINS
American, born Canada, 1952 –

Solar Gymnasium, New York, 1989
12½″ × 18½″ silver print
Collection of the artist

Shot from the top down like this, the young boxer seems to be all thought, all musing, all rumination, his slender body dangling down to the floor from the suspension of his lambent, inward-seeing eyes. Flanked by adults and the momentary distraction of another, younger child, he is the focus, the content of adult aspiration and expectation. This young athlete is slung between everything; his poignancy rests in his appearing to have nowhere to stand, nowhere to be.

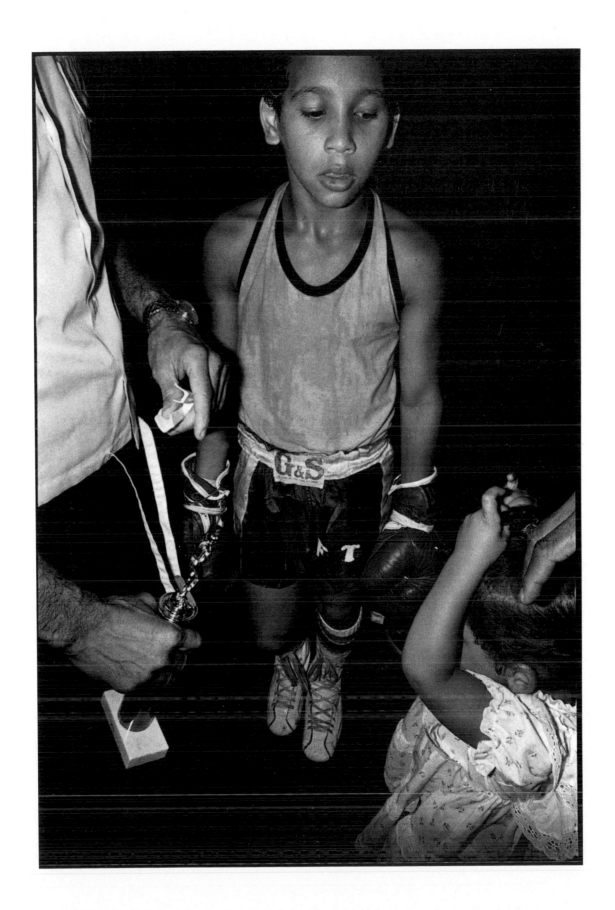

NICHOLAS NIXON
American, born 1947 –

Cambridge, 1988
8″ × 10″ silver print
Collection Fraenkel Gallery

Among the accomplishments of the young American photographer
Nicholas Nixon is his employment of the 8×10 and 11×14 view
camera as an agency of photographic spontaneity. Nixon set out to
make what are essentially "street photographs" in the Lee
Friedlander/Garry Winogrand tradition, but using the large format
camera and its equally large negative and contact print to do so.
The results, from the mid-1970s on, have been extraordinary—a
long series of apparently casual arrangements of people being
themselves, presented with the presence and the sensuous tonal
depth of the carefully lit studio still life. Nixon's series of
photographs of the elderly are brilliantly unflinching, honest,
noble in a way that seems both disturbing and invigorating in the
photographer's refusal to resort to any kind of cosmetic prettiness.
The same can be said of his recent series of portraits of people
with AIDS.

Nixon's photographs of children—including his own son and
daughter, shown here—are unusual in their melding of
documentary concerns with purely aesthetic ones. In this
particular photograph, the bodies of the children, their wayward
arms and legs (and that steadying parental hand) fill and energize
the space of the photograph in a way that is satisfyingly
constructivist. The up-down positioning the children have assumed
is a convincing shorthand for the omnidirectional, polymorphous
sensuality of every child.

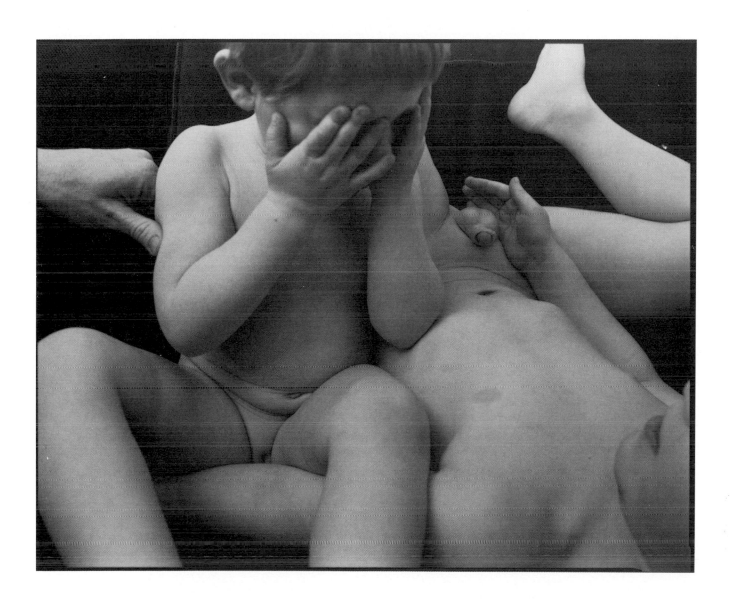

MARY ELLEN MARK
American, born 1940 –

Twin Babies Crying, Kentucky, 1988
16″×20″ silver print
Collection of the artist

Mary Ellen Mark, possessor of a photographic eye that has quite rightly been characterized as "unflinching," is an award-winning American photojournalist with a long list of credits which reflect her interest in the lives of those people living on the edge of society—the marginalized, the disenfranchised, the oppressed. She has worked in Turkey, in India and in Ethiopia. Her study of Mother Teresa and *Falkland Road*, a book about the prostitutes of Bombay, were both published in 1981. Her book *Streetwise* (1985), while it was photographed in Seattle, is in a sense no less exotic or distressing than her Third World photographs just for being shot at home. *Streetwise* is a tough, moving exploration of the sad, surreal world of child prostitutes and prepubescent hustlers, the world of the runaway.

Not the least remarkable feature of Mark's photograph of the twin babies crying is the horrifying fact that the babies have yowled themselves into dehumanization. They no longer look as much like human babies as they do drawings by Lewis Carroll illustrator John Tenniel; they look like Tweedledum and Tweedledee, or like the Queen of Hearts, with her heavy bulldog face.

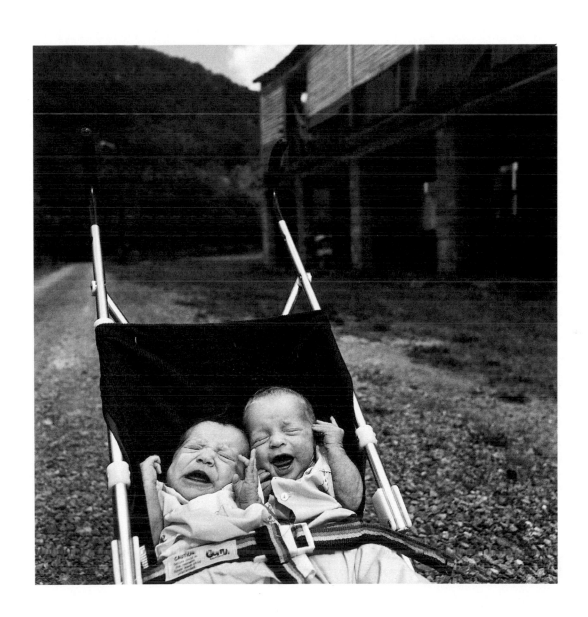

MARY ELLEN MARK
American, born 1940 –

Homeless Damn Family Life, Los Angeles, California 1987
16″×20″ silver print
Collection of the artist

Everybody looks tired. The man's name is Dean, an ex-trucker. He is the children's stepfather. When the photograph was taken he was 33. His wife, the children's mother, is Linda, 27. She is a former nursing-home aide. The children are Crissy, 6, and Jesse, 4. They are homeless. They live a lot of their time in the car. Going down the road used to be the direction you took to find the pot of gold at the end of that great socio-economic rainbow, the American Dream. You used to be able to get your kicks on Route 66. Not now. The empty highway that opens up behind this family looks like a threat, not like an opportunity. All this is presumably harder on the children than on anyone else. You can feel the pressure on them from the structure of the photograph, where the roof of the car slopes down claustrophobically over them, squeezing them into a wedge where they can hardly breathe.

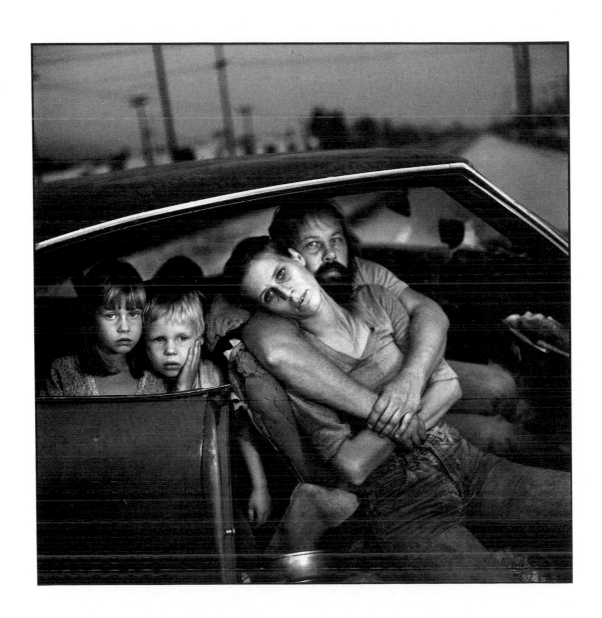

MARY ELLEN MARK
American, born 1940 –

Homeless in America, Venice, California, 1987
16″ × 20″ silver print
Collection of the artist

The fence is important here. Good fences, as poet Robert Frost once wrote (in a paroxysm of Yankee isolationism), might make good neighbors, but it is the function of a fence to say No, and this one—long and dark and high—is the essence of exclusion, division, negation. The way it stretches out into the distance, furthermore, makes you feel that whatever the conditions are that underlie and define the lives of these two boys, they are destined to go on forever. The fence says that symbolically, nothing much is likely to change.

Which certainly isn't the boys' fault. The boys are Darcy and Andrew and they're standing outside the Bible Tabernacle Mission in Venice, California. They are all dressed up, touchingly so. Pictorially, it is hard to see anything else in the photograph except for Darcy's big striped tie and Andrew's white collar worn out over his jacket. Their clothes make them look as if they're trying awfully hard to align themselves with middle-class success. Darcy's tie is more grown-up than he is. It's like an albatross around his neck.

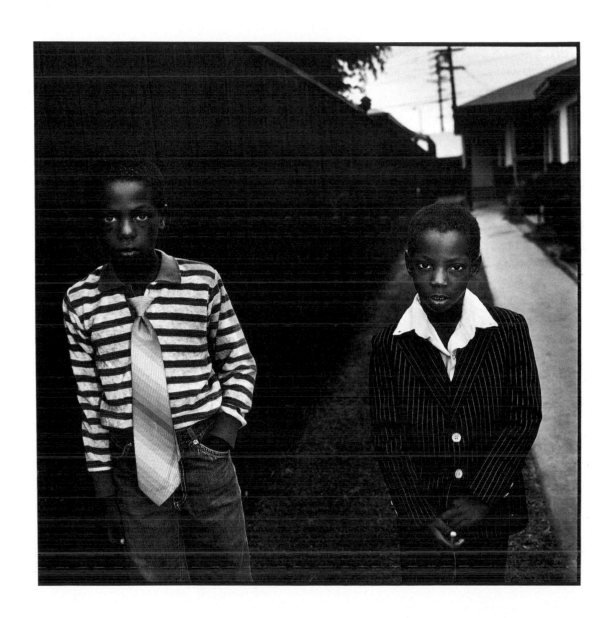

DAVID LAURENCE
Canadian, born Ghana, West Africa, 1955 –

Alexander, 1989
13″ × 8¾″ silver print
Collection of Gary Michael Dault and Jocelyn Laurence

Alexander Dault-Laurence was two weeks old when his uncle,
David Laurence, took this photograph of him.

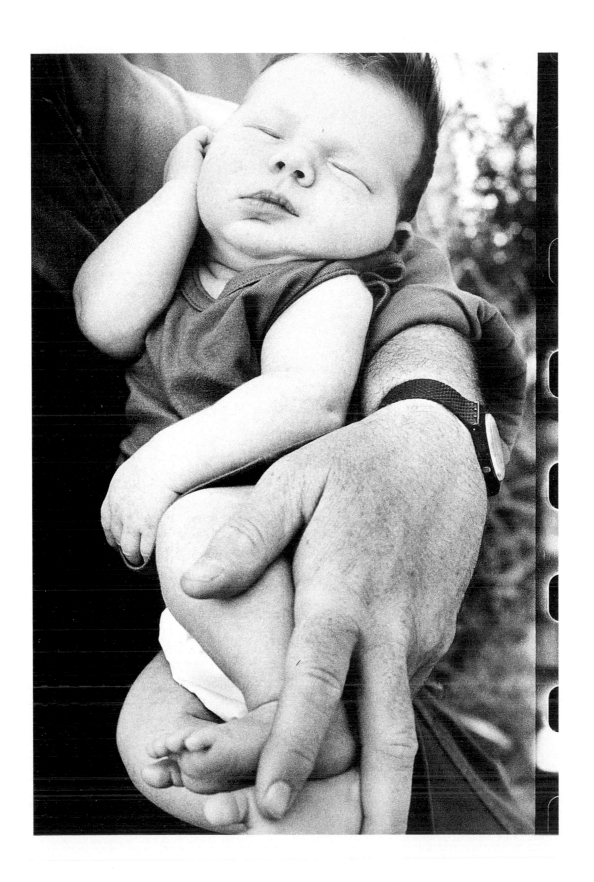

JOHN BALDESSARI
American, born 1951 –

Announcement, 1987
30¼″ × 24¼″ silver print
Collection of Jane Corkin Gallery

"Man is born free", Rousseau wrote in *The Social Contract*, "and he is everywhere in chains." This disturbing two-part photograph by American artist John Baldassari appears to speak precisely to that diminishing transformation. The raw, heavy chain held, Samson-like, in the hand of the rigidly muscled man filling the panel on the right (is this fascistic imagery made literally right-wing by being placed where it is?) is inescapably readable—no matter what benign function it might fulfill as a tool—as an adjunct to and emblem of restraint and suppression. The naked, vulnerable-looking boy at the left, standing so unnaturally to attention, seems destined, because of the juxtaposition of the two panels, to undergo the life-denying oppression the wielded chain seems to promise. This may happen as an act of direct aggression. It may also come to pass in the process of merely growing up. Perhaps the boy at the left *is*, alas, the man on the right.

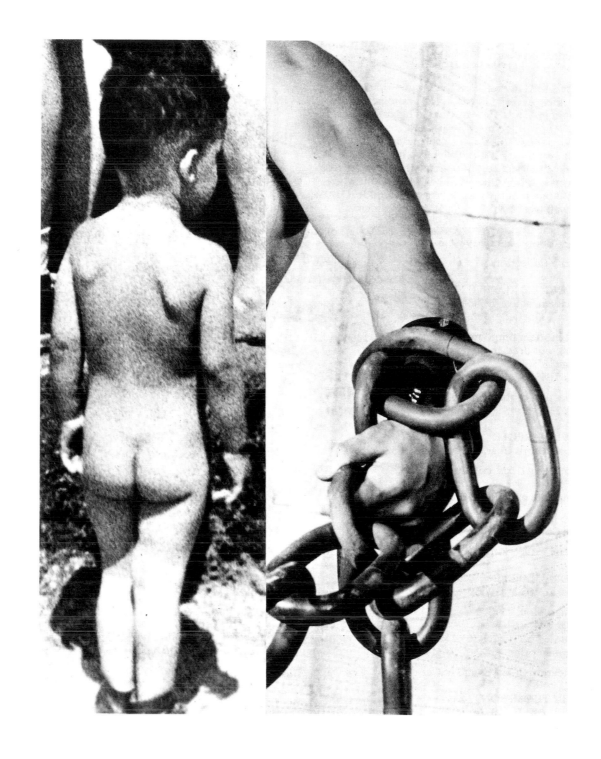

142. DC
An

Mc
9⅝
vir

illu
Ph
Mc

Cc
© 1

Cc
Ne

144. EL
An

Tk
3 ½
vir

Pr

146. H/
Ar

Cl
im
m
vir

si¡
illi
El

Tl

148. RC
Fr

Po
15
sil

Cc

150. RC
Fr

U.
15
sil

Cc

152. W
A¡

Se
1(
si
©

C

194. IRVING PENN
American, born 1917 –

Hippie Family F. , San Francisco, Aug/Oct, 1967
20¾″×19½″
edition 8/48
platinum/palladium

Copyright © 1967, Irving Penn

Collection of Mr. and Mrs. Jack Creed

196. ROBERT MINDEN
Canadian, born 1941 –

Doukhobour Women and Children, 1978
image: 12½″×19½″
paper: 15¼″×20½″
cibachrome

Collection of the artist

198. ANDRÉ KERTÉSZ
American, born Hungary, 1894 – 1985
worked in Paris 1925 – 1936,
New York from 1936

Gypsy Girl, Arles 1979
8″×10″
silver print

signed by the photographers in pencil au verso
''July 1979''

Collection of the Winnipeg Art Gallery:
Anonymous gift

200. JUDITH CRAWLEY
Canadian, born 1945 –

Conchita and Lulu, 1979
16″×20″
silver print

illus: Judith Crawley and Susan MacEachern.
*Giving Birth is Just the Beginning: Women Speak
about Mothering*, Montreal: Book Project NDG,
1985, p. 32

Collection of the artist

202. THADDEUS HOLOWNIA
Canadian, born England, 1949 –

Untitled, From the Headlighting Series, 1978
8″×20″
silver print

Collection of the artist

204. MARY BOURDEAU
Canadian, born 1940 –

Untitled, 1979
4″×5″
silver print

Collection of the artist

206. RAY VAN DUSEN
Canadian, born 1949 –

Untitled, 1980
8¾″×13″
ortho print

Collection of J. Zachary Corkin

208. MICHAEL KLEIN
Canadian, born 1958 –

Baltimore, 1982
16″×20″
type 'c' print

Collection of the artist

210. JOANNE JACKSON JOHNSON
Canadian, born 1943 –

Untitled, Inukjuak, Quebec, May 1982
14″×14″
ektacolour

Collection of Jake Averill Corkin

212. ROGER P. MULLIGAN
Canadian, born 1955 –

Pam at the Rink, 1978
11″×14″
silver print

Collection of the Winnipeg Art Gallery; acquired
with funds from Hongkong Bank of Canada

214. NICHOLAS NIXON
American, born 1947 –

Covington Kentucky, 1982
8″×10″
edition 22/50
silver print

illus: The Museum of Modern Art.
Nicholas Nixon, Pictures of People,
New York: MOMA, 1988, p. 54

Collection of Nina and Norman Wright

216. NICHOLAS NIXON
American, born 1947 –

Tennessee Street, Lakeland, Florida, 1982
8″×10″
edition 5/50
silver print

Courtesy Fraenkel Gallery, San Francisco

218. DAVID LAURENCE
Canadian, born Ghana, West Africa, 1955 –

Rail Car House, Mexico, 1983
9″×13¼″
edition 4/6
silver print

Collection of the Winnipeg Art Gallery; acquired
with funds from Hongkong Bank of Canada

all works: © the artist

220. BARBARA COLE
Canadian, born 1953 –

Serenade, 1984
38″×57″
silver print, painted, mixed media

Collection of the artist

222. NIC NICOSIA
American, born 1951 –

Domestic Drama #4, 1982
30″×40″
type 'c' print

Collection of Musée d'arts contemporain, Montreal

224. NIGEL SCOTT
Canadian, born Jamaica, 1956 – living in Paris

'Crab Boy', Jamaica, 1985
23″×16½″
silver print

Collection of the Winnipeg Art Gallery; acquired
with funds from Hongkong Bank of Canada

226. LINDA McCARTNEY
British, born United States, 1944 –

Boy in Mask, 1985
image: 8″×10″
paper: 11½″×15½″
cyanotype

illus: MPL Communications Ltd. *Sun Prints*,
London: Barrie and Jenkins, 1988, p. 71

Collection of the artist

228. SHEILA METZNER
American, born 1939 –

Stella, Mouelle Forms, 1986
image: 16½″×24¾″
paper: 24″×32″
fresson print

illus: Jane Corkin. *Photographs*, Toronto:
Jane Corkin Gallery, 1989, p. 139

Collection of the artist

230. BARBARA COLE
Canadian, born 1953 –

The Governess, 1986
11″×16″
edition 1/10
silver print, painted, mixed media

Collection of the Winnipeg Art Gallery; acquired
with funds from Hongkong Bank of Canada

232. ANDREAS TRAUTTMANSDORFF
Canadian, born 1962 –

Flying Shovel, 1989
8½″×12½″
silver print

Collection of Zachary C. Kennedy

234. EDOUARD BOUBAT
French, born 1923 –

Paris, La Refuse, March 1980
14″×9½″
silver print

signed in pencil by the photographer
"Paris La Refuse, Mar 1980"

Collection of the artist

236. GAIL HARVEY
Canadian, born 1952 –

Between the Ages, Paris, 1985
16″×20″
silver print

Collection of the Winnipeg Art Gallery; acquired
with funds from Hongkong Bank of Canada

238. WOLFGANG ZURBORN
German, born 1956 –

Untitled, c. 1985
7″×9¼″
ektacolour

Collection of the artist

240. ANDRÉ KERTÉSZ
American, born Hungary, 1894 – 1985
worked in Paris 1925 – 1936
New York from 1936

Jardin des Tuileries, Paris, 1980
8″×10″
silver print

signed in pencil au verso
"A. Kertesz Nov 9 – 1980. No 34"

Collection of the Winnipeg Art Gallery;
Anonymous gift

242. DEBORAH SAMUEL
Canadian, born 1956 –

Beauty, 1987
19″×16″
cdition 4/50
silver print

Collection of the Winnipeg Art Gallery; acquired
with funds from Hongkong Bank of Canada

244. HELEN HEIGHINGTON
Canadian, born 1944 –

Dreams, From the Joy Series, 1987
10¼″×8¼″
photocollage

Collection of Alyse Jane Kennedy

246. FRANCESCO SCAVULLO
American, born 1930 –

Tara D'Ambrosio, 1983
20″ × 30″
silver print

illus: Sean M. Byrnes. *Scavullo*, New York: Harper
and Row, 1984, pp. 245-246

Collection of the artist

248. CAROL MARINO
Canadian, born United States, 1943 –

Mother and Twins, 1985
13¾″ × 10¾″
toned silver print

Private Collection

250. DEBBIE FLEMING CAFFERY
American, born 1948 –

After the Snake Bite, 1985
image: 18⅞″ × 18⅞″
paper: 23″ × 19⅞″
silver print

Collection of the artist

252. JEFF NOLTE
Canadian, born United States, 1950 –

Papal Visit, 1985
12″ × 8″
silver print

Collection of the artist

254. LUBO STACHO
Czechoslovakian, born 1953 –

Brothers, 1975 / 1985
12¾″ × 8″
silver print

Collection of the artist

256. DEBRA FREIDMAN
Canadian, born 1955 –

Deadheads, Buffalo, 1985
13¾″ × 11″
silver print

Collection of the artist

258. MARTHA DAVIS
Canadian, born 1959 –

Nantucket, 1987
8½″ × 13″
ektacolour

Collection of the artist

260. BURT COVIT
Canadian, born 1953 –

Sante Fe, 1989
4¾″ × 7¼″
silver print

Collection of the artist

262. RICK ZOLKOWER
Canadian, born United States, 1950 –

Anna with Braided Hair, Toronto, 1986
20″ × 16″
toned silver print

Collection of Winnipeg Art Gallery; acquired with
funds from Hongkong Bank of Canada

264. DAVID HLYNSKY
Canadian, born 1947 –

Woman, Child, Strawberries, Poland, 1988
11″ × 14″
ektacolour

Collection of the artist

266. JOAN MOSS
Canadian, born 1931 – living in the United States

The Sublime Lucy, 1986
16″ × 20″
silver print

Collection of the artist

268. GREG STAATS
Canadian, born 1963 –

She Who Knows, Grand River Pow Wow, Six
Nations Reserve, 1988
image: 4″ × 12¼″
paper: 11″ × 13¾″
edition 3 / 50
silver print

Collection of the artist

270. GREG STAATS
Canadian, born 1963 –

Karontose Jacobs and his Mother Mona, Grand
River Pow Wow, Six Nations Reserve, 1989
image: 8¾″ × 8½″
paper: 14″ × 11″
edition 3/50
silver print

Collection of the artist

272. LOUISE ABBOTT
Canadian, born 1950 –

Jessica Benoit with her Dolls, Black Duck Brook,
Newfoundland, 1989
8″ × 10″
silver print

Collection of the Winnipeg Art Gallery; acquired
with funds from Hongkong Bank of Canada